SO YOU THINK YOU KNOW ANTIETAM?

ALSO BY JAMES AND SUZANNE GINDLESPERGER

So You Think You Know Gettysburg?

ALSO BY JAMES GINDLESPERGER

Escape from Libby Prison
Fire on the Water
Seed Corn of the Confederacy

JOHN F. BLAIR
PUBLISHER
WINSTON-SALEM, NORTH CAROLINA

So You Think You Know
ANTIETAM?
The Stories Behind America's Bloodiest Day

James and Suzanne Gindlesperger

Published by
JOHN F. BLAIR
PUBLISHER
1406 Plaza Drive
Winston-Salem, North Carolina 27103
www.blairpub.com

COVER PHOTOGRAPH
Cattle now peacefully graze on ground once contested by Northern and Southern armies on America's bloodiest day.

Design by Debra Long Hampton

Library of Congress Cataloging-in-Publication Data
Gindlesperger, James, 1941-
 So you think you know Antietam? : the stories behind America's bloodiest day / by James and Suzanne Gindlesperger.
 p. cm.
 Includes index.
 ISBN 978-0-89587-579-2 (alk. paper) — ISBN 978-0-89587-580-8 (ebook) 1. Antietam, Battle of, Md., 1862. 2. Antietam National Battlefield (Md.)—Guidebooks. 3. Maryland—History—Civil War, 1861-1865—Monuments—Guidebooks. 4. War memorials—Maryland—Guidebooks. 5. United States—History—Civil War, 1861-1865—Monuments—Guidebooks. 6. United States—History—Civil War, 1861-1865—Battlefields—Guidebooks. I. Gindlesperger, Suzanne. II. Title.
 E474.65.G56 2012
 973.7'336—dc23
 2012013058

10 9 8 7 6 5 4 3 2 1

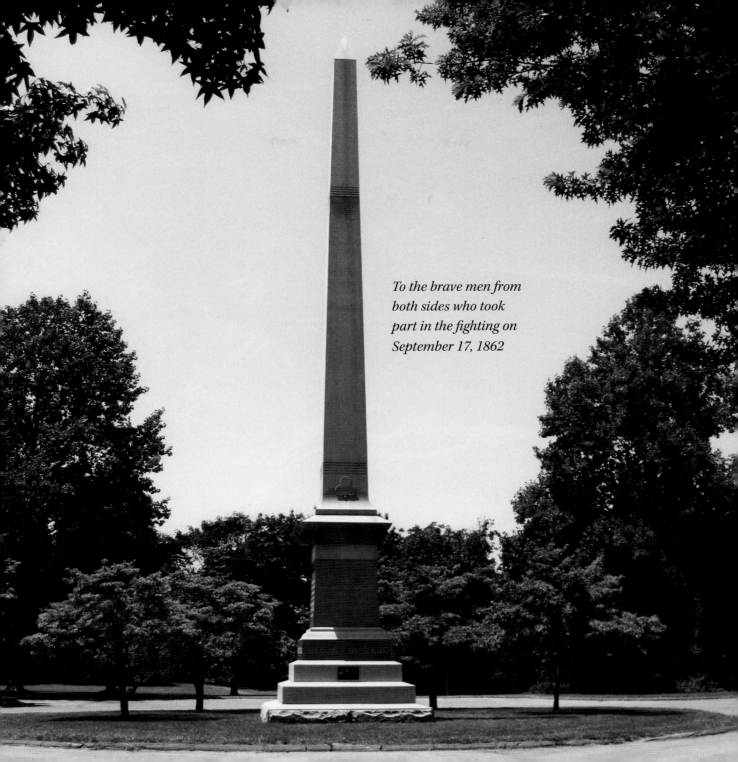

To the brave men from both sides who took part in the fighting on September 17, 1862

Contents

Chapter 8

Chapter 9

Chapter 10

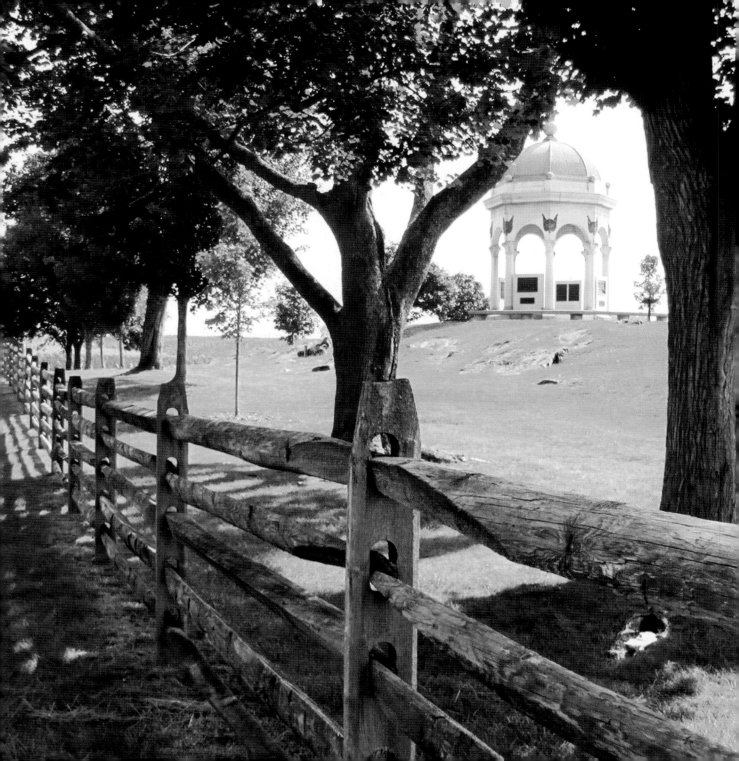

Preface

Following the success of *So You Think You Know Gettysburg?* we have been asked by numerous readers to write similar works on other Civil War battlefields. Our choice was Antietam, and thus this book was born.

Approximately ninety-six monuments adorn the Antietam National Battlefield. Most were created with money raised by the veterans of the respective regiments. In most cases, the monuments are positioned in the approximate locations where the particular regiments fought. Some regiments have more than one monument. And some states chose to honor all their troops with separate state memorials. Observant visitors will note that many of the monuments were dedicated on September 17, although not all in the same year. The selection of the anniversary of the battle illustrates how much the date meant to the men who fought.

Also present are six monuments honoring each of the generals killed or mortally wounded in the battle. Each side lost three generals.

Not every regiment that fought at Antietam is represented by a monument. The widespread poverty and economic devastation that the South experienced immediately after the war made it difficult for Confederate regiments to raise the necessary funding for monuments. For that reason, few Confederate monuments are on the field. Likewise, many Northern regiments chose not to erect monuments. We have included an order of battle in Appendix B that lists the Confederate regiments present that day, and another in Appendix C showing the Union regiments that fought, so readers may check for themselves to see if particular regiments were present but are not represented by markers.

Visitors may want to think of the battle as

three distinct fights. The first, in the morning, centered around the Miller Cornfield, the West Woods, and the Dunker Church. Late morning and early afternoon saw the fighting concentrated in the Sunken Road area, often referred to as Bloody Lane. By late afternoon, most of the fighting had moved to the area around the Burnside Bridge. This book is laid out so readers can follow the fighting in the approximate order in which it occurred.

We have divided the battlefield into color-coded sections. Each of these sections comprises a chapter in the book. The map of the particular section, coded in the same color as on the overall battlefield map, opens each chapter. The locations of all the monuments in that area, plus a few historical sites, are numbered and placed on the map, enabling readers to find them easily and to read about what took place there. For instance, location number 1 on the map of Area A corresponds with photo A-1 in the first chapter. To further assist readers in locating monuments, we have included GPS coordinates. We have also included a final, more general chapter that includes features common to most of the battlefield, rather than exclusive to any one particular area.

Today, the peaceful calm and natural beauty of the Antietam countryside belie the carnage, heartbreak, and destruction of September 17, 1862. While we don't wish to re-create that horror, even in print, we do want to tell the story of the men who were a part of those bloody twelve hours.

We believe we owe them that. We hope these pages do them justice.

Acknowledgments

No book of this type can be completed without the assistance of a large group of people.

We are indebted to individuals from many state agencies for their research assistance in providing information about their states' monuments. In that regard, we must offer our thanks to Jamie Cantoni of the Massachusetts Historical Society, Ed Richi of the Delaware Historical Society, Francis P. O'Neill and Dustin Meeker of the Maryland Historical Society, John Potter of the Connecticut Historical Society, Jennifer Fauxsmith of the Massachusetts State Archives, and Maire Gurevitz of the Indiana Historical Society. We also appreciate the information provided by the Holden (Massachusetts) Historical Society.

The interlibrary loan department at Carnegie Mellon University always seems to come through when asked. No matter how difficult our request, the staff members always find what we are looking for. They have been invaluable in our quest for the obscure. Thank you so much.

We must also acknowledge the work of the men and women of the National Park Service at both Antietam and Gettysburg, for without them this book would not be what it is. Those at Antietam provided much of the information in this work. They are always friendly, even on days when things do not go as smoothly as everyone would like. Special thanks go to Ed Wenschhof, chief ranger, for his help and guidance, and to Jane Custer, chief of cultural resources management, for her review of our manuscript. The Gettysburg National Military Park Library houses the Gregory Coco Collection of manuscripts and papers, which includes information about Antietam. The staff members there also showed a

knack for finding exactly what we needed. The staffs at both battlefields deserve any accolades they receive. NPS personnel are highly professional at what they do.

The staff members at the National Museum of Civil War Medicine and its satellite facility at the Pry House were extremely helpful in many ways. We thank them and appreciate the information they provided. And the tour of the house was fantastic!

Thanks must also go to the people at the National Archives and the Library of Congress for providing the period photos that appear in the book. The photos enhance the final result, and we appreciate the assistance.

Our book employs maps to direct readers to the locations of the monuments. Without them, the book would not be nearly as informative. We must thank the people at MapQuest for their kind permission to adapt their maps to our needs.

Our agent and friend, Rita Rosenkranz, has gone above and beyond the call of duty with her support and invaluable advice. Rita, we couldn't have done any of this without you, and we appreciate it more than you'll ever know.

Also, the great people at John F. Blair, Publisher, deserve our thanks. Carolyn Sakowski, Steve Kirk, Debbie Hampton, Brooke Csuka, and Angela Harwood all had a hand in *So You Think You Know Gettysburg?* We look forward to similar success with this work.

And finally, we can never thank our family and friends enough. They have supported and encouraged us from the very beginning, and we are forever grateful. You folks are the greatest!

We hope we haven't missed anyone. If we have, it was inadvertent, and you have our apologies.

Thanks to all of you, named and unnamed, for what you have done.

Introduction

To the people in the North, it was Antietam, after the stream whose name translated from a Native American language as "the swift current." Those in the South referred to it as Sharpsburg, after the nearby town. Whatever the name, this much is undisputed: it would become known everywhere as the bloodiest one-day battle in American history. Following just twelve hours of brutal combat, some twenty-three thousand soldiers were killed, wounded, or missing. To put that in perspective, the Normandy invasion on June 6, 1944, produced an estimated six thousand to seven thousand American casualties.

Following his dramatic victory at Second Manassas less than three weeks earlier, General Robert E. Lee pushed his Confederate offensive northward. Among his goals was the opportunity to exert influence in the fall midterm elections.

While many in the North believed the war was being won, antiwar Copperheads still held great sway. Lee hoped that an antiwar victory in the election could persuade the North to negotiate some kind of settlement that would allow the Confederacy to exist in peace.

Lee also hoped to obtain badly needed supplies and to move the war out of Virginia and into the North. Doing so, he reasoned, might persuade Maryland to join the Confederacy. If nothing else, he believed he could convince many of Maryland's male residents to sign up for his Army of Northern Virginia. Recognition by foreign governments could follow.

In a cruel twist of fate, however, three Union soldiers—Corporal Barton W. Mitchell, Private David Vance, and Private John Bloss of the Twenty-seventh Indiana's Company F—found an

Antietam

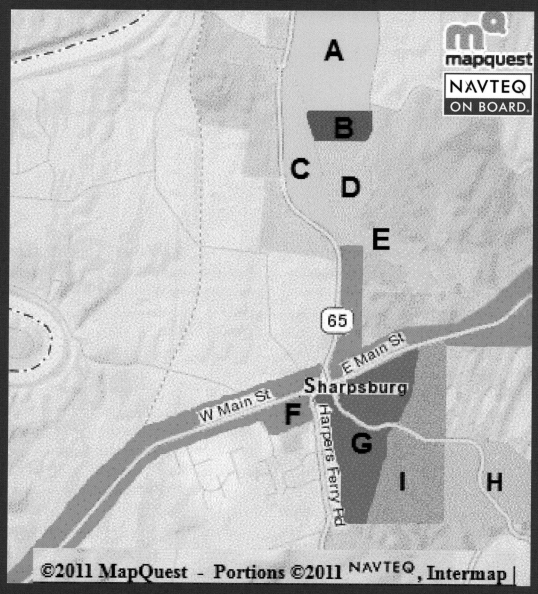

envelope while resting along the roadside near Frederick, Maryland. Inside that envelope, addressed to General D. H. Hill and wrapped in a piece of paper, were three cigars. It was not the cigars that were important, though. The paper enclosing them turned out to be a copy of Lee's Special Orders No. 191, outlining his plans for the upcoming campaign (see Appendix A to read the orders).

The Indiana soldiers reported their discovery, and the contents were taken to Major General George McClellan. The orders included plans for the upcoming campaign, including the splitting of Lee's army, and what each branch would do. McClellan already had a decided advantage in numbers. Knowing Lee's intentions only added to that advantage.

Once across the Potomac, Lee split his army, just as Special Orders No. 191—destined to become known as "the Lost Orders"—said he would. One section moved into Harpers Ferry, capturing the Union garrison there and neutralizing a major threat to Lee's advance. The rest of Lee's troops moved toward South Mountain and Hagerstown, Maryland. At South Mountain, Lee was met by McClellan's Union troops, and his advance was halted. Lee was forced to retreat, ultimately gathering his troops just west of Antietam Creek near the small town of Sharpsburg. Stonewall Jackson's forces held the left of the line, while General James Longstreet held the center and the right. It was here that Lee would make his stand. Before long, McClellan's Army of the Potomac formed on the opposite side of the creek, ready to oblige him.

The morning of September 17, 1862, dawned damp and foggy, the products of a steady rain the night before. In the distance loomed South Mountain, where the dead and wounded from a battle just three days earlier still lay. Many of the individual regiments, especially on the Union side, had only recently organized and had never seen battle. That was about to change.

The tranquil morning was soon punctuated by the roar of cannons and the sharp crack of musket fire. Over the next several hours, both sides attacked and counterattacked. By evening, little had been settled, and the sounds of the cannons and muskets were replaced by the cries of the wounded.

Casualties were not limited to the soldiers on the battle lines. Six generals were also killed at Antietam, three on each side. Twelve more generals were wounded. Again, they were evenly divided, six Federals and six Confederates suffering wounds. Each general who died is honored with a cannon tube turned muzzle down and mounted in stone at the location where he was struck or killed. Referred to as "mortuary cannons," they offer mute testimony to the fact that death is no respecter of rank.

The day following the battle, September 18,

was devoted to the gathering of the wounded and the burial of the dead. The task continues today. The remains of a soldier from New York were found by a hiker in the Miller Cornfield as recently as October 2008. He was returned to his native state for formal burial, unidentified, in 2009. More remains will likely be found in the future.

As the armies licked their wounds, both sides anxiously waited to see if the other would resume the fight. Neither had the desire. By the evening of September 18, the bloodied Confederate army began its march back to Virginia, ending Lee's first invasion of the North. To President Abraham Lincoln's chagrin, McClellan's equally battered troops failed to seriously pursue Lee. However, the battle and Lee's retreat produced what Lincoln had been waiting for: an opportunity to issue one of the most important documents in American history.

In July 1862, Lincoln had drafted his Emancipation Proclamation, a document that would free the slaves in the Confederate states. His cabinet convinced him to withhold it until a Union victory would allow him to issue it from a position of strength. While Antietam was not a decisive victory for the North, it was enough of a triumph for Lincoln to release the proclamation. Its effect on securing freedom for those enslaved in the South is questionable, but it added a new dimension to the war. Now, it was no longer simply a fight to preserve the Union. The war's expansion to end slavery effectively ended any hope the Confederacy had of bringing England and France into the fray. The Emancipation Proclamation led to the passage of the Thirteenth Amendment to the United States Constitution in 1865.

A few innovations never before associated with war came about as a direct result of the battle.

Photographer Mathew Brady sent assistant Alexander Gardner to the battlefield, resulting in shocking photos that revealed the true savagery of war. Theretofore, the horrors of the fighting had been conveyed by drawings and descriptive newspaper articles. Those sanitized sources could never unveil the real brutality. Now, however, the facts were laid bare. War really wasn't romantic after all, but far more cruel than their imaginations let people believe. Displayed in Brady's New York gallery, Gardner's photos attracted large crowds. Visitors looked at them with hushed reverence. Some recoiled in horror. The faces of the dead, many of the bodies without limbs, forever changed the way people viewed war.

Two other developments from the Battle of Antietam revolutionized the treatment of combat wounds. The chief medical officer for the Army of the Potomac, Dr. Jonathan Letterman, used ambulances on a large scale for the first time, enabling the transportation of the wounded to safer areas for treatment. He also developed

a triage system to evaluate wounds and prioritize their treatment based on severity.

Despite these innovations, many of the wounded never recovered, their names added to the roll call of the dead. And much more fighting was to come. The war would drag on for two and a half more years, and the Army of the Potomac would meet the Army of Northern Virginia again at places named Fredericksburg, Chancellorsville, Gettysburg, the Wilderness, and Spotsylvania Court House. Each of these battles evoked memories of Antietam. None, however, matched that horrendous September day in 1862.

"Older men declare war. But it is the youth that must fight and die."

Herbert Hoover

Chapter 1
Area A

NORTH WOODS

Area A North Woods

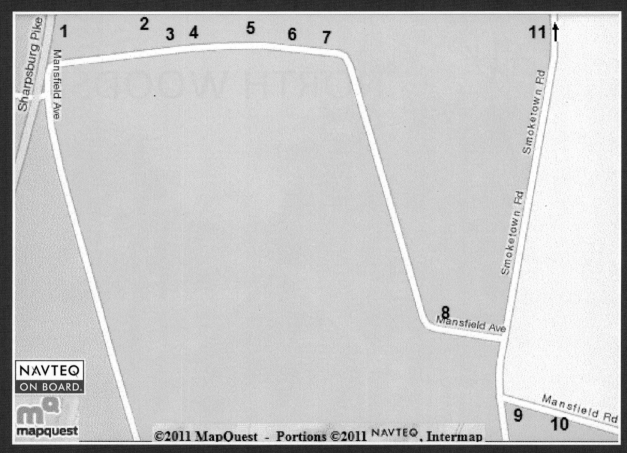

At dawn on the morning of September 17, 1862, the Union's First Corps, under General Joseph Hooker, formed a double battle line nearly a half-mile in length and moved toward an unseen enemy. The rising sun reflected off the bayonets of the Federal soldiers. In a small cornfield just ahead lay the Confederate army.

Initially, the Union troops pushed the Confederates back, but the advance was only temporary. Reinforcements from the Confederate side pushed Hooker's men back. Hooker regrouped his troops and attacked once more. Stopped again by the Southerners, the First Corps found itself back almost at its starting point. Hooker was slightly wounded in the fighting and relinquished his command to General George Meade.

A-1: Seventh Indiana Infantry Monument
39° 29.421′ N, 77° 45.037′ W

This marker stands at the regiment's position at four in the afternoon on the day of the fighting. Under its commander, Major Ira Grover, the Seventh Indiana was to support a heavy artillery concentration near the Joseph Poffenberger Farm. The regiment, as part of the Second Brigade, First Division, First Army Corps, was positioned parallel to the road, following the fence line. This placed it in a crossfire between Federal artillery on the Poffenberger Farm and twenty Confederate artillery guns to the west. It suffered only slight losses, however, with one officer and three men wounded.

Grover was later brought before a court-martial for abandoning his post in the summer of 1863. While guarding corps trains in Emmitsburg, Maryland, he had been ordered to remain in that position until relieved by a regiment from Vermont. When his relief never came, Grover moved his men northward. Along the route, he received word that a battle was under way at Gettysburg. He rushed the Seventh Indiana toward the Pennsylvania hamlet. Positioned first

Indiana markers, this one was designed by architect John R. Lowe and constructed and erected by the J. N. Forbes Granite Company of Chambersburg, Pennsylvania.

A-2: Joseph Poffenberger Farm
39° 29.232′ N, 77° 44.844′ W

Owned and occupied by Joseph Poffenberger and his family, this farm had enjoyed a prosperity that was about to come to an end. Hearing the sounds of battle from nearby South Mountain, the family grew concerned. Word soon came that the armies were approaching Sharpsburg. The Poffenbergers moved their livestock to a place where they hoped the animals would be safe from the advancing troops, locked up as well as they could, and fled to a safer area.

The night before the battle, approximately fifteen thousand Federal soldiers from Major General Joseph Hooker's First Corps and Major General Joseph K. F. Mansfield's Twelfth Corps crossed Antietam Creek and rendezvoused on the farm. Artillery batteries set up behind the house, and Hooker made the farm his headquarters. His plan was to attack the Confederate left flank, under the command of Major General Thomas J. "Stonewall" Jackson, located between the Miller Cornfield and the Dunker Church.

on Cemetery Ridge, it later moved to Culp's Hill, where it assisted in securing that area. Not only was Grover exonerated at his court-martial, but on March 13, 1865, he was awarded a brevet of brigadier general for his service.

The Seventh Indiana's monument was dedicated on Indiana Day, September 17, 1910, and rededicated on September 9, 1962. As with all the

Poffenberger Farm shortly after the battle
Library of Congress, Prints & Photographs Division, HABS, Reproduction Number HABS MD, 22-SHARP.V, 19-A-1

Hooker selected this location because the North Woods hid the preparations for the attack from the Confederates positioned at the Dunker Church, which sat approximately one mile away.

On the morning of September 17, 1862, Hooker launched the first attack of the battle from this location. The farm later became a rallying point for Federal troops pushed out of the Cornfield and the West Woods, however. Soon, it was filled with wounded soldiers and supply wagons. After the battle, the farm was used as a hospital.

When the Poffenbergers returned, they found that the house had been ransacked by hungry soldiers. Joseph Poffenberger noted that the family members subsisted for five days on army crackers they found on the battlefield. Soldiers remained on the farm for the next several weeks, eating everything they could find, using the fences for firewood, and taking the hay for bedding. Joseph Poffenberger filed a claim with the government for his losses but never received any payment.

The Poffenberger family was well represented at Antietam. In addition to the Joseph Poffenberger Farm here in the North Woods, Samuel Poffenberger farmed in the East Woods area and Alfred

Poffenberger farmed in the vicinity of the West Woods.

A major renovation project is in progress to restore the Joseph Poffenberger Farm to its 1862 appearance.

A-3: Seventh Pennsylvania Reserves (Thirty-sixth Infantry) Monument

39° 29.331' N, 77° 44.851' W

So many men enlisted from Pennsylvania that the quota was quickly filled. Those who still wished to enlist were placed in reserve regiments, which received permanent designations when the next call for troops was issued. The new regimental numbers given the reserve regiments were twenty-nine higher than their reserve des-

ignations. The Seventh Reserves were thereby turned into the Thirty-sixth Pennsylvania Volunteer Infantry. The regiment received its new designation after First Manassas.

The commander of the Seventh Reserves at Antietam was Major Chauncey A. Lyman, who took over after Colonel Henry Bolinger was wounded at South Mountain in the fighting at Turner Gap.

On the morning of the battle, the regiment

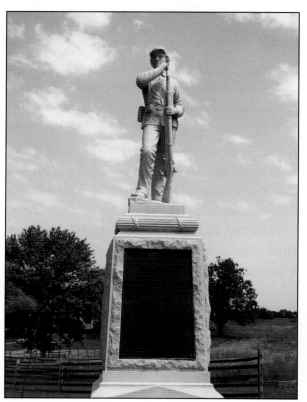

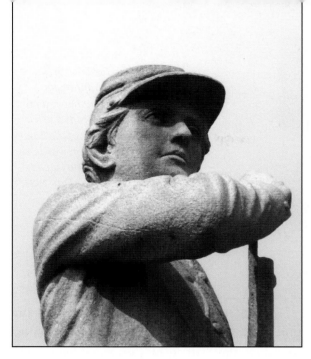

A detachment from the regiment was designated for the unpleasant task of burying the dead over the next few days.

Two years later at the Battle of the Wilderness, the regiment was surrounded and forced to surrender, losing 272 men as prisoners of war. Most ended up in the notorious Andersonville Prison.

The monument was dedicated on September 17, 1906, the unveiling done by Emma Foller, daughter of Sergeant John Foller of Company A and niece of Leo Foller, who was killed near the monument's location.

A-4: Clara Barton Monument
39° 29.332' N, 77° 44.842' W

Late in the afternoon, it was apparent that Union surgeon James L. Dunn was in dire need of bandages to treat the wounded. Things were so desperate that the surgeons were using cornhusks for dressings. Dunn was pleasantly surprised when a covered wagon arrived with medical supplies. He was even more pleasantly surprised when he saw his old friend Clara Barton in the wagon. For the next three days, Barton spent every waking minute treating the wounded and dying, many of them where they fell. She and her staff risked their lives by carrying water and food to the wounded, helping them wherever they lay.

formed at the approximate location of its future monument before moving six hundred yards southward, where it engaged General John Bell Hood's division. Initially, the Seventh Reserves appeared to have the upper hand, driving Hood's men back. However, the Confederates quickly regrouped and forced the Union troops to retreat. While moving back, they were hit on their flank by raking fire from the woods. A battery was quickly brought into position to provide covering fire, and once again the Seventh Reserves moved forward. This ebb and flow of battle was typical for most regiments in the Cornfield throughout the day. The regiment lost twelve killed and sixty wounded in the Battle of Antietam, most of the casualties coming in the Cornfield.

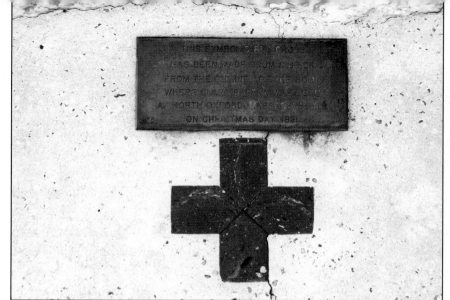

A plaque at the base of the Clara Barton Monument reads, "This symbolic red cross has been made from a brick from the chimney of the home where Clara Barton was born at North Oxford, Massachusetts on Christmas Day 1821."

At one point, as Barton knelt to give a wounded soldier a cup of water, a stray bullet passed through her sleeve and struck her unfortunate patient. The bullet passed through his chest, killing him almost instantly.

As she examined another of her patients, she was surprised to notice that the soldier was in fact a woman. The woman had been wounded in the neck as she searched for her husband in the Cornfield. Barton nursed the young lady to a point where she was able to return to her home to recover from her wound.

Clara Barton, known as "the Angel of the Battlefield," went on to found the American Red Cross, as is commemorated on her monument at Antietam. The small red cross on the monument's base was constructed of bricks from the chimney of the house where she was born on Christmas Day in 1821.

A fact not as well known but no less important is that, after the war, Clara Barton established the "Office of Correspondence with Friends of the Missing Men of the United States Army." That organization was credited with locating the graves of many missing United States soldiers. She also assisted in identifying and

marking the graves of nearly thirteen thousand prisoners who died at the Confederacy's infamous Andersonville Prison in Georgia. She led the effort to establish a national cemetery there.

Clara Barton's monument was dedicated on September 9, 1962. The unveiling was conducted by American Red Cross members, assisted by United States Army personnel. It is likely, however, that the monument is misplaced. Although it was long thought that Barton performed her nursing duties on the Joseph Poffenberger Farm, it is now believed she expended most of her efforts at the Samuel Poffenberger Farm, slightly east of her monument's location.

A-5: Fourth Pennsylvania Reserves (Thirty-third Infantry) Monument
39° 29.331′ N, 77° 44.806′ W

This monument, titled *Loading Musket*, depicts a young soldier using his ramrod to tamp the powder into his barrel in preparation for taking his next shot. At the base of the monument are the accouterments of the foot soldier: a knapsack, canteen, and blanket roll. On the east side of the base, a unique corps symbol shows a Maltese cross enclosed by a circle. The circle represents the regiment's affiliation with the First Corps, while the Maltese cross represents the Fifth Corps, under which the regiment also served.

At the monument's dedication on September 17, 1906, Miss Alexine Nicholas—daughter of Private Alexander Nicholas of Company G—did the unveiling, giving the event a personal flavor.

The monument sits at the approximate location from which the Fourth Reserves began their advance on the morning of September 17, 1862. After advancing six hundred yards, they encountered Hood's Confederate division in the infamous

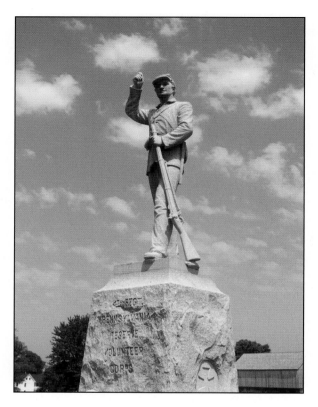

A-6: Third Pennsylvania Reserves (Thirty-second Infantry) Monument
39° 29.329′ N, 77° 44.762′ W

When the Third Reserves arrived on the field the day before the battle, they immediately detached eight companies to act as skirmishers, who quickly encountered opposing fire. Separated at nightfall, many of the skirmishers were unable to locate the regiment, which had only about two hundred troops available the next morning as a result.

On the morning of the battle, the short-handed regiment advanced with the Fourth Reserves toward Hood's division and received

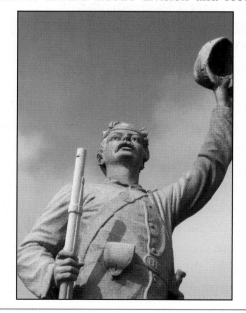

Cornfield. The Confederates waited until the men of the Fourth Reserves and the rest of the brigade got to a point less than fifty feet away, at which time Hood's men rose and delivered a withering fire on the unsuspecting Pennsylvanians, routing them into a chaotic retreat. With no support, the Confederates chose not to pursue.

Casualties for the regiment at Antietam totaled five killed and forty-three wounded.

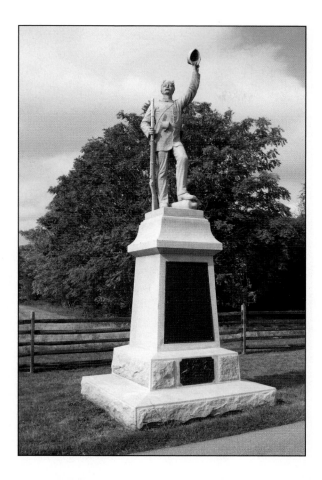

was unveiled on September 17, 1906, by Mrs. Amanda Dauth. Private Owen Jones, who served with the regiment in the battle, stood beside the monument during the unveiling, holding a reproduction of the regiment's battle flag.

A Maltese cross inside a circle adorns the east side of this monument, indicating that the regiment served in both the First Corps and the Fifth Corps. It was commanded by Lieutenant Colonel John Clark.

At Antietam, the regiment lost twelve killed and thirty-four wounded.

A-7: Eighth Pennsylvania Reserves (Thirty-seventh Infantry) Monument
39° 29.327′ N, 77° 44.722′ W

Under the command of Major Silas M. Baily, the Eighth advanced into the Cornfield with the other Pennsylvania reserve regiments, where it came under withering fire at close range. The battle raged back and forth for four hours, during which time the regiment suffered twelve men killed and another forty-four wounded. Nearly out of ammunition, the regiment did not press the attack further.

On September 19, the regiment moved about three miles, the route taking it across the site where the Confederate line of battle had stood

much the same fate as its sister regiments. Shells from Pelham's artillery on Nicodemus Heights took a terrific toll on the regiment and others in the First Corps as they attempted to advance through the Cornfield.

The regiment's monument, titled *Victory*, depicts a young Union soldier waving his cap in jubilation as the enemy retreats. The monument

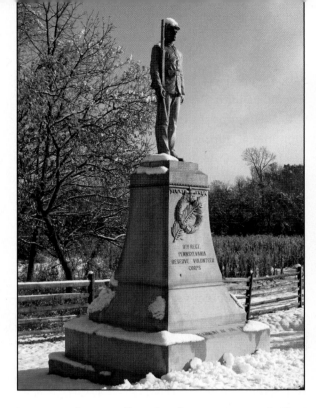

just two days earlier. As the men passed, they noted the long rows of Confederate dead and remarked that they must have been advancing in a well-dressed formation when they were killed.

Titled *Carry Arms*, the monument shows the standard marching position during the Civil War. The statue was one of several Pennsylvania monuments dedicated on September 17, 1906. It was unveiled by Miss Mayette McWilliams, daughter of Private Daniel McWilliams of Company D. The wreath and palm branch on the monument's face represent memory and victory.

In addition to those lost at Antietam, the monument's inscription notes that, out of a total enlistment of 1,062, the regiment had 158 men killed over the course of the war, another 490 wounded, 147 captured or missing, and 68 who died of either disease or accidents as prisoners of war.

A-8: Twelfth Pennsylvania Cavalry Monument

9° 29.064' N, 77° 44.564' W

This monument was one of thirteen dedicated on Pennsylvania Day, September 17, 1904. The state had allotted fifteen hundred dollars for monuments for each of the regiments that had no marker on any other battlefield, but that amount was later cut in half. The regiments all refused the sum, saying it was an insult. Eventually, the legislature authorized twenty-five hundred dollars for each regiment, which was accepted. For unknown reasons, the four reserve regiments, despite not having their own monuments on other fields, were omitted from the authorization.

This regiment's participation in the battle consisted mostly of provost duty in the East Woods. The assignment meant that the men were responsible for rounding up stragglers and deserters, taking charge of prisoners, and generally maintaining order—a role similar to that of today's military police. As such, they saw little or no combat action at Antietam, although they were involved in some minor skirmishing as they protected the Union flanks. They also performed some scouting activities.

The monument, sculpted by E. L. A. Pausch, was dedicated on September 17, 1904. Titled *The Cavalryman*, it was designed to show the cavalry-man as rough and ready, not one to back down. The Twelfth Cavalry, also known as the 113th Pennsylvania Volunteers, was nicknamed "the Curtin Hussars," after Governor Andrew Curtin of Pennsylvania.

The Twelfth Pennsylvania Cavalry was com-manded by Major James Congdon. The regi-ment's last colonel was Marcus Reno, who was destined to die at Little Big Horn.

A-9: Major General Joseph K. F. Mansfield Monument
39° 28.997' N, 77° 44.506' W

The state of Connecticut erected this monu-ment to native son Joseph K. F. Mansfield. Mans-field was in command of the Twelfth Corps of the Army of the Potomac when he was mortally wounded not far from the site of the monument at about 7:35 A.M. on September 17, 1862. He was one of three Union generals killed at Antietam. Three generals were also killed on the Confeder-ate side of the line.

Mansfield had entered West Point at the age of fourteen and graduated second in his class of forty. He had served in the army for forty-five years when he died. A corps commander for only two days, Mansfield was killed as he deployed his troops and came under fire from the nearby woods. He assumed those in the woods were part of Hooker's corps and shouted a reprimand at his troops from the Tenth Maine for firing on their own men. The soldiers from Maine countered that the troops in the woods had been firing on them for some time, and that they couldn't be Union soldiers. Mansfield had just realized that those doing the shooting were indeed Confeder-ate soldiers from the Fourth Alabama and the

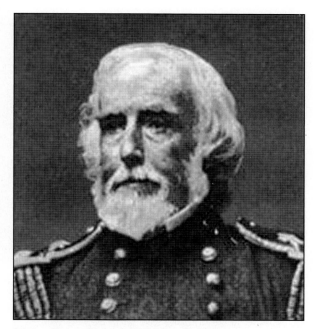

Major General Joseph K. F. Mansfield
Photo courtesy of National Park Service

Twenty-first Georgia when he was struck in the chest. His men helped him dismount, but he collapsed as he led his horse to the rear. He was carried to a field hospital at the nearby George Line Farm, where he died the next morning. His family retrieved the body and transported it to Middletown, Connecticut, for burial.

It is possible that Mansfield had a premonition of his death. A few days prior to the battle, he said to a friend as they parted, "We may never meet again."

His monument was dedicated on May 24, 1900. It was rededicated on September 13, 2002,

after a plaque removed by vandals was replaced. Because little information was available concerning the original plaque, sculptor Bruce Papitto of Westerly, Rhode Island, replicated the plaque on Major General John Sedgwick's monument at Gettysburg.

The government honored Mansfield by placing his picture on a five-hundred-dollar United States note issued in the 1870s.

A-10: Major General Joseph K. F. Mansfield Mortuary Cannon
39° 28.989′ N, 77° 44.470′ W

This cannon with its muzzle pointing down marks the approximate site of the mortal wounding of Major General Joseph K. F. Mansfield. It is

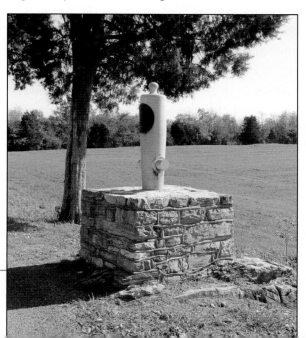

one of six such mortuary cannons on the field, each commemorating the death of a general. Twelve additional generals, six from each side, were wounded in the battle.

The plaque on the cannon indicates that Mansfield was actually shot thirty-eight yards north and seventy-six feet west of the cannon.

At age fifty-nine, Mansfield was one of the oldest officers of any rank on the field that day.

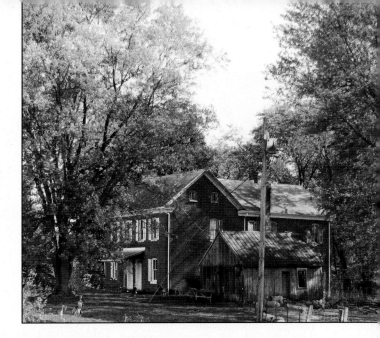

A-11: George Line House (Death of Mansfield)
sign at 39° 29.976' N, 77° 43.942' W
house at 39° 30.009' N, 77° 44.170' W

Major General Joseph K. F. Mansfield was carried to the George Line Farm after his wounding on the morning of September 17, 1862. Although the sign notes that he died there later that day, most accounts say he lived until the next morning. The lane to the farm is about a mile and a half north of the mortuary cannon, on Smoketown Road. The house is private property; visitors should enter the farm only with permission.

The farm served as the approximate site of the camp of the Twelfth Corps the night before the battle.

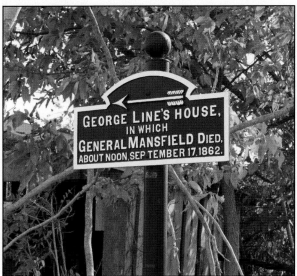

Chapter 2
Area B

CORNFIELD AVENUE/ EAST WOODS

Area B Cornfield Avenue/East Woods

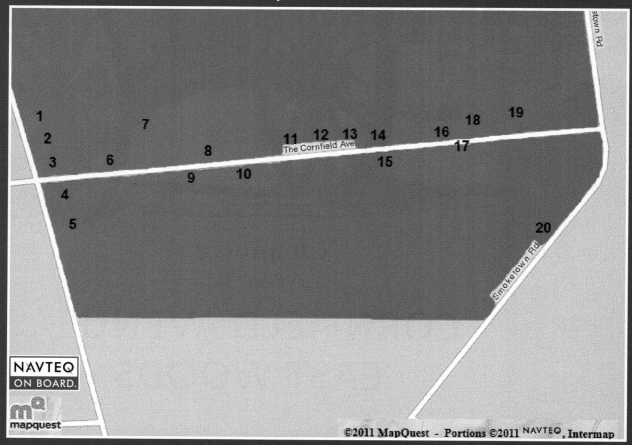

At the break of dawn on September 17, 1862, General Joseph Hooker's First Corps moved southward through farmer David Miller's cornfield. The men hadn't advanced far before Hooker spied Confederate troops positioned in front of his men. He moved four batteries into position and ordered them to fire on the Southerners, allowing the First Corps to resume its march. In short order, the men were met with a hail of musketry from Confederate troops posted along the Mumma Farm lane and artillery in the area of the Dunker Church and on nearby Nicodemus Heights. Men fell where they stood, never knowing what had happened. Regrouping, Hooker's troops renewed their advance as the bloodbath grew even greater on both sides.

General John Bell Hood ordered his division to move from behind the nearby Dunker Church. Within minutes, his men joined the fray. Shortly afterward, Robert E. Lee ordered troops from the Sunken Road to move to the Cornfield. Fighting their way along the northern edge, those troops encountered the Union's Twelfth Corps and took heavy losses.

The two armies punched and counterpunched, the lines moving forward and back. Control of the Cornfield changed hands as many as eight times before the action subsided around nine o'clock that morning. In the fighting, Major General Joseph K. F. Mansfield of the Union forces fell mortally wounded. Together, the two armies lost more than eight thousand men killed or wounded. This small cornfield is considered by some the bloodiest patch of land in America.

General Joseph Hooker wrote, "Every stalk of corn in the northern and greater part of the field was cut as closely as could have been done with a knife, and the slain lay in rows precisely as they had stood in their ranks a few moments before."

The fighting was so fierce that men on both sides would later write of the

large numbers of their comrades who at the first opportunity became concerned for the welfare of their fellow soldiers. Letters home derisively told of the many able-bodied troops who accompanied their wounded friends back to the safety of field hospitals under the guise of "helping" the wounded receive treatment.

Visitors are often confused by the name Cornfield. Given the many farms in the Sharpsburg area, it was inevitable that more than one cornfield would be mentioned in accounts of the battle. Actually, seven cornfields saw fighting. However, the cornfield of the Miller family is generally accepted as the Cornfield because of the savage fighting that took place on that small, thirty-acre plot of land.

Perhaps no story from Antietam is more poignant than that of Charles

King. The thirteen-year-old was a drummer boy with the Forty-ninth Pennsylvania, which was positioned in the East Woods adjacent to the Cornfield. There, the Pennsylvanians came under a barrage from the Confederate artillery. One shell burst in the midst of the Forty-ninth Pennsylvania, badly injuring several soldiers, one of them Charles King. His comrades carried him to a nearby field hospital, where he died three days later. Drummer Boy Charles King is believed to be one of the youngest from either side to die from wounds in the Civil War.

B-1: Thirteenth New Jersey Infantry Monument

39° 28.868′ N, 77° 44.903′ W

The Thirteenth New Jersey had just left home seventeen days before the battle. The green troops were thrown into the fray early in the fighting. Their first casualty was Captain Hugh C. Irish, who fell mortally wounded while leading his troops across the Cornfield.

This marker designates the center of the regiment at 10:20 A.M. and notes that part of the right wing sat across the Dunker Church Road. Later in the day, the Thirteenth New Jersey moved to the rear of the Dunker Church, where the men took heavy casualties when they saw troops from North Carolina moving to their right and mistakenly believed they were surrendering.

This is one of three monuments at Antietam

common type of bullet used during the war, surrounds the base of the monument.

Indiana dedicated its state monument and five regimental monuments on September 17, 1910, Indiana Day. The names of all five Indiana regiments are inscribed on a bronze tablet affixed to the front of the monument, above which are raised letters spelling out Indiana. The front also includes the state coat of arms. The state memorial is located adjacent to the Miller Cornfield, where three Indiana regiments (the Seventh, Nineteenth, and Twenty-seventh) fought.

to the regiment (see also photos B-12 and C-8), making it relatively easy to track the Thirteenth's movements throughout the battle. The regiment lost 102 men at Antietam. This monument was dedicated on September 17, 1903, and rededicated on September 9, 1962.

B-2: Indiana State Monument
39° 28.863′ N, 77° 44.895′ W

This monument, erected by the state of Indiana, honors all the regiments that represented the Hoosier State at Antietam: the Seventh, Fourteenth, Nineteenth, and Twenty-seventh infantries and the Third Cavalry.

The fifty-foot-tall obelisk symbolically follows the time-honored Egyptian method of honoring great men. A series of minie balls, the most

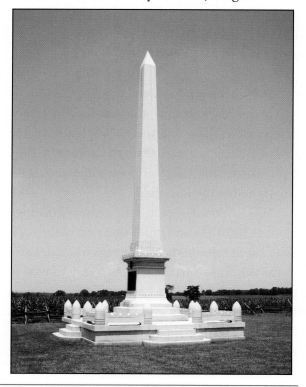

All the Indiana monuments, including the state marker, were rededicated on September 9, 1962, as part of a joint Sisters States Monuments weekend, during which the monuments of New Jersey and Massachusetts were also rededicated.

All of Indiana's monuments were designed by architect John R. Lowe and were constructed and erected by the J. N. Forbes Granite Company of Chambersburg, Pennsylvania.

B-3: New Jersey State Monument
39° 28.851' N, 77° 44.894' W

The state of New Jersey chose this monument to honor its six regiments that fought at Antietam: the First New Jersey Infantry, Second New Jersey Infantry, Third New Jersey Infantry, Fourth New Jersey Infantry, Thirteenth New Jer-

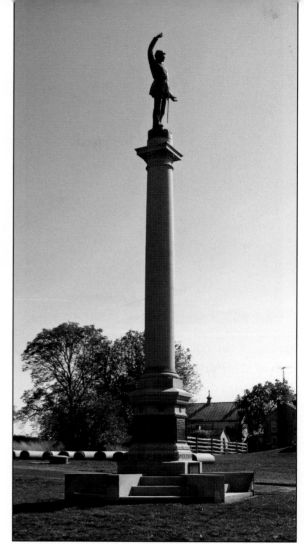

sey Infantry, and Hexamer's Battery A, First New Jersey Artillery. All of these except the Thirteenth New Jersey Infantry made up the First New Jersey Brigade. Their soldiers were the first three-year volunteers from the Garden State.

The pedestal has six sides, each representing one of the six state regiments. The figure at

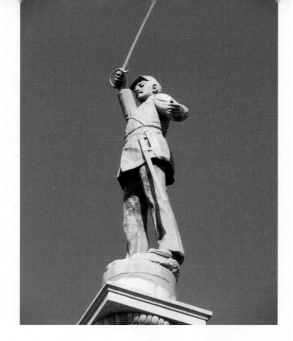

September 9, 1962, as part of a joint Sisters States Monuments weekend, during which all the monuments of Massachusetts and Indiana were also rededicated.

B-4: Massachusetts State Monument
39° 28.835′ N, 77° 44.889′ W

Massachusetts had fifteen infantry regiments, one cavalry regiment, three artillery batteries, and two regiments of sharpshooters at Antietam. Each of these is listed on bronze tablets placed on the front face of the monument. The Twelfth Massachusetts Infantry suffered the highest percentage of loss of any Union regiment at Antietam, 67 percent of its number falling. Most of the losses came in the Miller Cornfield.

Meant to honor all the Massachusetts troops who fought at Antietam, the monument has a feature on the back that is missed by many visitors: a bronze tablet containing a map of the battlefield that shows the location of each Massachusetts regiment in the battle.

The monument was placed on land purchased from the Nicodemus family. The site was selected because the commonwealth's Commission on the Antietam Battlefield felt it was the highest point on the battlefield. The monument was dedicated on September 17, 1898. All the

the top of the column represents Captain Hugh Irish of the Thirteenth New Jersey's Company K. Captain Irish died in the Cornfield. Some sources claim he was the first Union soldier killed at Antietam.

A tablet on the side of the monument reproduces a letter from Colonel A. T. A. Torbert to the brigade, praising the men for their performance just three days earlier at Crampton's Pass.

President Theodore Roosevelt helped dedicate the monument on September 17, 1903. The unveiling was conducted by Mrs. Sarah Hartwell, Captain Irish's sister. The monument was designed by John and W. Passmore Meeker, along with James Wallings of New York. These three designed all the New Jersey markers on the field. The New Jersey monuments were rededicated on

Massachusetts monuments were rededicated on September 9, 1962, as part of a joint Sisters States Monuments weekend, during which the monuments of New Jersey and Indiana were also rededicated.

The monument was based on a design by Winslow and Wetherell of Boston and constructed by Norcross Brothers of Worcester. Even its shape—roughly that of an H—was designed to be symbolic. While its outline is simple, it is meant "to exemplify the character and nobility of the soldier fighting for the preservation of his country," according to the commission's report.

At least two men from Massachusetts were

The back of the monument showing the bronze tablet that depicts a map of the battlefield.

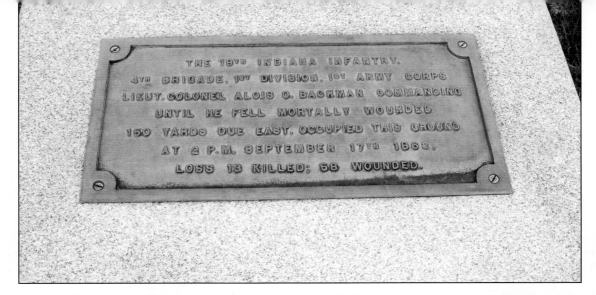

destined to become well-known characters in American history. Captain Robert Gould Shaw of the Second Massachusetts Infantry gained fame as the commander of the Fifty-fourth Massachusetts, a regiment of African-American troops featured in the 1989 movie *Glory*. Oliver Wendell Holmes, who served in the Twentieth Massachusetts, was appointed an associate justice of the United States Supreme Court in 1909.

B-5: Nineteenth Indiana Infantry Monument
39° 28.775′ N, 77° 44.874′ W

Part of the famed Iron Brigade, which had received its nickname just a short time earlier, the regiment occupied the area around this simple monument in the midafternoon. The plaque on the memorial honors Lieutenant Colonel Al-

ois O. Bachman, who commanded the regiment as it fought along the Dunker Church Road until he was mortally wounded while leading a charge against Battery B, Fourth Artillery. The twenty-three-year-old Bachman had taken command just the day before the battle when Colonel Solo-

mon Meredith had to step down due to lingering ailments arising from injuries suffered a month earlier at Groveton. Following the death of Lieutenant Colonel Bachman, Captain William Dudley, nineteen years old, led the regiment. For his leadership in the battle, Captain Dudley was promoted to major the next day. Three weeks later, he was promoted to lieutenant colonel.

Three color bearers were seriously wounded in the charge. After the colors fell for the third time, they were picked up by Lieutenant D. S. Holloway of Company D, who carried them the rest of the way. The regiment was able to capture the colors of one Confederate regiment.

The Nineteenth Indiana's monument was dedicated on Indiana Day, September 17, 1910. A rededication was held on September 9, 1962. As with all the Indiana markers, this one was designed by architect John R. Lowe and constructed and erected by the J. N. Forbes Granite Company of Chambersburg, Pennsylvania.

The regiment lost 13 killed and 58 wounded in the fighting. It had also suffered heavy losses at Second Manassas and South Mountain and would suffer further at Gettysburg, where the loss of 210 of the 288 men on the first day of fighting would nearly wipe out what remained of the regiment.

B-6: Monument to Second United States Sharpshooters, Vermont Companies E and H
39° 28.852′ N, 77° 44.877′ W

Equipped with breechloading rifles rather than the standard muzzleloaders, sharpshooters were able to load and fire quickly. Only the best marksmen became sharpshooters. They fought more individually than did men in standard regiments, spreading out and using whatever cover they could find, rather than fighting in a line of battle.

Company E was commanded by Captain Homer R. Stoughton, while Lieutenant Albert

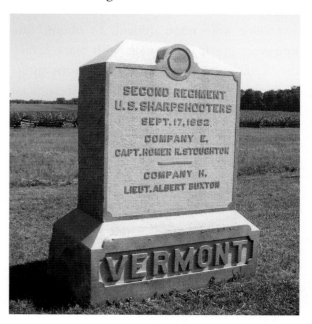

Buxton commanded Company H. Part of the famed Berdan's Sharpshooters, the men of these regiments were recruited in Vermont. To be considered for Berdan's regiments, recruits were required to prove their ability to take ten shots at a target, with the total distance from the center for all ten shots not to exceed fifty inches, or five inches per shot. This had to be done from a distance of three hundred feet in the "offhand" position or six hundred feet when resting. Many of Berdan's men were said to be able to put all ten shots in the bull's-eye from either distance.

Uniforms for Berdan's regiments included distinctive forest-green frock coats with light green piping, worn with either green or blue trousers. Green was preferred, but trousers of that color were often difficult to obtain. The men wore green forage caps with black brims. The Vermonters were said to have worn sprigs of evergreen in theirs, as opposed to the official ostrich-feather plumes.

This monument was dedicated in 1900.

B-7: Miller Cornfield
39° 28.860′ N, 77° 44.875′ W

At daybreak, General Joseph Hooker's First Corps, numbering approximately eight thousand men, advanced south through the Cornfield, only to meet heavy opposition. Although they were

initially stopped, Hooker's men regrouped and began to counterattack as the casualties on both sides quickly escalated.

Meanwhile, General John Bell Hood had two thousand Confederates positioned behind the Dunker Church. Called to respond, Hood's men drove north, forcing the First Corps back across the Cornfield.

At about the same time, General Robert E. Lee ordered troops under General D. H. Hill to move north into the Cornfield from their positions at the Sunken Road. Fighting their way to the northern edge of the field, they ran headlong into the Union's Twelfth Corps. It was at this stage of the fighting that General Joseph K. F. Mansfield fell mortally wounded and Gener-

al Alpheus Williams took command of the Union corps.

At about nine o'clock that morning, the action briefly subsided, allowing the Confederates on the north end of the battlefield to retreat to the West Woods. In just a few hours of fighting, nearly eight thousand Union and Confederate soldiers had been killed or wounded in and around the Cornfield.

When it had become obvious that a battle was imminent, the Miller family took refuge at the home of David Miller's father on the other side of the ridge. When they returned, the family members were pleased to note that little damage had occurred to the house. Further examination, however, revealed that the crops had been trampled and the hay and straw stored in the barn had been taken to feed horses and to provide bedding for the wounded. The Millers filed a damage claim in the amount of $1,237 and received reimbursement for about 75 percent of their losses.

After the battle, observers claimed that so many bodies were in this field that it would have been possible to walk from one corner to the other without ever touching the ground.

B-8: Eighty-fourth New York Infantry (Fourteenth Brooklyn) Monument

39° 28.858′ N, 77° 44.815′ W

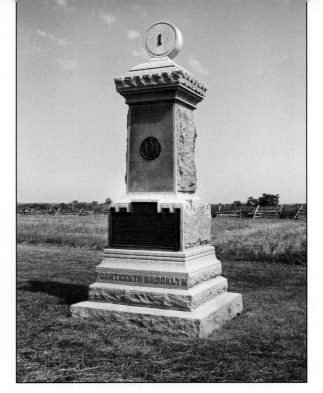

Dedicated in 1915, this monument to the Eighty-fourth New York also indicates the other name given the regiment—the Fourteenth Brooklyn. The number 1 at the top of the monument represents the First Corps, of which the regiment was a part. The First Corps made the initial attack against the Confederate army the morning of September 17, 1862.

For several hours, the regiment fought in the Miller Cornfield, suffering eight killed and twenty-three wounded. Just three days earlier at

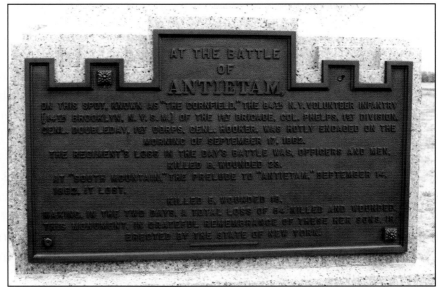

South Mountain, it had lost eight killed and eighteen wounded. The two battles in just three days took a heavy toll on the men of the regiment, not only in losses but also in morale.

The dual name came from the regiment's beginnings as the Fourteenth Regiment, New York State Militia. The unit adopted a modified French chasseur uniform, complete with red trousers, after seeing the uniforms of Colonel Elmer Ellsworth's Chicago Zouaves. Although officially a militia unit, the Fourteenth was more a social club prior to the war. At First Manassas, it fought under the original name, but later in 1861 it was given the official designation of the Eighty-fourth New York Infantry. However, the regiment resisted the new name. Most of the men continued to refer to themselves as the Fourteenth Brooklyn. They felt so strongly that the regiment finally petitioned successfully to be permitted to continue under the original designation.

Stonewall Jackson, upon seeing the men fight, gave them the nickname "the Red Legged Devils." Other names for the regiment included the Brooklyn Chasseurs and the Brooklyn Phalanx.

The regiment fought in all the war's major campaigns—including First and Second Manassas, Fredericksburg, Chancellorsville, Gettysburg, the Wilderness, and Spotsylvania—until it was mustered out in May 1864. After the war, the unit stayed intact as a state militia and National Guard unit.

B-9: Texas State Monument
39° 28.851′ N, 77° 44.818′ W

One of the newer memorials on the battlefield, the Texas State Monument recognizes all the Texas troops who fought at Antietam. It is significant for its simplicity. Except for the inscription, it is identical to other Texas monuments erected at battlefields in Gettysburg, the Wilderness, Chickamauga, Bentonville, Kennesaw

Mountain, Mansfield, Fort Donelson, Pea Ridge, Shiloh, and Anthony, Texas.

Texans fought valiantly, rushing out of the West Woods behind the Dunker Church and into the Cornfield, passing this monument's location. As the battle raged back and forth, men on both sides were cut down in horrendous numbers.

No regiment suffered more than the First Texas Infantry, which rushed to close a gap in the line during the heaviest fighting. In so doing, the regiment lost 41 killed, 141 wounded, and four missing, or 82 percent of its roster of 226, all in the space of 30 minutes. No other Confederate regiment lost a greater percentage of its men at any time in the war. The regiment also lost its flag in the Cornfield. The Union soldier who found it claimed that "13 men lay within touch of it and the body of one of the dead lay stretched across it." Eight of the regiment's color bearers were among the casualties. At the next morning's roll call, nobody responded from Company F, and only one reported from Company A. Company C had only two men left. Later, the regiment's replacement flag was given a black border, in memory of those who had fallen.

Also referred to as Hood's Brigade after its earlier commander, General John Bell Hood, the Texas Brigade at Sharpsburg included the First, Fourth, and Fifth Texas infantries. The Texas Brigade was not made up entirely of Texans, however. The Eighteenth Georgia Infantry and Hamp-

ton's South Carolina Legion also were part of the brigade. Two months after the Battle of Antietam, the Georgia and South Carolina troops were transferred out, but the Third Arkansas joined at about the same time and remained in the brigade until the end of the war.

Over the course of the war, the Texas Brigade suffered 530 casualties out of a total contingent of 850 men.

The monument was dedicated on November 11, 1964.

B-10: Georgia State Monument
39° 28.853' N, 77° 44.753' W

This monument was placed by the state of Georgia to honor those from the Peach State who served at Antietam. Georgia was well represented in the Antietam Campaign, providing thirty-nine infantry regiments, two infantry battalions, seven artillery batteries, and one cavalry battalion.

Although their monument sits at the Cornfield, Georgians fought at several other sites as well. Georgia troops were part of the overwhelmed Confederate forces in the Sunken Road. And although they were greatly outnumbered, troops from the Second, Twentieth, and Fiftieth Georgia regiments, holding the better ground, delayed for several hours twelve thousand

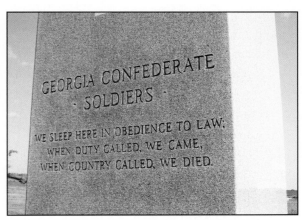

176 men into the battle and brought out fewer than half of them.

The monument, dedicated on September 20, 1961, is identical to one at Gettysburg and another at Vicksburg. All three were constructed as part of the centennial celebration of the Civil War. A simple, yet poignant, inscription states,

> We Sleep Here in Obedience to Law
> When Duty Called, We Came
> When Country Called, We Died

B-11: 104th New York Infantry Monument
39° 28.864' N, 77° 44.728' W

Also known as the Wadsworth Guards, the 104th Regiment was formed through the consolidation of the Morgan Guards and the Geneseo

Union troops attempting to cross the Burnside Bridge. Those Georgia troops were finally forced to withdraw.

The ferocity of the fighting at Antietam resulted in three color bearers of the Thirteenth Georgia being wounded or killed. And the colors of the Tenth Georgia were riddled with 46 bullet holes, as nearly 57 percent of the regiment's men fell. Other Georgia regiments suffered similar fates, such as the Eighteenth Georgia, which took

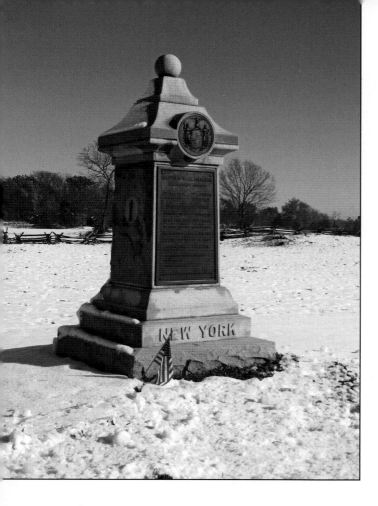

the left flank was withdrawn, followed shortly by the remainder of the regiment. Along with the rest of Duryea's Brigade, the 104th New York attempted a second advance but was pushed back a second time.

At Antietam, the 104th New York had eighteen killed or mortally wounded, fifty wounded, and fourteen missing in action, all in the Cornfield.

The New Yorkers dedicated their monument in 1917 at a cost of $1,392.70. It consists of a square granite shaft topped by a ball twelve inches in diameter. Disks representing the badge of the First Corps were placed on the sides, with the figure 1 in the center of each disk. The stonework was done by the National Granite Company of Montpelier, Vermont. The bronze plaques were made by John Williams, Inc., of New York.

B-12: 128th Pennsylvania Infantry Monument
39° 28.866' N, 77° 44.701' W

The 128th Pennsylvania was a nine-month regiment, serving only from August 14, 1862, through May 20, 1863. It entered the fight at Antietam with only one month's experience and little or no training. Antietam was the first time it had come under fire.

On the morning of the battle, its men charged

Regiment. The 104th fought mostly in the Cornfield at Antietam.

Early in the morning on the day of the battle, the 104th New York moved from its bivouac in a wood lot on the Joseph Poffenberger Farm and continued through the North Woods and through the Cornfield to its south end. There, the men encountered Confederate troops positioned about 150 yards away. In less than thirty minutes,

ates, twenty-six of its number killed or mortally wounded, another eighty-six wounded, and six missing.

During the fighting, Corporal Ignatz Gresser of Company D rushed to the aid of a comrade while under heavy fire. Ignoring the danger, Gresser picked up his friend and carried him to a position of safety. For his actions, Gresser was awarded the Medal of Honor on December 12, 1895.

The statue honoring the 128th Pennsylvania, titled *On the Firing Line*, was sculpted by E. L. A.

through the East Woods and into the Cornfield, long on enthusiasm but short on experience. They immediately came under heavy fire. Colonel Samuel L. Croasdale was killed early in the fighting while placing his troops into position. Lieutenant Colonel William W. Hammersly took command and was soon wounded badly enough that he had to leave the field. He was relieved as commander by Major Joel B. Wanner.

In a matter of minutes, the inexperienced regiment was decimated by the Confeder-

Pausch, assisted by granite cutter Charles A. Pinardi. A soldier is shown raising his musket in preparation for taking a shot. The Twelfth Corps badge, a five-pointed star, is carved on the monument's front. The monument was erected, but not dedicated, in 1905. It was supposed to have been included in the Pennsylvania Day dedications the year before but had not been completed by that time.

B-13: 137th Pennsylvania Infantry Monument
39° 28.867' N, 77° 44.686' W

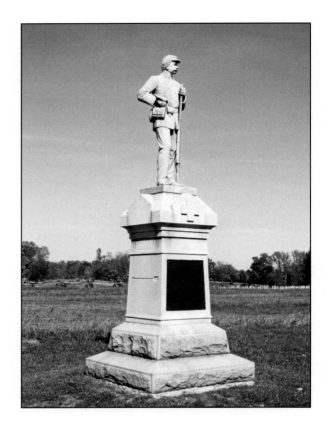

The 137th Pennsylvania, another new regiment, was organized just three weeks before the battle.

Dedicated on September 17, 1904, this memorial is titled *Handle Cartridge*. The figure on the monument is removing a paper cartridge from his cartridge box. This was the preliminary step to tearing the cartridge by biting off the end, which is depicted on the monument to the Forty-fifth Pennsylvania. The need to do this was eliminated when the breechloading rifle became available—which also eliminated the need for the leather cartridge box and the percussion cap box, both of which are shown on this statue.

The regiment was held in reserve at Antietam and did little fighting, although one company did support a battery during the battle. The regiment's position was about a quarter-mile north of the monument. As a result, the 137th Pennsylvania experienced no casualties at Antietam. After the battle, it was assigned to burial detail.

The Sixth Corps badge, the Greek cross, is affixed to the front of the pedestal.

The monument, created by artist Stanley Edwards, was dedicated on Pennsylvania Day, September 17, 1904, the forty-second anniversary

would have heavy losses again at Gettysburg less than a year later.

The Twenty-seventh attacked the flanks of the Confederate army, rushing out of the East Woods into the Cornfield. The fighting had been in progress for some time, and the Hoosiers found themselves stepping over bodies as they advanced with fixed bayonets against troops from Louisiana, South Carolina, and Georgia. As the Confederates retreated into the woods, the Twenty-seventh followed until ordered to halt, as fresh troops were given the task of further pursuit.

The regiment remained in that position until

of the battle. Because the 128th Pennsylvania's monument was not ready for dedication, some of the men from the 128th assisted with the dedication service for the 137th.

B-14: Twenty-seventh Indiana Infantry Monument
39° 28.867' N, 77° 44.681' W

Fighting some four hundred yards north of the site of its monument, the Twenty-seventh Indiana suffered badly at Antietam, with 209 killed or wounded out of a force of 440. The regiment

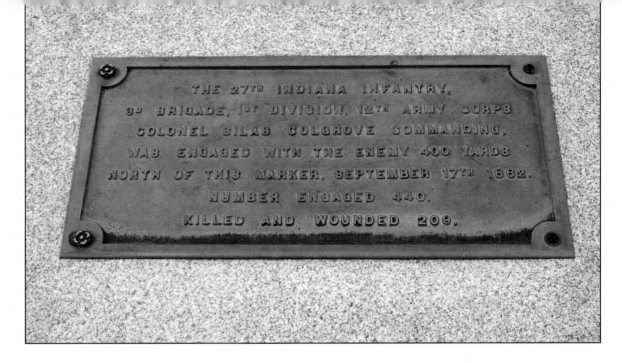

THE 27TH INDIANA INFANTRY,
3D BRIGADE, 1ST DIVISION, 12TH ARMY CORPS
COLONEL SILAS COLGROVE COMMANDING,
WAS ENGAGED WITH THE ENEMY 400 YARDS
NORTH OF THIS MARKER, SEPTEMBER 17TH 1862.
NUMBER ENGAGED 440.
KILLED AND WOUNDED 209.

ordered an hour later to support Federal troops posted in the woods at the rear of the Cornfield. The men came under heavy fire as they advanced and were forced to return to their original position. The regiment remained under artillery fire the rest of the day.

The Twenty-seventh Indiana's monument was dedicated on Indiana Day, September 17, 1910. As with all the Indiana markers, this one was designed by architect John R. Lowe and constructed and erected by the J. N. Forbes Granite Company of Chambersburg, Pennsylvania. It was rededicated on September 9, 1962.

Three soldiers from Company F of this regiment found Special Orders No. 191, outlining Lee's plans for the campaign (see the Introduc-

tion and Appendix A). Special Orders No. 191 provided much valuable information to General McClellan. Corporal Barton W. Mitchell, Private David Vance, and Private John Bloss passed the found document to their company commander, Captain Peter Kop, who sent it up the chain of command. Sadly, none would get through the battle unscathed. Kop was killed and Bloss, Vance, and Mitchell were wounded in the fighting in the Cornfield. All three survived their wounds, although Mitchell would die three years later as a result of complications attributed to his injuries. Both Bloss and Vance survived. Bloss went on to become president of what is now Oregon State University.

B-15: Ninetieth Pennsylvania Infantry Monument

39° 28.860' N, 77° 44.677' W

The Ninetieth was the first Pennsylvania unit to place its memorial on the Antietam Battlefield. This unusual monument is a reconstruction of the original, which dated to the 1880s. The original, made from three Civil War rifles with fixed bayonets and a hanging cook pot, gradually fell into a state of disrepair. Around 1930, it was dismantled not only because of its condition but because of fears of theft of the weapons.

Descendants of those who served in the Ninetieth Pennsylvania raised funds to replace the monument, which was designed and sculpted by Gary Casteel. The replacement was unveiled and dedicated on September 17, 2004, in the same location along the Cornfield Avenue. The cooking pot bears the inscription, "Here fought the 90th Penna. (Phila.), Sept. 17, 1862, A Hot Place."

The regiment boasted two Medal of Honor

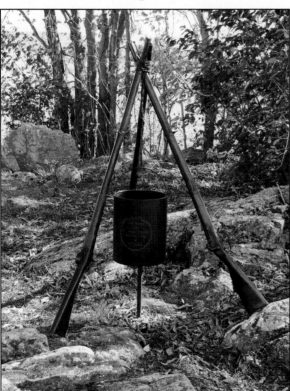

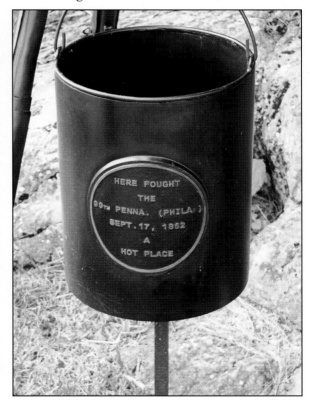

recipients. Lieutenant Hillary Beyer was awarded his for staying alone on the field after the Ninetieth Pennsylvania was forced to retreat. He cared for his wounded comrades and carried one to safety. Private William H. Paul gathered up the regimental colors after the bearer and two color guards had been killed. Despite placing himself as a focal point of enemy fire, he carried the colors proudly for the rest of the battle.

The regiment's total losses during the battle were ninety-eight, including several officers. The Ninetieth was commanded by Colonel Peter Lyle. When Lyle was promoted to command of the brigade, Lieutenant Colonel William Leech took over the regiment.

B-16: Monument to First Maryland Light Artillery, Battery B (US)

39° 28.871' N, 77° 44.642' W

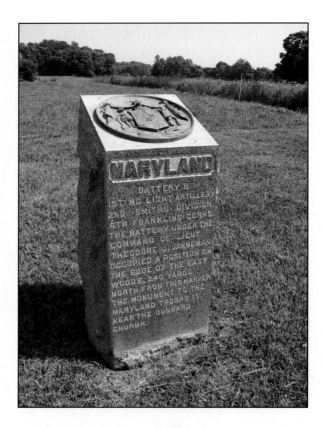

Also known as Snow's Battery after its captain, Alonzo Snow, this unit was armed with six three-inch ordnance rifled cannons. Part of the Purnell Legion at the time of its organization, it was transferred to General John Adams Dix's command two months later.

At the time the Civil War began, Dix became well known to the public when he sent a telegram to treasury agents in New Orleans ordering that "if any one attempts to haul down the American flag, shoot him on the spot." The telegram was intercepted by the South. But somehow, the text found its way to the press, making Dix a hero in the North when things were going badly for the Union army.

The battery, under Lieutenant Theodore J. Vanneman at Antietam, was originally positioned on the edge of the East Woods, on relatively high ground. That location provided a clear field of

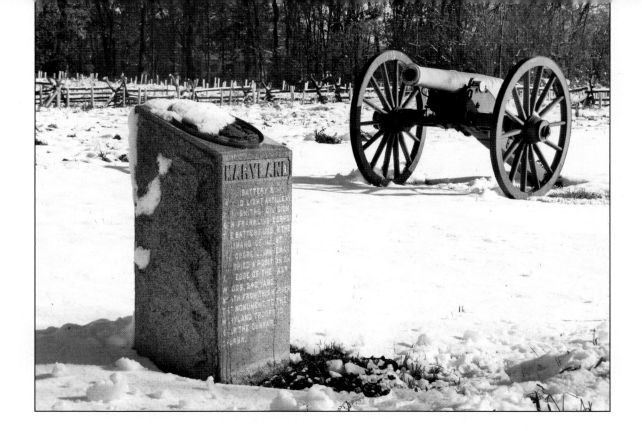

fire in the direction of the Dunker Church. By the time the battery was placed, however, the fighting had shifted farther south, offsetting any advantage it had due to its position.

Over the course of the war, the battery lost five enlisted men killed or mortally wounded and twenty-seven more enlisted men by disease. No officers were lost during the war.

The monument was dedicated on May 30, 1900.

B-17: Union Cannon Line
39° 28.872' N, 77° 44.639' W

Following Sedgwick's ill-fated assault on the Confederate position at the Dunker Church, a line of batteries was formed that extended from the Mumma Farm to the Poffenberger lane adjacent to the East Woods. The cannons in the photo on page 42 represent that line of artillery and are positioned where the line crossed the road.

The line was held in turn by batteries of the

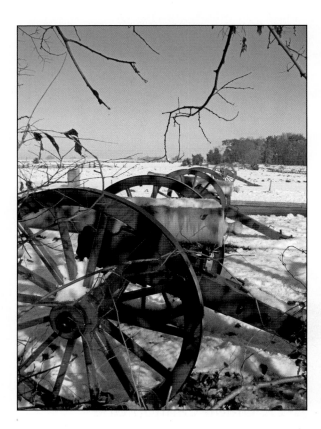

B-18: First New Jersey Brigade Monument
39° 28.874′ N, 77° 44.624′ W

This is one of two markers for the First New Jersey Brigade. The other is a short distance away on Smoketown Road near the Mumma Farm lane. The First New Jersey Brigade was made up of the First, Second, Third, and Fourth New Jersey infantries and Hexamer's Battery A. The brigade's men were the first three-year volunteers from the state.

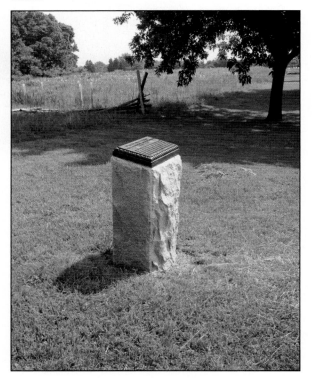

First, Twelfth, Second, and Sixth corps. These batteries successfully turned back attempts of the Confederate army to advance. They held this position until the end of the battle.

The brigade was commanded by its senior colonel, Alfred T. A. Torbert. Lieutenant Colonel Mark W. Collet commanded the First New Jersey. The Second New Jersey was commanded by Colonel Samuel L. Buck, the Third by Colonel Henry W. Brown, and the Fourth by Colonel William B. Hatch. Captain William Hexamer commanded Hexamer's Battery.

This marker designates the position occupied by the right of the brigade shortly after noon on September 17. It stood here while forming to charge the West Woods. When the order was countermanded, the brigade relocated to the position represented by the marker on Smoketown Road near the Mumma Farm lane. From there, Hexamer's Battery fired on and silenced a Confederate battery positioned near the Dunker Church.

This monument was dedicated on September 17, 1903, and rededicated on September 9, 1962.

B-19: Thirteenth New Jersey Infantry Monument

39° 28.878′ N, 77° 44.565′ W

This monument, one of three to the Thirteenth New Jersey, notes the regiment's first position, about 150 yards north. The Thirteenth entered the battle at that location around ten o'clock in the morning and quickly came under heavy artillery fire. Having been organized a

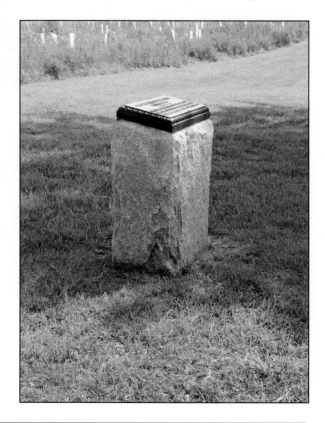

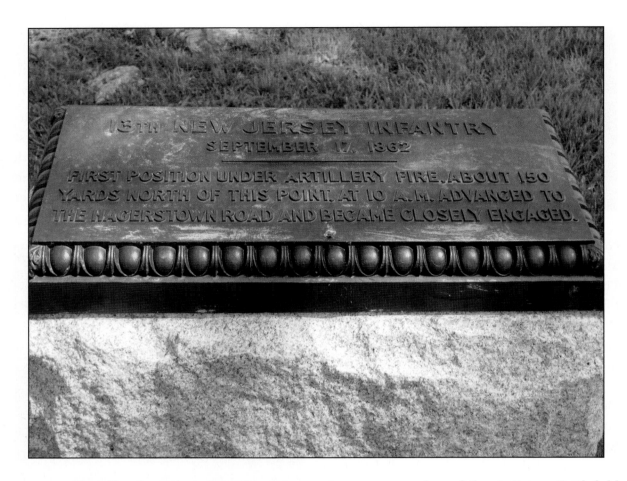

mere month earlier, the regiment was thus introduced to combat. Prior to the battle, its men had never fired their muskets.

The monument was dedicated on September 17, 1903, the forty-first anniversary of the battle, and rededicated on September 9, 1962.

The Thirteenth New Jersey Infantry was commanded by Colonel Ezra Ayres Carman, who became a member of the Antietam Battlefield Board in the 1890s. Two of his responsibilities as a board member were to document the positions and movements of the units that fought and to certify the placement of the various monuments.

B-20: First New Jersey Brigade Monument

39° 28.779' N, 77° 44.568' W

The First, Second, Third, and Fourth New Jersey infantries and Hexamer's Battery A were known as the First New Jersey Brigade. The brigade's men were the first three-year volunteers from the state. The brigade was commanded by its senior colonel, Alfred T. A. Torbert of the First New Jersey. Lieutenant Colonel Mark W. Collet commanded the First New Jersey. The Second New Jersey was commanded by Colonel Samuel L. Buck, the Third by Colonel Henry W. Brown, and the Fourth by Colonel William B.

Hatch. Captain William Hexamer commanded Hexamer's Battery.

The brigade did not arrive at Antietam until about noon, rushing from Crampton's Pass. Its initial position is marked by its monument on the Cornfield Avenue just a short distance from here. The men immediately formed for a charge against the Confederate line just north of the Dunker Church. When the order for the charge was countermanded, the brigade took position across the road from this monument in support of the Sixth Corps Artillery. From this location, Hexamer's Battery A silenced the Confederate artillery at the Dunker Church.

The right of the brigade was positioned in the

woods north of the road, the left in the open field to the south. The men remained in those positions until the morning of September 19.

This marker was dedicated on September 17, 1903, and rededicated on September 9, 1962. Visitors often wonder about the gate in front. The monument was placed back from the road, behind a fence and gate, so passing wagons would not splash it with mud. The current gate commemorates that fence.

Chapter 3
Area C

WEST WOODS/
DUNKER CHURCH

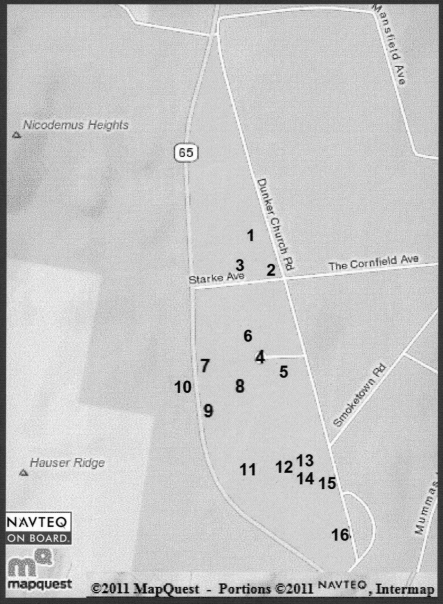

*A*s the fighting became more intense, General Edwin Sumner moved the Union's Second Corps across Antietam Creek and into the battle. The combination of the terrain and the stream caused the three divisions in Sumner's corps to become separated from each other. One division advanced toward the West Woods, while the remaining two fell behind and eventually became part of the attack on the Sunken Road.

At approximately nine-thirty that morning, Sumner led General John Sedgwick's division, numbering more than 5,000 men, into the battle. Sumner intended to move into the woods and attack Lee's left flank. As the Union lines moved through the West Woods, however, they came under heavy artillery fire from nearby Hauser Ridge. Confederate reinforcements under General Lafayette McLaws and General John Walker struck the Union flank. The Union troops were decimated by fire from three different directions. In less than twenty minutes, the Federal army suffered more than 2,000 casualties. Sedgwick himself was wounded. In the frenzy, New York troops shot into the backs of the Union men in front of them. The Fifteenth Massachusetts suffered 330 casualties, the highest number for any Union regiment on the field during the battle. Those who survived were forced to withdraw from the West Woods.

A Twelfth Corps division commanded by Brigadier General George Greene finally reached the Dunker Church. Unsupported, it also had to withdraw after only a few hours.

The Twenty-seventh North Carolina suffered a 67 percent casualty rate. The bodies of Federal troops were found the next day stacked two and three deep in places. The fighting for the West Woods produced about 2,200 Union casualties and only slightly fewer for the Confederate army, all in the span of less than ninety minutes. The fighting in the West Woods was the only time in the entire battle that Confederate forces outnumbered Federal troops.

A fine example of the role volunteers play in our national parks, the West Woods was an open field as recently as 1995, when a different army—an army of workers—planted the trees that make up the woods today. Because of their efforts, visitors can more easily grasp the problems the soldiers on both sides encountered here.

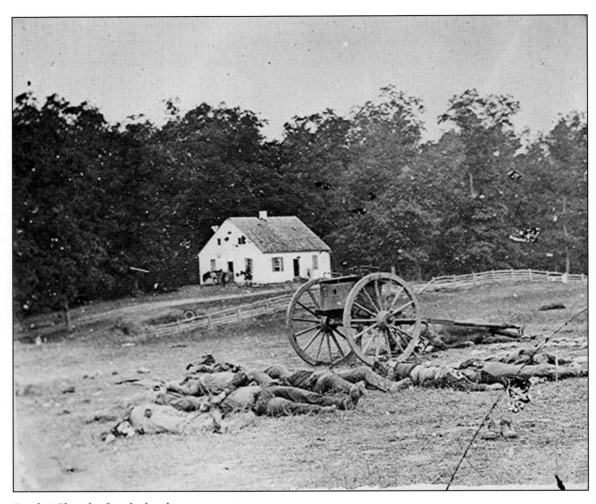

Dunker Church after the battle
Library of Congress, Prints & Photographs Division, Reproduction Number LC-DIG-cwpb-01099 (digital file from original negative)

C-1: Monument to Battery B, Fourth United States Artillery
39° 28.929' N, 77° 44.941' W

Battery B was decimated in the early fighting. Seventeen of its men died or were wounded as a result of a heavy volley from Stonewall Jackson's Confederate soldiers in the West Woods. Among the wounded was the battery's captain, Joseph Campbell. Fifteen-year-old Johnny Cook, a bugler, quickly stepped in to assist his captain to the rear. Once there, Captain Campbell directed Cook to return to the battery and inform Lieutenant James Stewart that he would have to take command. Cook did as directed and noticed that one of the dead cannoneers still had a nearly full pouch of ammunition. Despite his youth, Cook quickly took the pouch and began loading the nearest gun. His efforts helped repel three Confederate assaults, the last one coming within ten to fifteen feet of the battery. In 1894, Cook's actions were officially recognized when he was awarded the Medal of Honor, making him the youngest recipient from the Battle of Antietam, and possibly the youngest ever.

Cook was not the only hero in his battery. John Johnson, severely wounded in the fighting, and William Hogarty, destined to lose his left arm at Fredericksburg, were both awarded Medals of Honor for their gallantry in filling in for fallen gunners.

The condition of the battery was so bad that Brigadier General John Gibbon also stepped in and worked as a gunner and cannoneer for a time.

The battery lost forty-four men killed and

wounded, as well as about forty horses. This was double the number of human casualties for any other Union battery.

C-2: 124th Pennsylvania Infantry Monument
39° 28.849' N, 77° 44.915' W

The 124th Infantry was a nine-month regiment recruited just six weeks before seeing combat for the first time at Antietam. At seven o'clock in the morning, the green regiment formed near the wood line on the east side of the Cornfield. The men moved into the Cornfield a short distance but had to halt because they could not determine who the other troops were. Unable to distinguish friend from foe, they fell back to the edge of the Cornfield. When the order came to advance again, they went only about a hundred yards before they were hit with raking fire from the woods, followed by artillery fire from the opposite flank. Again, they fell back to the protection of the woods. Their colonel, Joseph W. Hawley, was wounded in the fighting. Command of the regiment fell to Major Isaac L. Haldemann, who led it through the rest of the battle.

A battery was brought up, and the right wing of the regiment was ordered to its support. The left wing then advanced on the Southern troops, until it was also ordered to the support of the

batteries. At three in the afternoon, the regiment was ordered to the rear, where it was directed by General Winfield Scott Hancock to remain in readiness to support batteries on the right if needed. However, that need never arose, and the regiment's participation in the battle had ended.

The regiment suffered five killed, forty-two wounded, and seventeen missing in the battle. It spent September 18 burying the dead.

The eight-foot-tall sculpture, depicting a typical soldier wearing a winter uniform, is titled *The Infantryman*. This is not the uniform the troops wore in the still-warm month of September 1862. The star near the top of the shaft represents the Twelfth Corps, of which the 124th Pennsylvania was a part. The inscription to Colonel Joseph W. Hawley is not meant to designate whom the soldier represents. Rather, it is meant to honor Colonel Hawley for his service as the regiment's commander. The monument, sculpted by Pierre Feitu, was unveiled by Mrs. J. M. Thompson, daughter of Colonel Hawley. She was assisted by Robert M. Green Jr.

The monument was dedicated on September 17, 1904, on the forty-second anniversary of the battle. The 124th Pennsylvania was one of two regiments (the Forty-eighth Pennsylvania being the other) that chose to add funds to their state allotments so they could have more elaborate memorials.

C-3: Rock Ledge
39° 28.861' N, 77° 45.004' W

This small rock ledge provided much-sought-after cover for soldiers from both sides during the heavy fighting in the morning. As the battle raged back and forth, so did possession of the rock ledge, which changed hands at least four times in the first three hours of fighting. While not a large outcrop, it provided shelter from the withering fire as troops huddled together beneath its upper edges to avoid becoming targets. The ledge was sufficiently sized to play an important role in the survival of many of these men and serves to illustrate how crucial the area's terrain was in the outcome of the battle.

C-4: Philadelphia Brigade Monument
39° 28.697′ N, 77° 44.945′ W

Fighting in the West Woods, the Philadelphia Brigade lost 545 men in less than twenty minutes. When time came for them to place their monument, the veterans of the brigade purchased eleven acres of ground where they had fought. Recognizing they had much more land than they needed, they chose to establish a public park on the area around their monument.

The obelisk is seventy-three feet in height, making it the tallest marker on the field. It cost fifteen thousand dollars. It commemorates the service of the Sixty-ninth, Seventy-first, Seventy-

second, and 106th Pennsylvania volunteer infantries, which made up the brigade. Officially known as the Second Brigade, Second Division, Second Army Corps, the brigade lost 3,409 men over the course of the war.

The brigade's monument was dedicated on September 17, 1896. Several Confederate generals attended the ceremony and were given a loud ovation when introduced—an indication that, at least to the participants, differences had been put aside.

Although the regiments were recruited in Pennsylvania, Senator Edward Baker of Oregon wanted the West Coast to be represented in the war, so they were credited to California when they were formed and were called "California Regiments." They were reclaimed by the Keystone State and given Pennsylvania regimental numbers after Baker was killed at Ball's Bluff.

At Antietam, the brigade was part of Sedgwick's attack on the West Woods, where the men met stiff resistance and were flanked. The Confederate attack took them by surprise. Some companies did not even have time to fire a volley.

The Philadelphia Brigade was the only brigade in the Union army named after a city. It was commanded at Antietam by Brigadier General Oliver O. Howard until General John Sedgwick was wounded. Howard assumed command of the division at that point, and Colonel Joshua T. Owen of the brigade's Sixty-ninth Pennsylvania

Infantry took over Howard's position.

The city of Philadelphia sold the park to the National Park Service in 1940 for one dollar.

C-5: Brigadier General William E. Starke Monument
39° 28.704' N, 77° 44.924' W

William Starke worked as a stagecoach operator and was a successful cotton planter before the war. He began his military career as a lieutenant colonel with the Fifty-third Virginia Infantry. He served a short stint on the staff of Robert E. Lee before being named colonel of the Sixtieth Virginia Infantry. In that capacity, he suffered a wound to his hand during the Seven Days Battles. Starke was promoted to brigadier general about six weeks before Antietam. His brother, Peter, was also a general in the Confederate army.

At Antietam, the commander of the Stonewall Division, General J. R. Jones, was wounded by shrapnel. Command of the division fell on William Starke's shoulders. Starke had begun moving his brigade out of the West Woods in a counterattack when he was mortally wounded. He survived only an hour after being struck three times by Union bullets. His troops helped stop a Union attack that was advancing down the Hagerstown Pike.

Starke's body was taken to Richmond for

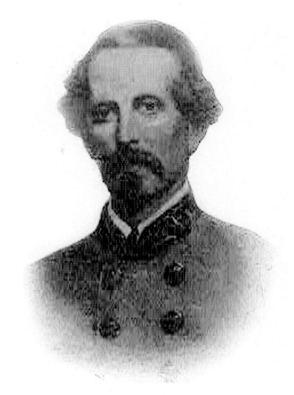

Library of Congress, Prints & Photographs Division, Reproduction Number LC-USZ62-87411

burial in Hollywood Cemetery, where he was laid to rest next to his son, who had been killed just two months prior to Antietam.

This upright cannon tube marks the location of Starke's death. Along with the mortuary cannons for the other five generals killed or mortally wounded at Antietam, it was constructed by the Antietam Board between 1896 and 1898. The

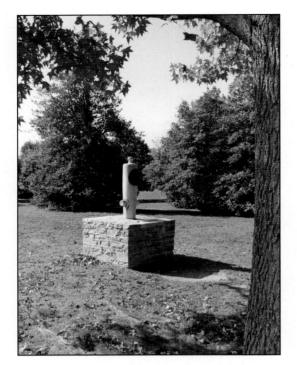

cannon tube is a twelve-pounder light field gun, commonly known as a Napoleon.

C-6: Third Delaware Infantry Monument
39° 28.742' N, 77° 44.971' W

The Third Delaware suffered greatly in the Second Manassas Campaign and had only five officers and 120 men at Antietam as a result. It formed on the right of the Union line and helped repel a Confederate counterattack when Sedgwick's division was hit hard in the West Woods. The regiment then conducted a fighting retreat toward the high ground north of the Cornfield. Its final position was about sixty-five yards north of the monument.

Colonel Arthur Maginnis commanded the Third Delaware at Antietam until he was wounded. At that time, Captain William J. McKaig assumed command.

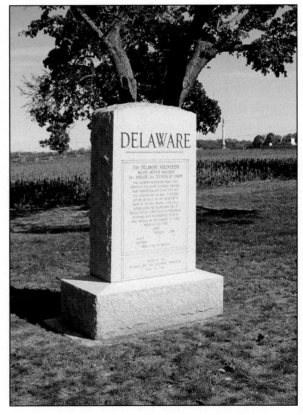

During the battle, the regiment had one officer and five enlisted men killed. Two additional officers and nine men were wounded. The monument was dedicated on May 30, 1964, making it one of the newer markers on the field.

C-7: Fifteenth Massachusetts Infantry Monument
39° 28.707' N, 77° 45.097' W

The Fifteenth Massachusetts Infantry's unique monument features a wounded lion carved in granite. Although injured, the lion still raises a paw in defiance, symbolizing the regiment's determination and bravery. Those qualities were best exemplified by the regimental color sergeant, who, seeing the bearer of the state flag fall wounded, seized the flag and carried it in one hand and the national colors in the other.

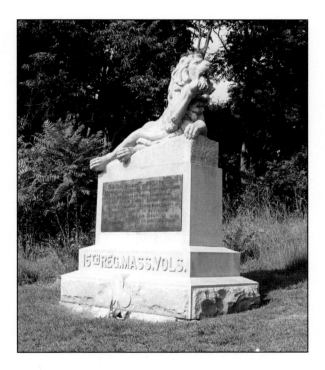

The regiment's soldiers had with them a company of the First Andrews Sharpshooters as they moved from the East Woods across the Cornfield and into the West Woods. At the approximate location of their monument, they came under heavy artillery fire and could go no farther. They moved back with the rest of the brigade to a field near the Miller barn.

Under the command of Lieutenant Colonel John W. Kimball, the regiment suffered heavy casualties. Seventy-five men were killed during the fighting, and another 43 were mortally wounded. Company H alone lost 53 of its 62 men. Another 212 members of the regiment suffered nonmortal wounds. The 330 casualties out of a force of 606 were the highest number for any Union regiment at Antietam. All the casualties came in a twenty-minute period, which serves as a good indication of the ferocity of the fighting. The regiment chose to honor its dead by listing their names on the monument.

Sculpted by Andrew O'Connor of Holden, Massachusetts, the monument was dedicated on

September 17, 1900, and rededicated on September 10, 1995. It sits just north of the Alfred Poffenberger Farm, where the regiment was positioned at about nine o'clock on the morning of the battle. The foundation includes a small copper box containing papers, a roster of the regiment, and a book by Captain David M. Earle.

C-8: Baltimore Battery (CSA) Monument

39° 28.676' N, 77° 44.999' W

At daybreak on September 17, 1862, the Baltimore Battery, commanded by Captain J. B. Brockenbrough, occupied a position near its marker in the West Woods. From here, the battery fired the opening shots of the battle into Union forces in the Cornfield. This position also enabled it to fire

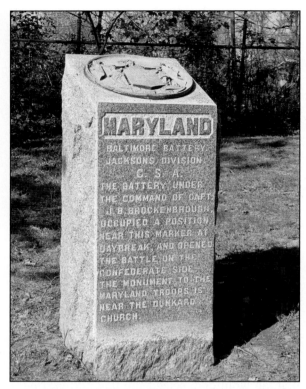

on the Union's First Corps as it moved down the Hagerstown Pike.

Shortly after eight o'clock that morning, the battery moved to Hauser Ridge to the west, from which it fired on Sedgwick's troops as they advanced through the West Woods.

Among the battery's artillery was a twelve-pounder iron howitzer (shown in the photo on page 58), the only one of its kind at Antietam out of the five hundred cannons used by both sides. The battery also had a three-inch ordnance rifle, a twelve-pounder Blakely rifle, a ten-pounder Parrott rifle, and a twelve-pounder smoothbore howitzer.

The monument was dedicated on May 30, 1900.

C-9: Monument to Lieutenant Colonel J. L. Stetson, Fifty-ninth New York Infantry
39° 28.658' N, 77° 45.091' W

This monument marks the location of the death of John Lemuel Stetson of Plattsburgh, New York. Stetson, the lieutenant colonel of the Fifty-ninth New York, fell here after being shot in the abdomen while leading his regiment in an advance. He was a cousin of John B. Stetson, maker of Stetson hats.

The Fifty-ninth New York was nearly wiped out at Antietam. Stetson, only twenty-eight years

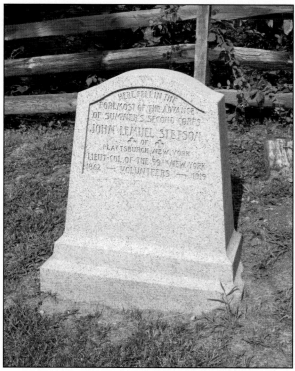

old, was buried where he fell. His father, Judge Lemuel Stetson, arrived at Antietam a few days after the battle and was taken to his son's grave. He added earth and stones to aid in locating and identifying the resting place.

The memorial was placed by John Lemuel Stetson's brother in 1920. The brother also purchased the property at the intersection of the Dunker Church Road and Smoketown Road, where the regiment's marker was placed.

Stetson was one of nine officers of the Fifty-ninth New York who fell at Antietam. His name also appears prominently on the regiment's marker.

Stetson's last words were reported to be, "Men, rally on your colors!" Another of his brothers was also killed in the war.

C-10: Mary Locher Cabin
39° 28.617' N, 77° 45.240' W

This structure, often referred to as the Mary Locher Cabin, was already more than a hundred years old when the fighting at Antietam took place. Mary and her husband, Jacob, however, were not living on the land at that point, having moved to Lancaster, Pennsylvania. At the time of the battle, she was leasing the cabin and farm to Alfred Poffenberger. The property is also referred to as the Alfred Poffenberger Farm. The cabin is

the oldest historic structure on the battlefield.

Prior to the battle, Confederate troops occupied the farm. The Poffenbergers had fled in anticipation of the action to come.

Early in the fighting, troops moved from one

Library of Congress, Prints & Photographs Division, HABS, Reproduction Number HABS MD, 22-Anti.V.2-13

area to another across the farm's fields and past the cabin. Soldiers took cover in the farm's buildings and orchard. The area around the cabin quickly became an ambulance station, where wounded troops under Stonewall Jackson were brought for transport to areas in the rear. Given the fierce fighting all around the cabin, the fields became a cemetery. Bodies were buried in mass graves, one on top of another to save space.

For several weeks after the fighting, the farm was used as an encampment and field hospital.

At the time of this writing, a temporary roof had been placed over the cabin to prevent snow accumulation on the roof, as well as general deterioration from rain and wind. The National Park Service is restoring the cabin to its original appearance.

C-11: Thirteenth New Jersey Infantry Monument
39° 28.510' N, 77° 44.988' W

This marker locates the third position of the Thirteenth New Jersey Infantry. The regiment occupied this ground in late morning, from about 11:20 until noon. Commanded by Colonel Ezra Ayres Carman, the regiment had been formed less than three weeks before the battle and had never seen combat.

C-12: 125th Pennsylvania Infantry Monument
39° 28.514' N, 77° 44.889' W

Only six weeks in existence, and never having seen action, the 125th Pennsylvania bivouacked on the farm of George Line the night before the battle. At dawn, under the command of Colonel Jacob Higgins, the men moved from a place of relative safety into the East Woods to provide support for the First Rhode Island Battery. Passing through Samuel Poffenberger's wood lot, they encountered their first images of war as they met wounded men from the various Pennsylvania reserve regiments painfully working their way to the field hospitals in the rear.

They eventually advanced into the West Woods area, capturing several prisoners on their way. The first Union regiment to enter that part of the battlefield, the 125th fought behind the Dunker Church. As the men advanced, they were cut down by a ferocious Confederate barrage, during which Color Sergeant George Simpson was shot through the head and killed instantly. A second man picked up the flag and was wounded. A third and a fourth took their turns and also became casualties. After the fourth color bearer fell, Sergeant W. W. Greenland of Company C picked up the flag. Accompanied by his company's captain, William Wallace, he carried it to the rear of the nearest battery, Monroe's First Rhode Island

Upon reaching the West Woods, the men of the Thirteenth New Jersey stepped across the bodies of those who had been there before them. Seeing troops from North Carolina moving to their right, they believed the Rebels were surrendering. Instead, they were forming for a flank attack on the troops from New Jersey, and they delivered a devastating fire on the Thirteenth. Within minutes, the New Jersey line collapsed and was forced into a chaotic retreat.

The regiment's monument was dedicated on September 17, 1903, and rededicated on September 9, 1962.

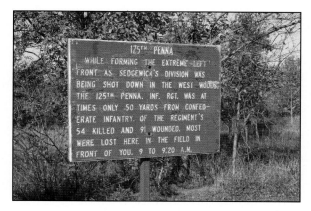

Battery. There, the regiment rallied and defended the battery for the remainder of the fighting.

Simpson's brother, J. Randolph Simpson, was shot through the breast and carried off the field shortly after George was killed. He survived his wound but suffered its effects until his death several years later.

When the veterans met to decide on the design of their monument, they chose to honor George Simpson, killed as he carried the national flag he loved so much. Comrades noted that the twenty-two-year-old's body fell across the flag and stained it with his blood. The remnants of the flag were kept in storage after the war and were brought out to be used at the dedication of the monument on September 17, 1904.

The monument, sculpted by Stanley Edwards and erected on the spot where Simpson was killed, depicts him as he stood holding the flag. The statue was unveiled by his sister, Annie Simpson. Buried on the field, Simpson's remains now rest in the national cemetery. If the monument looks familiar, that is because it is almost a duplicate of the statue on the monument to the Thirteenth Massachusetts at Gettysburg. That monument exhibits different facial features, but the poses are eerily similar. Molds were often reused in sculpting monuments in that era. That is the likely explanation, despite the fact that two different sculptors did the work.

The regiment suffered heavily at Antietam, losing fifty-four killed or mortally wounded, ninety-one severely wounded, and eighty-four slightly wounded and not reported. Among those mortally wounded was the regiment's adjutant, Lieutenant R. M. Johnston.

The statue on the monument to the Thirteenth Massachusetts at Gettysburg

Company C was known as the Huntington Bible Company, since each soldier had been given a Bible by the people of Huntington County upon entering the service.

C-13: Thirty-fourth New York Infantry Monument
39° 28.519' N, 77° 44.881' W

Since most of its members lived in Herkimer County, the Thirty-fourth New York was also known as the Herkimer Regiment. It was com-

manded by Colonel James A. Suiter.

The battle was already in progress when the regiment arrived on the field, having marched from nearby Keedysville. The men fought their way from the East Woods across the Hagerstown Pike to the West Woods behind the Dunker Church. They were on the extreme left of the brigade, leaving their flank unprotected. This vulnerability put them in danger of being overrun. Forced to quickly retreat, they re-formed in the East Woods not far from their starting point. As

he gave the order to retreat, General John Sedgwick was badly wounded in the wrist and neck.

The regiment lost forty-three men killed in the battle and another seventy-four wounded. Its color bearer, Sergeant Charles Burton, was struck by five Confederate bullets in the West Woods.

On September 17, 1902, the surviving members of the regiment dedicated this monument to their comrades who fell not only at Antietam but also at other battlefields. Herkimer County provided funding to the regiment to assist in purchasing the memorial.

The monument has the appearance of a castle tower. The clover leaf represents the Second Corps, of which the regiment was a member. The captains of each company and their respective home counties are listed on the monument.

C-14: Maryland Purnell Legion (US) Monument
39° 28.514' N, 77° 44.883' W

The Purnell Legion was originally made up of nine infantry companies, two companies of cavalry, and two batteries of light artillery operating as a regiment. They were recruited under the auspices of Colonel William H. Purnell, who served as postmaster at the Pikesville Arsenal, near Baltimore. When Purnell resigned his commission, the cavalry and artillery were separated

from the infantry. All subsequently operated independently of each other. As a result, the legion in September 1862 consisted exclusively of the nine infantry regiments, under the command of Lieutenant Colonel Benjamin L. Simpson.

At Antietam, it occupied a line that extended northward from where its marker stands. In the midday assault on the Dunker Church, the legion moved through the West Woods to a point near the monument. It lost three men killed and another twenty-three wounded in the fighting.

The monument was dedicated on May 30, 1900.

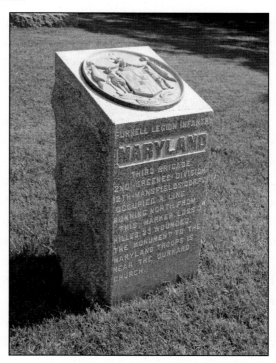

C-15: Dunker Church

39° 28.529' N, 77° 44.806' W

Arguably the most recognizable landmark on the battlefield, this simple structure served as the church for the German Reformed Brethren. It sat on ground donated by Samuel Mumma, who owned the nearby Mumma Farm. The Dunkers were so named for their practice of totally immersing their members for baptism. Dunkers historically espoused a modest lifestyle and opposed slavery, war, and any form of alcohol. The church exemplified this simplicity in its worship. Men sat on one side, women on the other. Dunkers opposed any kind of ornamentation, and thus the church had no steeple. This led many soldiers on both sides to assume the building was a schoolhouse.

In a cruel irony, the pacifist congregation's church was destined to become a focal point of the fighting in the West Woods area.

During the early part of the action, Stonewall Jackson made the church his headquarters. After the battle, the church served as a temporary medical aid station. Although it has not been proven, it was said that Lincoln may have come to the site during his visit to the Army of the Potomac in October 1862.

The church was in a poor state of repair, having taken serious damage to its roof and walls from artillery and musket fire. Within two years, the congregation repaired the battle scars. Services were held here until the early 1900s, when the Dunkers built a new church in Sharpsburg.

After the battle, the church's leather-bound bible was taken by Sergeant Nathan Dykeman of the 107th New York. It remained in his possession until his death in 1903. His sister sold the Bible to the veterans' organization of the 107th New York, which in turn gave it to John T. Lewis, an African-American who had moved from Maryland to New York. Lewis returned the Bible to the Dunkers in 1903. Today, the Mumma Bible is on display in the visitor center.

The church visible today is not the one that existed during the battle. The original church was destroyed by a violent storm that swept through the area in 1921. Fortunately, a local citizen named Elmer Boyer salvaged many of the building's pieces.

By the 1930s, a home and gas station occu-

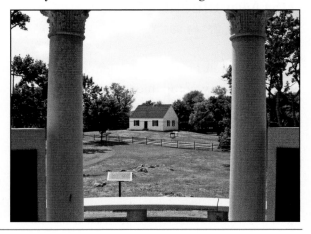

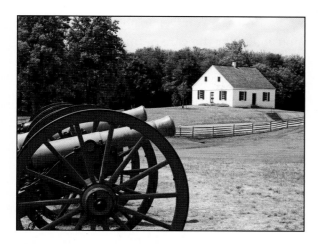

C-16: O. T. Reilly Monument
39° 28.415' N, 77° 44.759' W

At the age of five, O. T. Reilly witnessed troops from both sides marching past his home in Keedysville on the way to Sharpsburg. As he grew older, he listened to the tales of veterans of the battle, eventually writing those stories down as a compilation of the participants' oral histories.

His interest in the battle expanded to the

pied the site. In 1951, the Washington County Historical Society purchased the site, removed the buildings, and donated the property to the National Park Service. In 1962, in commemoration of the hundredth anniversary of the battle, the church was rebuilt on the original foundation, using as much as possible of the original material saved by Boyer.

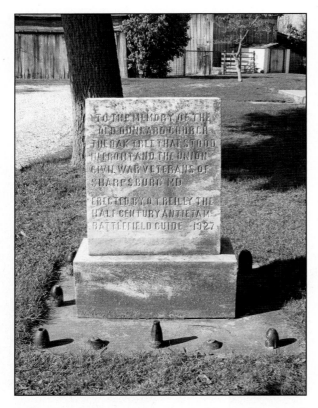

By 1924, the War Department transferred responsibility for the care of the battlefield to the National Park Service, which insisted that Reilly and any others who wished to serve as guides had to pass an examination and be licensed by the government. Reilly fought back, arguing that he had lived on the battlefield at the time of the fighting and didn't need to depend on others to tell him what had happened there. Reilly's stubbornness worked in his favor. He never took the test or obtained a license.

When the Dunker Church was destroyed by a windstorm in 1921, Reilly decided to place this monument as a memorial to the church, said to be his favorite battlefield site. Although the church has since been rebuilt, the marker remains as Reilly's memorial for future generations. Erected in 1927, the marker is surrounded by authentic artillery shells from O'Reilly's collection. Visitors are asked to be respectful of the fact that it now sits on private property.

point that he became a tour guide at the age of fifteen and earned his living escorting visitors around the battlefield. Reilly is believed to have been the first tour guide at Antietam. He marketed his services with a calling card that stated he had personally explored the field with many high-ranking officers from both armies. Eventually, he opened a small museum stocked with artifacts he had collected as he wandered the battlefield. Of course, he also had a gift shop that sold many of those relics.

VISITOR CENTER /
MUMMA FARM

Area D Visitor Center/Mumma Farm

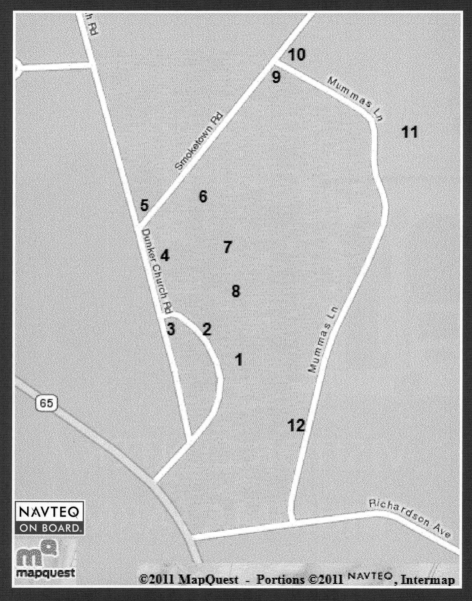

This area of the battlefield has no specifically designated name, yet fighting here was no less fierce. The Union's First Corps crossed the property as it advanced toward the Dunker Church. Major General D. H. Hill, fearing the Mumma Farm's buildings could be used by Union sharpshooters, ordered they be burned. When Confederate forces set fire to the buildings, horses from Battery A, First Rhode Island Artillery, panicked and became trapped in the burning timbers. Six were killed and four badly injured. Three sets of harnesses were lost.

Union forces fell at the rate of 13 per minute, or one every four to five seconds, for a forty-minute period near the Dunker Church. The Thirtieth Virginia Infantry lost 160 of its 236 men on the small ridge just east of the church. General John Sedgwick of the Union forces was wounded twice just north of the Mumma Farm.

D-1: Visitor Center
39° 28.445' N, 77° 44.678' W

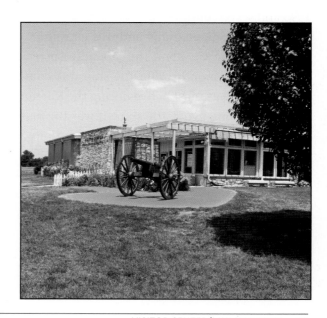

The structure housing the park's visitor center was built in 1962, at the height of the Cold War. Indeed, a unique feature was the solid-concrete fallout shelter in the basement. The building now houses a theater, a small museum, a bookstore, and a large room on the second level that provides a panoramic view of the morning and midday portions of the battlefield. Ranger talks originate here in the summer.

The ground on which the visitor center is located was hotly contested. The center sits at the

point from which Colonel Stephen Lee's Confederate artillery battalion poured a murderous fire onto the Union soldiers in the Cornfield. Lee's position, however, also left him open to heavy return fire from Union artillery. The ensuing carnage led Lee to make his famous declaration that his position was "artillery hell."

D-2: Ship's Bell
39° 28.453' N, 77° 44.718' W

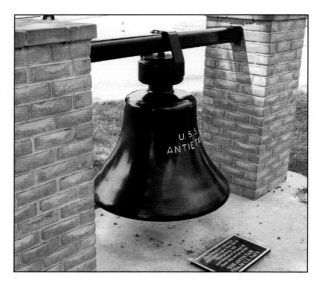

This ship's bell, located just outside the visitor center, is from the USS *Antietam* (CV-36), an aircraft carrier. The *Antietam*, one of several ships that have borne the name, was commissioned in 1945 and served until 1963. It had already passed through the Panama Canal and was en route to the western Pacific when the Japanese surrendered just two months after the ship was commissioned. It was most active during the Korean Conflict, earning two battle stars. It was the first angled-deck aircraft carrier built for the United States Navy.

The *Antietam* achieved peacetime fame in 1961, when its deck was used as the launching pad for the stratospheric balloon flight piloted by Commander Malcolm Ross and Lieutenant Commander Victor Prather of the United States Navy. The two reached an altitude of 113,740 feet, a record for manned balloons that still stands.

During the recovery operation, Prather fell from the helicopter's rescue harness, receiving injuries that led to his death on board the *Antietam*.

As more modern ships were built, the *Antietam* was no longer needed. It was placed in the reserve fleet and then decommissioned. Sadly, it was sold for scrap in 1974. This bell is all that remains.

A newer ship carries the name today. A guided missile cruiser, that *Antietam* (CG-54) was commissioned in 1984. Its home port is San Diego.

D-3: Third Maryland Infantry (US) Monument

39° 28.455' N, 77° 44.760' W

Advancing from the East Woods, the Third Maryland Infantry passed across the Mumma Farm. It continued until reaching a small ridge near the monument's current location. The men remained there until about ten-thirty, helping repel several Confederate assaults on the position. They then moved into the West Woods near the Dunker Church. Again, they were called on to assist in defending against several assaults. They remained in that location until about noon, when they returned to the East Woods.

The regiment had four killed and twenty-five wounded at Antietam.

The monument was dedicated on May 30, 1900.

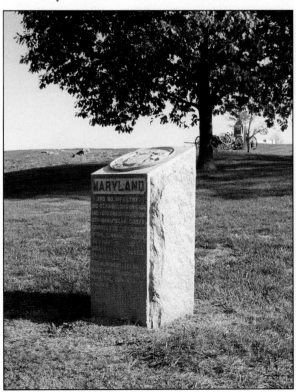

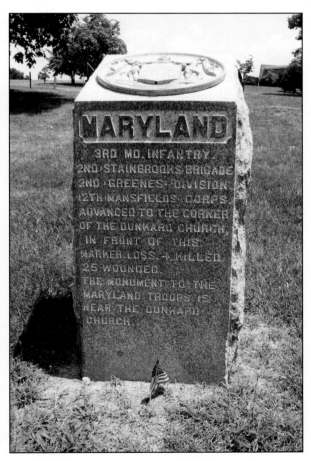

D-4: Fifth, Seventh, and Sixty-sixth Ohio Infantries Monument

39° 28.520' N, 77° 44.783' W

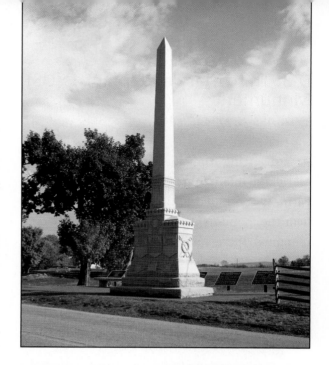

These three regiments had been hit so hard in previous fighting that they could muster only 415 men among them, or about 50 percent of a typical single regiment. At Antietam, they confronted the Confederate army in the vicinity of the Dunker Church. The Fifth Infantry was commanded by Major John Collins, the Seventh Infantry by Lieutenant Colonel Eugene Powell, and the Sixty-sixth Infantry by Major Orrin J. Crane.

The three regiments entered the fight at about seven-thirty in the morning, pushing the Confederates out of the woods behind the Dunker Church. They remained in action for five hours, until about one-thirty in the afternoon. Their combined losses were 17 men killed, four officers and 87 men wounded, and two men declared missing, for a total of 110 casualties.

Having fought together, the three regiments chose to jointly erect a monument on the field. The tall obelisk sits on a pedestal. The base contains three shields, one for each of the regiments. Below the shields, two crossed muskets rest behind a knapsack and bedroll. The monument was dedicated on October 13, 1903.

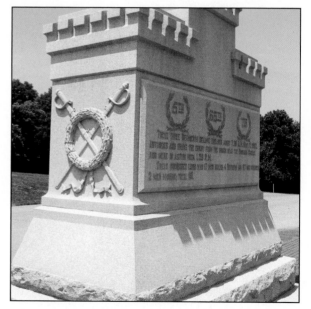

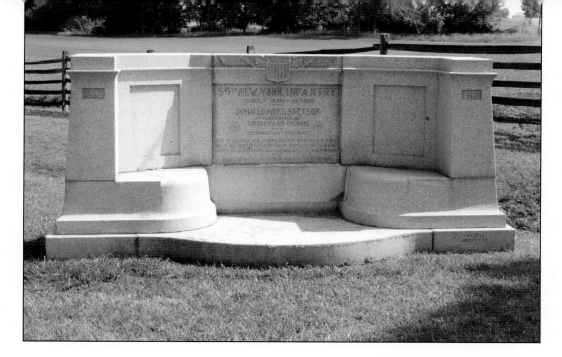

D-5: Fifty-ninth New York Infantry Monument

39° 28.557' N, 77° 44.796' W

The Fifty-ninth New York was formed by consolidating several independently recruited organizations.

This monument, dedicated in 1920, is often referred to erroneously as the Lieutenant Colonel John Stetson Monument because Stetson's name is prominently displayed on the center panel. The actual monument to Stetson is located on the Sharpsburg Road (Route 65). Stetson's brother, Francis Lynde Stetson, purchased the land where this marker sits as a memorial to his fallen brother.

Out of 300 men and 21 officers who went into battle nearby, 66 were killed or mortally wounded, another 135 were wounded, and 23 were missing. Nine of the officers became casualties.

Antietam marked the first severe action for the Fifty-ninth. The regiment, also known as the Union Guards, took part in Major General John Sedgwick's advance into the West Woods, where it was hit hard by General Jubal Early's Confederate brigade. In the confusion, some members of the regiment were said to have mistakenly fired into the rear of the Fifteenth Massachusetts, positioned just ahead of them.

D-6: Maryland State Monument

39° 28.552′ N, 77° 44.773′ W

This monument is unique among all those on the battlefield in that it honors soldiers on both sides. The statement on the monument indicates that the memorial is intended to be neutral: "Erected by the State of Maryland to her Sons, Who on this field offered their lives in maintenance of their Principles." Eight regiments from Maryland—six Union and two Confederate—participated in the battle. Thus, the monument has eight sides.

The Latin inscription at each corner is the state motto: "*Fatti Maschi, Parole Femine*," or "Manly Deeds, Womanly Words." A bronze female figure holding a sword and wreath stands atop the dome.

The four bas-reliefs surrounding the monument represent four scenes from the battle, in which Maryland troops played a significant role. The first shows the Second Maryland Infantry (US) at the Burnside Bridge. The second depicts the Confederate army's Brockenbrough's Battery (also known as the Baltimore Light Artillery, or the Baltimore Battery) in the West Woods. The third commemorates the Fifth Maryland (US)

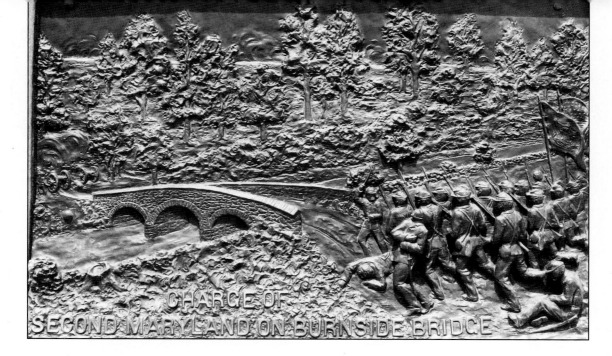

crossing the Roulette Farm en route to the Sunken Road. The Union's Battery A, First Maryland Light Artillery (also known as Walcott's Battery), is honored on the fourth tablet for defending its position near the Cornfield.

All eight Maryland units that fought at Antietam are honored on plaques inside the monument. In addition to those already mentioned, the Union's Battery B, First Maryland Light Artillery (Snow's Battery), the Purnell Legion (US), the Confederacy's First Maryland Battery (Dement's Battery), and the Third Maryland (US) are recognized.

The monument was dedicated on May 30, 1900, before a crowd of twenty thousand, including many veterans of both sides. President William McKinley, another Antietam veteran, gave the keynote address. The memorial was rededicated on July 1, 1989. It was also rededicated on June 3, 2006, after extensive repairs. The original iron framework beneath the copper-paneled dome had corroded so badly because of moisture that it was replaced with a stainless-steel frame. The original copper panels were then reinstalled.

D-7: New York State Monument
39° 28.502' N, 77° 44.698' W

New York furnished more troops at Antietam than any other state, its twenty-seven thousand men representing sixty-seven infantry regiments,

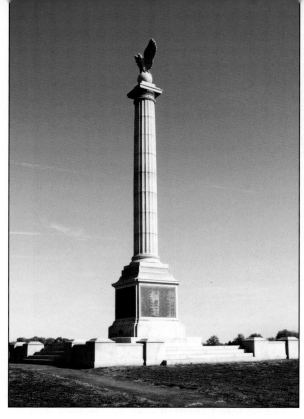

five cavalry regiments, fourteen artillery batteries, and two regiments of engineers. All these troops are honored by this state monument which, at fifty-eight feet in height, is one of the tallest on the field.

New York's losses at Antietam were 65 officers and 624 enlisted men killed or mortally wounded, 110 officers and 2,687 enlisted men wounded, and two officers and 277 men captured or missing, for a total of 3,765 casualties. A tablet on the side of the monument lists the general officers from New York who were in command at Antietam.

The monument is a column that is classified as Roman Doric in design, topped by an eagle with outstretched wings, symbolizing the United States. The plans were prepared by architect Edward P. Casey and the construction done by the John Swenson Granite Company of Concord, New Hampshire. The models for the bronze tablets and the eagle were supplied by architectural sculptors Rizzi and Zarri of New York. Casting of the tablets was done by the Henry-Bonnard Bronze Company of Mount Vernon, New York.

The monument was dedicated on September 17, 1920, with more than 250 veterans present. The main speaker was Lieutenant General Nelson Miles, who had taken command of the

Sixty-first and Sixty-fourth New York when their commander was wounded. Miles was later awarded the Medal of Honor for his gallantry at Chancellorsville.

Interestingly, the monument's cost of $30,000 was more than twenty times that of the land on which it was built. The state of New York had paid $1,420 in 1907 for the 7.1 acres surrounding the monument, at a cost of $200 an acre.

The monument was rededicated on September 1, 1962.

D-8: Monument to Twentieth Regiment, New York Volunteer Infantry

39° 28.476' N, 77° 44.689' W

Also known as the Turner Rifles, the Twentieth Regiment was made up mostly of German immigrants, having been organized by the New York Turn Verein, a German physical fitness organization. The Turn Verein, or Turners, encouraged members to develop a sense of patriotism. The Twentieth was one of several German regiments formed during the war to support the immigrants' new homeland.

Twenty-six survivors of the battle attended the dedication of this marker. The monument contains the symbols of the Turner movement: an owl (representing wisdom), a wreath (repre-

senting glory), a sword (signifying military prowess), and a torch (symbolizing learning). The monument is topped by a draped flag, signifying memorialization. The total height of the monument is slightly over eighteen feet. A bronze relief depicts the regiment in action.

The monument sits where the regiment held a line in the early afternoon on the day of the battle. Ordered to attack Confederate skirmishers near the Dunker Church, the regiment was forced back under heavy fire. Its new position,

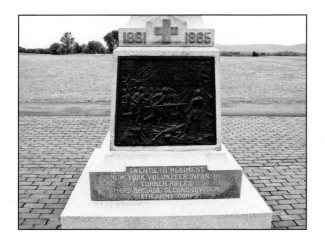

D-9: Hexamer's New Jersey Battery Monument
39° 28.710' N, 77° 44.627' W

This is one of two monuments to Hexamer's New Jersey Battery, the other being at the tower at the Sunken Road.

Commanded by Captain William Hexamer, the battery was positioned about sixty yards south of the site of the monument, where in midafternoon it engaged in a duel with the Con-

which it held until the next morning, is marked by this monument.

During the fighting around the Mumma Farm, the colonel of the Twentieth, Swedish-born Ernest Mathias Peter von Vegesack, is said to have spent much of his time forcing members of his regiment back into the fighting after they had failed to participate. Von Vegesack was later awarded the Medal of Honor for his actions at Gaines' Mill some three months earlier, where he "successfully and advantageously charged the position of troops under fire."

The regiment's casualties at the Battle of Antietam included thirty-eight killed, ninety-six wounded, and eleven missing.

The marker was dedicated in 1910. The Twentieth Regiment also has a monument in the national cemetery.

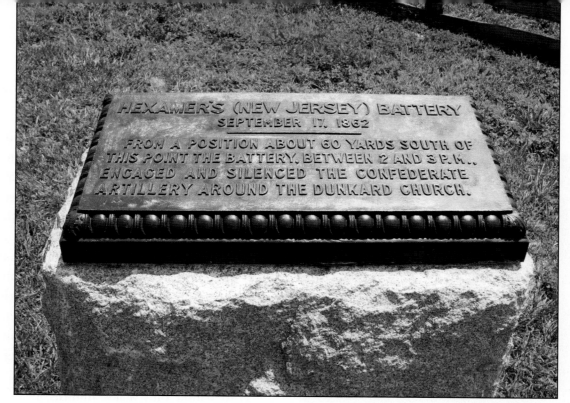

federate artillery located in the vicinity of the Dunker Church.

The monument was dedicated on September 17, 1903, and rededicated on September 9, 1962.

D-10: Monument to Battery A, First Maryland Light Artillery (US)
39° 28.716′ N, 77° 44.623′ W

The First Maryland Light Artillery, including Battery A, was organized in August 1861 and served a three-year enlistment. At the end of that time, most of the men reenlisted and were rec-

ognized as members of a veteran regiment. They continued to serve until they were mustered out in March 1865. In addition to their service at Antietam, the men also fought in the Seven Days Battles, as well as at Deep Bottom, Second Bull Run, Crampton's Pass, Fredericksburg, Marye's Heights, Salem Heights, and Gettysburg.

Known also as Wolcott's Battery, after its commanding officer, Captain John W. Wolcott, the battery relieved the Second United States Artillery, Battery D, at Antietam and took a position along a line about a hundred feet behind this marker. Expecting further attacks by the Rebel army, the battery's eight guns faced the Dunker

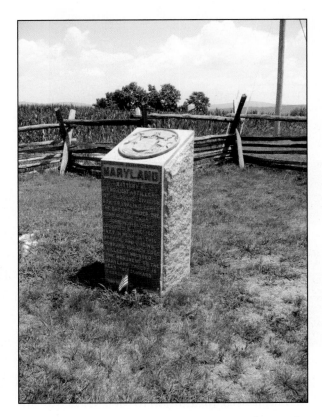

D-11: Mumma Farm
39° 28.617′ N, 77° 44.488′ W

The farm shown on page 83 was owned by Samuel and Elizabeth Mumma at the time of the battle. The family members were not at the farm during the fighting, however, having fled to safety. They would return home after the battle to find their property destroyed.

Confederate troops, fearing Union sharpshooters could use the farm buildings as vantage points, burned every building except the springhouse, which still stands. All the other buildings on the farm have been reconstructed. The burning of the Mumma Farm was the only deliberate destruction of civilian property in the battle.

With winter only a few months away, the family—Samuel, Elizabeth, and their ten children—moved to the Sherrick Farm near what is now known as the Burnside Bridge. They began rebuilding the following summer. Learning that the Federal government was compensating citizens for losses and battle damage caused by Union soldiers, the Mummas filed a claim. Their damages included ten thousand dollars in property destruction, as well as the loss of tons of hay, wheat, rye, and corn. The claim was turned down because the damage was done by the Confederate army, however, and the Mummas never received any compensation.

Several years after the battle, Sergeant Major

Church. Those guns sat approximately in the middle of the field.

The battery lost one killed, eleven wounded, and two missing at Antietam. Its actions are recognized on one of the plaques on the Maryland State Monument.

This monument was dedicated on May 30, 1900.

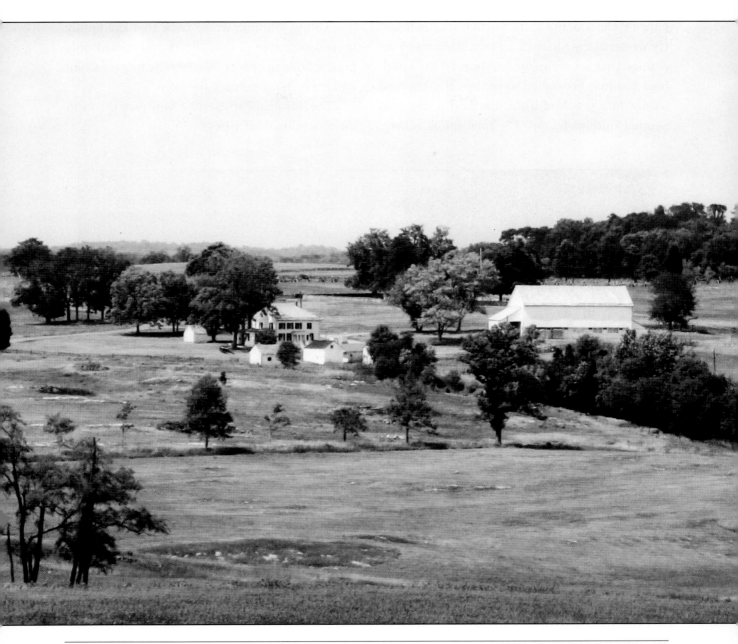

James F. Clark of the Third North Carolina Infantry wrote to the Sharpsburg postmaster and explained that his regiment had burned the buildings and that he wished to contact the Mumma family. In a touch of irony, the postmaster was Samuel Mumma Jr., son of Samuel and Elizabeth.

The young Mumma wrote back that the family indeed understood that the regiment had only been following orders. In effect, he forgave Clark and his men for burning the farm.

The National Park Service now uses the farm for educational activities.

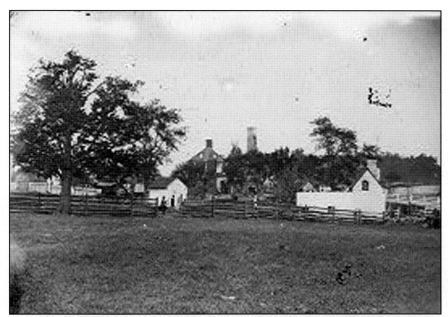

Mumma Farm ruins
Library of Congress, Prints &
Photographs Division, Reproduc-
tion Number LC-DIG-cwpb-00245
DLC (digital file from original
negative)

*Period drawing of Mumma
Farm burning*
Library of Congress, Prints
& Photographs Division, Re-
production Number LC-DIG-
ppmsca-21452 (digital file from
original drawing)

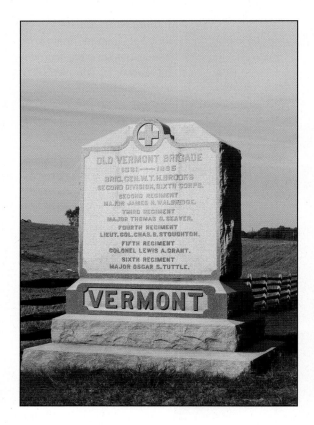

D-12: Old Vermont Brigade Monument

39° 28.362' N, 77° 44.587' W

The Old Vermont Brigade was made up of the Second, Third, Fourth, Fifth, and Sixth Vermont infantries. It was also known as the Brooks Brigade, after commanding officer William Thomas Harbaugh Brooks.

When it arrived on the field around noon, the brigade formed in the Mumma family's cornfield in support of Brigadier General William H. French's division. It occupied ground formerly held by the Fourteenth Connecticut. The men spent the afternoon of September 17, 1862, defending this section of the field. Their monument sits approximately where their right flank was anchored during the battle. Surprisingly, the brigade was not heavily engaged and suffered only minor casualties.

The brigade had been more heavily involved just three days earlier, at Crampton's Pass. There, First Lieutenant George Hooker of the Fourth Vermont rode ahead of his regiment and into Confederate lines. Before the rest of the regiment arrived, Hooker single-handedly received the surrender of an entire Southern regiment, including a major, 116 men, and the regiment's colors. On September 17, 1891, Hooker received the Medal of Honor for that feat.

The Old Vermont Brigade dedicated its monument in 1900.

Chapter 5
Area E

SUNKEN ROAD

(BLOODY LANE)

Area E Sunken Road (Bloody Lane)

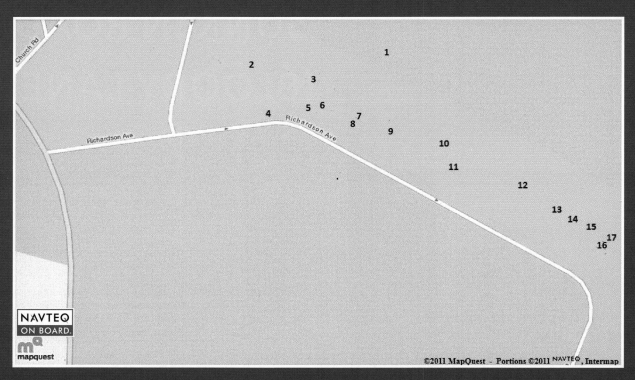

*T*his small farm road connected the Hagerstown Pike with the Boonsboro Pike. It was used primarily by local farmers in moving their grain to a gristmill along Antietam Creek. On September 17, 1862, this unobtrusive lane became part of history.

Over the years, the many trips from farm to mill, combined with natural erosion, had worn the road down until its surface was several feet below the original level, creating steep embankments on both sides. This topographical condition offered a strong defensive position for anyone who chose to position himself there. On that fateful day, it was the Confederate army under General D. H. Hill that held the road.

From about nine-thirty in the morning until about one in the afternoon, some three thousand Confederates faced a force that grew to become three times as large. The first five thousand Union soldiers, mostly green troops from the First Delaware, the Fifth Maryland, and the Fourth New York, crested the small ridge immediately in front of the Confederate position, coming from the direction of the Roulette Farm. The Rebels held their fire until they could not miss. The opening volley tore huge chunks out of the Union line, and the fight was on.

Within an hour, the Union moved another four thousand troops into the area, led by the Irish Brigade. Confederate troops were brought in as reinforcements but were unsuccessful in their efforts to strengthen the line.

By one o'clock, the Union broke through the entrenched Confederate line, bringing to an end the fighting on that portion of the field. The Sunken Road now had a new name: Bloody Lane.

The lane had been the scene of a slaughter. Nearly three thousand Union troops became casualties in the attack. Twenty-five hundred Confederates met the same fate. Southern troops lay five deep in places, according to witnesses. Many of the Southern casualties fell as they attempted to retreat over open fields with little or no cover.

When men from the 130th Pennsylvania began burying the dead the next morning, they found one brave Confederate soldier who had been hit with

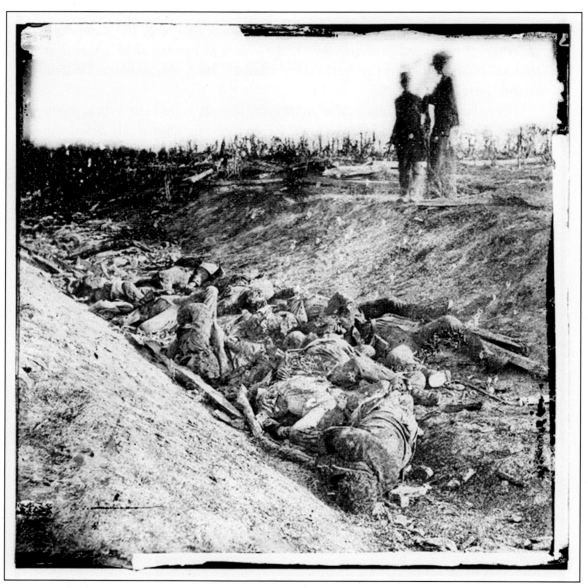

Sunken Road after the battle
Library of Congress, Prints & Photographs Division, Reproduction Number LC-DIG-cwpb-01087

seventeen bullets. Two generals, George B. Anderson from the Confederate side and Israel Richardson of the Union, would die from wounds suffered in the fight. Colonel John B. Gordon of the Sixth Alabama was wounded five times. The last wound caused him to fall with his face pressed into his hat, which rapidly filled with blood. Fortunately for Gordon, a hole had been shot through the hat, allowing it to drain and saving him from drowning in his own blood. Gordon not only survived but went on to become governor of Georgia, a three-term United States senator, and one of the organizers of the United Confederate Veterans.

Seven of the ten regiments in the Union's Third Division, Second Corps, under Brigadier General William H. French, had never been in combat prior to Antietam. Their inexperience was costly, as they suffered heavy casualties.

Sadly, the suffering was for naught. Neither side gained much of an advantage. The Union army returned to the Roulette Farm, while the Confederates pulled back to the Piper Farm, neither side having anything to show for more than three hours of fighting.

E-1: Roulette Farm
39° 28.362' N, 77° 44.587' W

Owned by William and Margaret Roulette, the farm had enjoyed a good year. The family had already brought in large quantities of fruits from the orchard and corn from the fields. Hogs and sheep had either been butchered or soon would be, providing a generous supply of meat that would last the winter.

However, by the time the battle was over, none of this remained. Troops from both sides consumed much of the foodstuffs, and the livestock

that remained was killed or ran away. Fences were destroyed, and many personal belongings disappeared from the house. The barn was used as a hospital. Some seven hundred bodies were buried in the fields immediately surrounding the house and barn. The house itself also sustained significant damage.

Troops from the 130th Pennsylvania reported that the barn floor contained piles of amputated limbs. In the stables and outbuildings were hundreds of wounded and dying men. The fields contained piles of gathered-up muskets.

William Roulette had returned to the farm to check on his livestock when the battle began. Caught between the lines of the two armies, he sought refuge in his cellar. Several Confederate soldiers were taken captive in the springhouse.

As the Federal troops pushed toward the Sunken Road, Roulette is said to have rushed from his hiding place and exhorted the Union troops to take anything they wanted, as long as they drove the Rebels back.

Once he saw the damages, though, he had a change of heart. William Roulette filed a series of claims to the Federal government requesting a total of $3,500 in damages. More than twenty years later, he received his reimbursement: $371. Unable to prove the damages had been done by Union soldiers, Roulette is not known to have ever received any additional reimbursement.

A month after the battle, the Roulettes' woes reached their zenith when their youngest child, twenty-month-old Carrie, died of typhoid fever.

E-2: Fourteenth Connecticut Infantry Monument
39° 28.346' N, 77° 44.510' W

Another of the many new regiments that fought at Antietam, the Fourteenth Connecticut had been in service less than a month. The regiment got its baptism by fire quickly, fighting furiously on both the Roulette Farm and the Sunken Road. At nine-thirty that morning, its men mounted a charge that brought them to the approximate location of where their monument now stands. They were pushed back quickly to a fence line about eighty-five yards to the rear, where they held for nearly two hours. They then moved to the Roulette Lane, where they remained for two more hours. When fighting in that area quieted down, the regiment moved to support Brooke's Brigade on the left of the division. Late in the afternoon, it moved to a small rise overlooking the Bloody Lane, where it remained until being relieved the next morning.

In the confusion at the Bloody Lane, the inexperienced men of the Fourteenth Connecticut fired into the backs of the men of the First Delaware, the regiment in their immediate front. Many of the First Delaware's casualties came from this action.

The monument is located at about the point where Companies B and G formed their lines on the left of the regiment. Constructed by the

Smith Granite Company of Westerly, Rhode Island, it was dedicated on October 8, 1894.

The Fourteenth, commanded at Antietam by Lieutenant Colonel Sanford Perkins, suffered 38 killed or mortally wounded, another 88 wounded, and 21 missing. Some soldiers were believed to have been killed by friendly fire. Over the course of the war, the regiment suffered more casualties than any other from Connecticut, losing 202 killed or mortally wounded and another 166

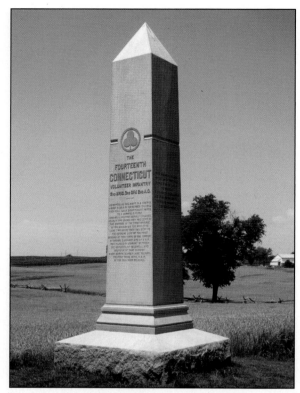

brigade in the attack on the Sunken Road.

Three disks, created by J. Page and Son of Philadelphia, are attached to the sides of the marker: the seal of the state of Maryland, an encampment scene showing stacked rifles, and a depiction of a soldier firing his weapon. A fourth disk was on the monument originally but has been missing since the 1980s, presumably removed by vandals. A line on the monument reads, "Can their glory ever fade!"

Designed by Charles A. Foster of Company

dead of disease. It also had 549 wounded and 319 discharged for disability.

E-3: Monument to Fifth Maryland Veteran Volunteer Infantry (US), Companies A and I
39° 28.326′ N, 77° 44.440′ W

The survivors of the two companies chose to honor their fallen comrades with this monument, which marks the farthest advance of the

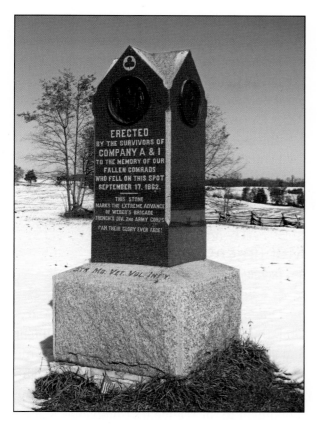

state. The state did compensate the veterans in the amount of $530 to help defray the cost of the monument, which was $940. It was rededicated on September 14, 1962.

The regiment suffered many casualties in the fighting for the Bloody Lane. Among the severely wounded was its commanding officer, Major Leopold Blumenberg.

The monument to the entire regiment sits closer to the lane (see photo on page 97).

E-4: First Delaware Infantry Monument
39° 28.280' N, 77° 44.492' W

As with many regiments on the field on September, 17, 1862, this was the initial battle for the men of the First Delaware. In the parlance of the day, they had never before "seen the elephant."

They crossed Antietam Creek early in the morning and advanced across the Roulette Farm, where they encountered heavy skirmishing. They quickly came under heavy fire in front of the Bloody Lane, causing them to withdraw to a stronger position approximately a hundred yards north of where their monument stands. In the fierce fighting, the entire color guard was either killed or wounded, as were eight of the 10 company commanders. Nearly a third of the regiment's number fell in the first Confederate volley.

A, the monument was erected on September 17, 1890, the twenty-eighth anniversary of the battle. Herbert Ford, son of Captain Samuel Ford, commander of Company A, removed the flag that covered the monument. The two companies were represented by eighteen survivors. Other veterans from Maryland raised the total to sixty-five. This was the first monument to Maryland troops placed on the battlefield and is the only Maryland monument not placed by the

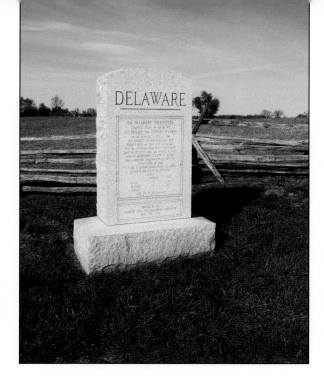

all for actions at Gettysburg. Lieutenant James P. Postles of Company A received his for volunteering to deliver an order under heavy fire, while Private John B. Mayberry of Company F and Corporal Bernard McCarren of Company C received theirs for capturing an enemy flag.

The monument was erected by the Delaware Civil War Centennial Commission and dedicated on May 26, 1962.

E-5: Fifth Maryland Infantry (US) Monument
39° 28.288' N, 77° 44.455' W

One of two monuments to the Fifth Maryland, this memorial honors the entire regiment and sits about three hundred feet closer to the Bloody Lane than where the men actually fought. Its true position was closer to the knoll where the monument to the regiment's Companies A and I is located.

The regiment lost 43 men killed and 123 wounded at Antietam in heavy fighting in and around the Sunken Lane. Its commanding officer, Major Leopold Blumenberg, was seriously wounded. He was replaced by either Captain W. W. Bamberger of Company B or Captain Ernest F. M. Faehtz of Company L, both of whom are mentioned in various sources.

The regiment would suffer heavy losses again

All told, 31 were killed at Antietam, another 182 were wounded, and 17 were declared missing, for a total of 230 casualties out of the 650 troops engaged. Many of the casualties were inflicted by friendly fire from the Fourteenth Connecticut.

Second Lieutenant Charles B. Tanner of Company H was awarded the Medal of Honor for his actions at Antietam. With the entire color guard either killed or wounded, Lieutenant Tanner rescued the regimental colors, despite being wounded three times in the attempt. The colors had fallen within twenty yards of the Confederate line.

Before the war was over, the regiment could boast three additional Medal of Honor recipients,

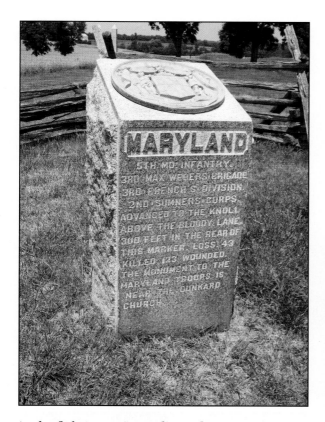

Antietam Creek and charged across the Roulette Farm, capturing about 20 prisoners who had hidden in the springhouse. The men then passed between the house and the barn into the orchard, driving the Confederates back toward the Sunken Road. When they got within a hundred yards of the road, they stopped and held their position the rest of the day, withdrawing only to replenish ammunition. They lost 32 killed, 14 mortally wounded, and 132 with nonfatal wounds.

Their monument sits at the right of the

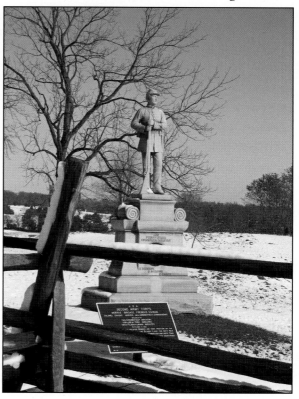

in the fighting at Second Winchester.

The monument was dedicated on May 30, 1900.

E-6: 130th Pennsylvania Volunteer Infantry Monument
39° 28.288' N, 77° 44.438' W

On the morning of September 17, 1862, the 130th Pennsylvania Volunteer Infantry forded

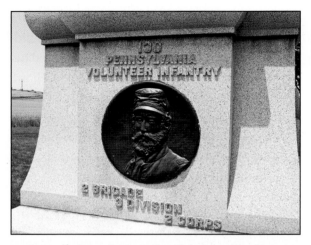

regiment's line during the fighting. The line extended to the Roulette Lane. Shown is a young soldier in the rest position, giving rise to the monument's title, recorded in various sources as *Rest* or *At Ease*. The front of the monument contains a portrait medallion of Colonel Henry Zinn, later killed at Fredericksburg as he carried the regimental colors. On either side of the capstone is a depiction of an army blanket, rolled and strapped.

Confederate troops referred to the men of the 130th Pennsylvania as "black devils" because their faces were covered in soot and their new uniforms appeared to be black. The uniforms actually were so new that their dark blue had not yet faded.

The regiment's men spent the days after the battle burying the dead. Regimental records indicate they buried more than three hundred

Confederate soldiers and a hundred Union men.

The monument was dedicated on September 17, 1904.

E-7: Fourteenth Indiana Infantry Monument
39° 28.271' N, 77° 44.381' W

Commanded by Colonel William Harrow, the Fourteenth Indiana arrived at the Sunken Road at nine o'clock in the morning and fought there for more than four hours. It suffered two officers and 28 enlisted men killed and another nine officers and 141 enlisted men wounded. Nineteen of the wounded eventually succumbed. The regiment's casualty rate was more than 56 percent. Every officer became a casualty. Sergeant Jesse Carroll was wounded five times.

Crossing the Roulette Farm en route to the

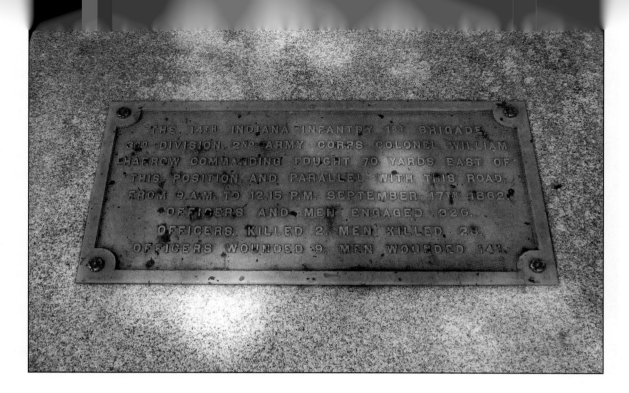

assault, each man carried sixty rounds of ammunition. As the fighting became more intense, the men found themselves scavenging ammunition from the dead and wounded to avoid running out. At about that same time, the Southern forces moved rapidly against the regiment's right flank. To counter this, the Fourteenth Indiana and the Eighth Ohio immediately moved to a position at a right angle to the original line and were able to repel the attack.

Colonel Harrow's official report of the fighting stated that as many as eight stands of Confederate flags could be seen in the regiment's immediate front at any one time.

The Fourteenth Indiana fought as part of General Nathan Kimball's brigade. The division commander, Brigadier General William H. French, dubbed it the Gibraltar Brigade for standing so strong in the fight. The brigade proudly carried that nickname for the remainder of the war.

The Fourteenth Indiana's monument was dedicated on Indiana Day, September 17, 1910. As with all the Indiana markers, it was designed by architect John R. Lowe and constructed and erected by the J. N. Forbes Granite Company of Chambersburg, Pennsylvania. It was rededicated on September 9, 1962.

E-8: Eighth Ohio Infantry Monument
39° 28.272' N, 77° 44.385' W

One of the first regiments to be fired on, the Eighth Ohio came under artillery fire the night before the actual battle as the men bivouacked near Keedysville. There, they lost their first man.

On the morning of the battle, they crossed the Roulette Farm and halted in the orchard after General W. H. French, the Third Division commander, expressed concern that the brigade's new troops might not stand up to the heavy fire. As they watched, Colonel Dwight Morris's Second Brigade broke under a heavy assault, returning at what some men of the Eighth Ohio described as a "Bull Run pace," in reference to the disorganized

retreat at that battle. The retreat was halted, and the Eighth Ohio and the rest of the First Brigade were ordered forward by the brigade commander, General Nathan Kimball.

As they advanced, the men came under murderous fire. As troops fell, their comrades closed ranks and continued. Two Confederate charges were repulsed. As more Confederate troops mounted a flank attack, the Eighth Ohio and several other regiments were forced to turn and face north as new threats developed. As man after man ran out of ammunition, it became necessary to scavenge from the dead and wounded. Finally, bolstered by the arrival of the Irish Brigade, the regiment and the rest of the brigade mounted a bayonet charge. Fortunately for the Ohioans, the Confederates were also low on ammunition. Federal troops took 300 prisoners at the Sunken Road and the Piper cornfield.

The regiment lost 32 men killed and 129 wounded. Another five were missing.

The monument, dedicated on October 13, 1903, states, "On this field Ohio's sons sacrificed life and health for one country and one flag."

E-9: Sunken Road
39° 28.259' N, 77° 44.360' W

About nine-thirty in the morning, the battle lines began moving south toward the small lane

known as the Sunken Road. The Mumma and Roulette farms saw more than five thousand Union forces under General William French cross their fields as they moved toward three thousand Confederates under General D. H. Hill, who held a strong defensive position hidden behind stacked-up fence rails at the road. The Confederates held their fire until the Federal soldiers crested the small ridge in front of the road, then released a ferocious barrage, removing large portions of the unsuspecting Union army before they were even aware the Southerners were there.

The action was brutal, each side firing at point-blank range into the other. An hour after the fighting began, General Israel Richardson arrived with four thousand Union reinforcements. Led by the Irish Brigade, the reinforcements were new in the truest sense of the word, 70 percent of them never having been in battle before. The Confederates countered by attempting to bring a similar number of reinforcements of their own. However, those troops, under General

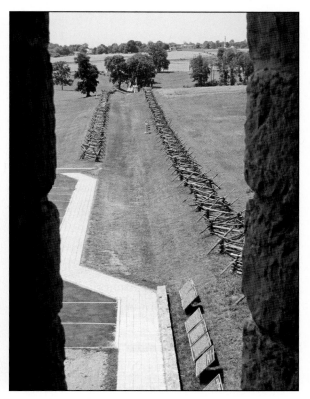

Richard Anderson, were pushed back.

After several hours, the larger contingent of Federal soldiers broke through the Confederate line, some of them reaching as far as the Piper Farm. By the time the fighting ended, more than five thousand soldiers had been killed or wounded. Both sides lost a general, George B. Anderson of the Confederate army and Israel Richardson of the Union falling mortally wounded.

Neither side had gained a decisive advantage. The Sunken Road now had a new name: Bloody Lane.

E-10: 132nd Pennsylvania Infantry Monument
39° 28.243' N, 77° 44.32' W

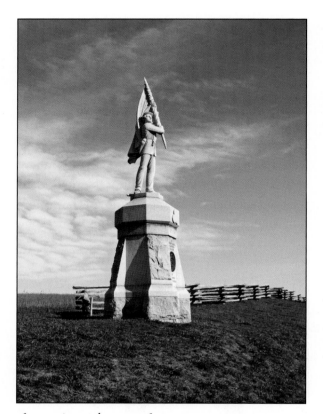

The commander of the month-old 132nd Pennsylvania, Colonel Richard A. Oakford, was mortally wounded shortly after the regiment arrived on the field. Thus demoralized, the regiment worked its way across the Roulette Farm on its way to the Sunken Road. Passing the farm's beehives, the men were met by a large swarm of honeybees disturbed by the fighting. Temporarily, they had to divide their attention between the bees and the artillery fire exploding all around them.

Dedicated on September 17, 1904, this regimental monument is highly unusual in what it depicts. Rather than their service at Antietam,

the regiment's men chose to commemorate an event that occurred during the fighting at Fredericksburg three months later. There, five men and two officers—Lieutenant Charles McDougal and Lieutenant Henry H. Hoagland—were killed while carrying the colors. The fighting became so intense that part of the flagstaff was shot away just as Adjutant Frederick L. Hitchcock grabbed it. Hitchcock was immediately shot through the head. The regiment was forced to retreat, leaving its colors on the field. After dark, Corporal Wil-

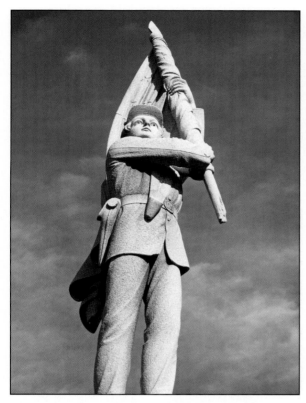

The broken shaft of the flag can be seen at the color bearer's feet.

liam I. D. Parks was seen crawling off the field. Although mortally wounded, he carried the colors. He died within a few minutes of returning the flag to the regiment. The statue reproduces the moment when the shaft was shot away. The broken shaft can be seen at the color bearer's feet.

The statue, sculpted by Stanley Edwards, is titled *The Color Bearer*. The shamrock commemorates the 132nd's position in the Second Corps. A medallion on the front of the monument honors Colonel Oakford, who was killed at the Sunk-

en Road. The medallion was a gift to the regiment from his son, Colonel James W. Oakford, who unveiled the statue at the dedication. He was assisted by Dr. R. W. Wilcox and Lewis B. Stillwell, son of Captain Richard Stillwell of Company K.

The regiment lost 30 killed, 114 wounded, and eight missing at Antietam.

E-11: Brigadier General George B. Anderson Monument
39° 28.224′ N, 77° 44.298′ W

A thirty-one-year-old North Carolina native, Anderson graduated from West Point in 1852, ranked tenth in a class of forty-three. He served in the regular army in the Second United States

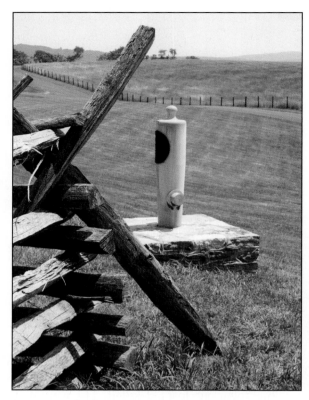

infected, and he died on October 16 in Raleigh, North Carolina, following surgery to amputate the injured limb. Anderson was thus one of six generals to die from the fighting at Antietam. The actual site of his wounding was about 225 yards south-southwest of his marker. He was buried in Oakwood Cemetery in Raleigh.

When Anderson received his wound, his place was taken by Colonel Charles C. Tew of the Second North Carolina Infantry. Tew was killed

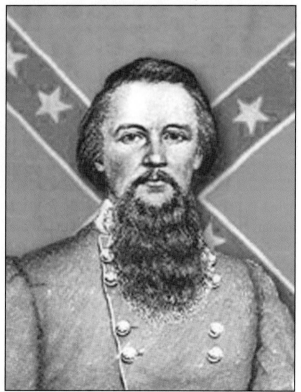

Photo courtesy of National Park Service

Dragoons before resigning his commission to fight for the Confederacy when the war broke out. He was immediately appointed colonel of the Fourth North Carolina Infantry by Governor John W. Ellis. Ten years after graduating from West Point, he found himself a brigadier general under General D. H. Hill. He suffered a hand wound while leading his troops at Malvern Hill.

At Antietam, Anderson was leading his men in the fighting in the Piper cornfield when he was wounded in the ankle. The wound became

shortly after taking command and was replaced by Colonel Risden T. Bennett of the Fourteenth North Carolina Infantry. Bennett was subsequently wounded.

E-12: Second Delaware Infantry Monument
39° 28.201' N, 77° 44.231' W

Nicknamed the "Crazy Delawares," this regiment actually included four companies from Maryland and Pennsylvania, which were added

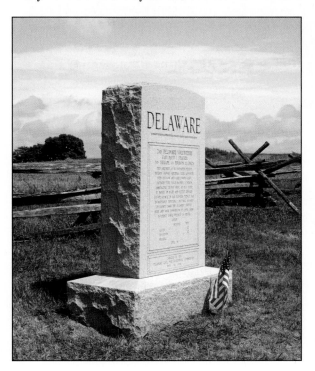

to quickly bring it up to full strength a few months after its formation in 1861. Its commanding officer at Antietam was Captain David L. Stricker.

The Second Delaware assisted in repelling a Confederate counterattack when a gap developed between the divisions of Generals William H. French and Israel B. Richardson. In the final assault on the Bloody Lane, the regiment and the rest of Richardson's division finally were able to break through the outmanned Confederates in this area around noon. The Second Delaware crossed the Bloody Lane in the general vicinity of its monument and took possession of the buildings on the Piper Farm until ordered to retire.

Losses for the Second Delaware included twelve men killed, two officers and forty-two enlisted men wounded, and two enlisted men missing.

The monument was dedicated on May 10, 1964.

E-13: Battle Overview Tablets
39° 28.173' N, 77° 44.172' W

This series of eight tablets describes the activities of the armies from September 14 through September 17, 1862.

Five of the tablets show the Union's Army of the Potomac. The first details McClellan's pursuit of the Confederate army from South Mountain on

SEPTEMBER 17, 1862.

THE BATTLE OPENED AT DAYLIGHT BETWEEN HOOKER'S CORPS AND THE CONFEDERATE DIVISIONS OF JACKSON AND EWELL AND RAGED IN THE EAST WOODS, IN MILLER'S CORNFIELD AND ON EITHER SIDE OF THE HAGERSTOWN PIKE ABOUT ONE THIRD OF A MILE NORTH OF THE DUNKARD CHURCH. EWELL'S DIVISION WAS RELIEVED BY HOOD'S, AND HOOKER'S CORPS BY MANSFIELD'S. HOOD WAS REENFORCED BY THE BRIGADES OF RIPLEY, COLQUITT AND GARLAND OF D.H.HILL'S DIVISION. AFTER A SANGUINARY CONTEST MANSFIELD'S CORPS FORCED THE ENTIRE CONFEDERATE LINE, NORTH OF THE BLOODY LANE, TO RETIRE WEST OF THE PIKE. SUMNER'S (SECOND) CORPS CROSSED THE ANTIETAM AT PRY'S FORD, ABOUT 8 A.M., SEDGWICK'S DIVISION ADVANCING TO AND THROUGH THE EAST WOODS, OVER MANSFIELD'S CORPS, ACROSS THE HAGERSTOWN PIKE TO THE WEST EDGE OF THE WEST WOODS, WHERE IT WAS CHECKED IN PART BY THE ARTILLERY AND INFANTRY OF JACKSON'S COMMAND, STRUCK ON THE LEFT BY THE DIVISONS OF McLAWS AND WALKER, AND DRIVEN NORTH AND EAST BEYOND D.R.MILLER'S. CONFEDERATE EFFORTS TO RECOVER GROUND EAST OF THE HAGERSTOWN PIKE WERE CHECKED BY HOOKERS, MANSFIELD'S AND SUMNER'S ARTILLERY. GREENE'S DIVISION OF MANSFIELD'S CORPS FOLLOWED THE CONFEDERATE REPULSE BY A CHARGE AND SEIZED THE WOODS WEST OF THE DUNKARD CHURCH, WHICH IT HELD UNTIL ABOUT NOON, WHEN IT WAS DISLODGED AND THE CONFEDERATES MADE ANOTHER EFFORT TO GAIN GROUND EAST, BUT WERE REPULSED BY THE FIRE OF THE UNION ARTILLERY AND THE ADVANCE OF FRANKLIN'S (SIXTH) CORPS, WHICH ARRIVED ON THE FIELD ABOUT NOON.

No. 120.

September 15. The second describes the Union army's movements prior to the battle, on September 16, while the next three discuss the various stages of the fighting on September 17.

The final three tablets discuss the activities of the Confederacy's Army of Northern Virginia. The first details its movements from September 14 through September 16, while the final two describe its participation in the action on September 17.

The grouping of eight tablets is part of a larger series called the Antietam Campaign War

Department Markers. While most of the 226 markers are in the Antietam/Sharpsburg area, a number have been placed at outlying areas such as Harpers Ferry, Crampton's Pass, and other significant sites that were part of the overall Antietam Campaign.

E-14: Major General Israel B. Richardson Monument
39° 28.166′ N, 77° 44.166′ W

Richardson was born in Vermont and graduated from West Point in 1841. A veteran of both the Seminole and Mexican wars, he resigned his commission in 1855 and moved to Michigan but returned to service in 1861 when Fort Sumter was fired on. Richardson would become known as one of the Union's best commanders at Antietam.

He served as a division commander in the Second Corps, fighting at the Sunken Road. Richardson moved his troops across the Roulette Farm to the area near where his marker stands. Expecting a Southern breakthrough, he had requested rifled guns. However, all that could be spared was one battery of smoothbores, which had limited range and accuracy. Still, he did what he could with the weapons at his disposal.

As he positioned Captain William Graham's artillery, Richardson was wounded in the leg by

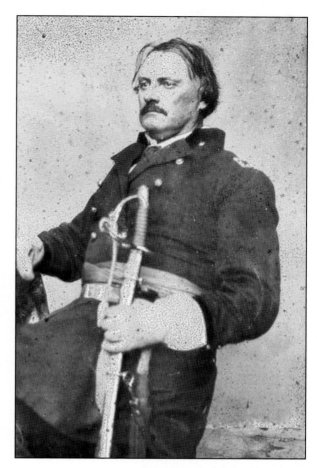

Library of Congress, Prints & Photographs Division, Reproduction Number LC-DIG-cwpb-07083 (digital file from original neg.)

case shot. Taken to the Pry House, he succumbed to his wounds on November 3, making him the third Union general to die as a result of the fighting at Antietam. Three Confederate generals were also killed.

sunset. From here, it engaged Confederate forces on the far side of the Piper Farm. Its fire kept the Confederates from moving to another position, although much of the fighting had subsided by then and no further large-scale assaults were undertaken.

In a three-hour period, the battery fired 280 shells, 200 shrapnel rounds, and 15 canisters,

Richardson was held in such high esteem that Abraham Lincoln himself made a point to visit the mortally wounded general at the Pry House on his October visit to the battlefield.

E-15: Hexamer's New Jersey Battery Monument
39° 28.167' N, 77° 44.168' W

Battery A was engaged at two different places at Antietam. This marker represents its second position, which actually sat about eighty yards north of the monument. It occupied this position from three-thirty in the afternoon until

forced two Confederate batteries out of their positions, and repelled an infantry force.

The monument was dedicated on September 17, 1903, and rededicated on September 9, 1962.

E-16: Monument to Irish Brigade
39° 28.164′ N, 77° 44.168′ W

The Irish Brigade originated in New York City when Colonel Michael Corcoran recruited soldiers for eventual service in the fight to liberate Ireland from the British. The brigade was commanded at Antietam by Thomas F. Meagher (pronounced Mahr), who had been found guilty of treason in Ireland for his part in an unsuccessful uprising to gain Irish independence. Originally sentenced to hang, Meagher was ultimately banished to Tasmania. After three years there, he

escaped and fled to the United States, where he ultimately fell in with the famed brigade.

The Irish Brigade was one of the best-known fighting units in the Union army. Initially made up of the Sixty-ninth, Eighty-eighth, and Sixty-third New York volunteers, the brigade later added the Twenty-ninth Massachusetts and 116th Pennsylvania volunteer infantries. The Twenty-eighth Massachusetts replaced the Twenty-ninth Massachusetts not long after Antietam. The

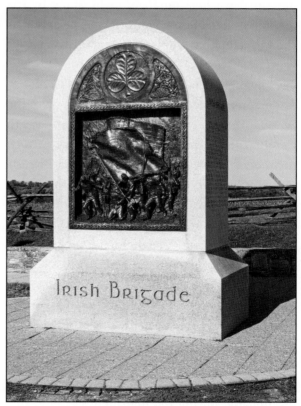

Twenty-ninth had been the only non-Irish regiment in the brigade and was never fully accepted by the Irish regiments.

As the brigade formed for its initial assault at the Sunken Road, its chaplain, Father William Corby, rode along the line giving absolution to the troops. Father Corby would be honored at Gettysburg with his own monument for doing the same at that battle. He eventually became president of the University of Notre Dame. An unnamed washerwoman brought along by the brigade gained her own notoriety at Antietam as she waved her hat while exhorting the troops onward by shouting, "Give 'em hell, boys!"

The men faced off against General George B. Anderson's Confederate brigade, made up of the Second, Fourth, Fourteenth, and Thirtieth North Carolina. Shouting its famed war cry, "*Faugh a Ballagh*," or "Clear the Way," the Irish Brigade mounted a bayonet charge, pushing the North Carolinians back and mortally wounding General Anderson before being repulsed. During the assault, General Meagher fell from his horse. Stunned, he had to give up command. Meagher claimed that his horse had been shot, but others said his fall was brought on by consumption of whiskey. It has never been proven either way.

With Meagher out of the fight, command of the brigade fell to Colonel John Burke of the Sixty-third New York. Burke mysteriously disappeared during the fight and was later discharged from service after a court-martial found him guilty of abandoning his troops under fire. Lieutenant Colonel Henry Fowler took command after Burke disappeared. When Fowler was wounded, Captain Joseph O'Neill became the commanding officer. O'Neill proved to be the only officer of the Sixty-third New York who was neither killed nor wounded in the assault.

The brigade suffered greatly at the Bloody Lane. The Sixty-third New York and the Sixty-ninth New York lost about 60 percent of their commands in just a few minutes. The Sixty-third had 16 color bearers shot down. Those killed at Antietam included four officers and 31 enlisted men from the Sixty-third New York, four officers and 40 men from the Sixty-ninth New York, two officers and 25 men from the Eighty-eighth New York, and seven enlisted men from the Twenty-ninth Massachusetts, for a total of 113. An additional 421 men and a staff officer were wounded from the four regiments. Another five men were missing, for a total of 540 casualties.

The brigade would lose more than 4,000 men over the course of the war. Three of its five commanding officers were killed or mortally wounded. Although none of the brigade would be awarded the Medal of Honor for actions at Antietam, it would see 11 of its number receive the award over the four years of the war.

Antietam proved to be Meagher's last battle. When attempts to disband the brigade were ini-

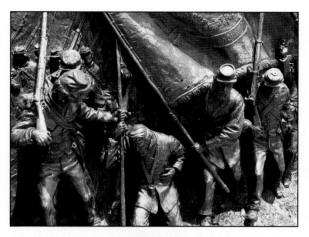

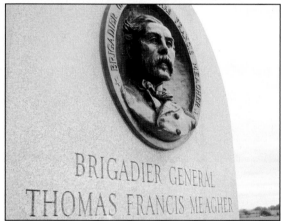

cemetery, where they were interred on September 17, 1989.

The Irish Brigade's monument was dedicated on October 25, 1997, about 135 years after the battle. It is likely to be the last monument erected at Antietam. A relief on the front features the brigade in battle, while one on the rear honors Meagher. The two sculptures were done by Ronald Tunison.

E-17: Observation Tower
39° 28.163' N, 77° 44.158' W

In 1896, the War Department placed cannons and informational tablets throughout the battlefield in an effort to better explain the action to visitors. Roads were also constructed to aid visitors in getting around the battlefield. At the same time, the observation tower was built to provide visitors a panoramic view of the area where much of the fighting took place. Originally, it had no roof. One worker died during the construction when he was struck by falling materials, knocking him off his scaffold and causing him to strike his head on the entrance steps.

At the base of the tower stands a marker identifying the areas to the north, south, east, and west. Four photos show the areas around the tower at various times since the battle. Most visitors eventually make their way to the tower and

tiated in May 1863, he resigned his position. The resignation was eventually cancelled, but Meagher never served in battle again. Two years after the war, he drowned in the Missouri River. His body was never recovered.

In 1988, the remains of four men from the Irish Brigade were found in the area where they fought. The remains were moved to the national

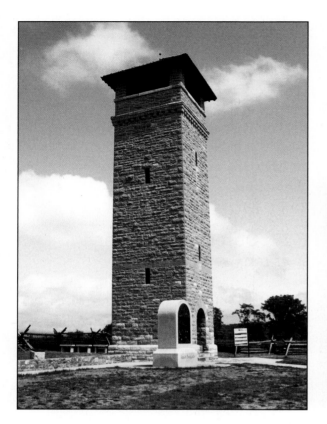

find it an excellent means of gaining a perspective of the field, getting views of the farms and landmarks, and achieving an appreciation for how the topography and terrain influenced the fighting.

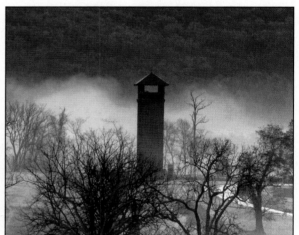

Chapter 6
Area F

IN TOWN/
BOONSBORO PIKE

Area F In Town/Boonsboro Pike

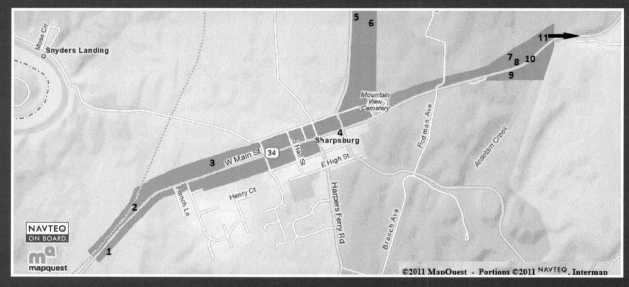

*W*hile the streets of Sharpsburg saw relatively little fighting in comparison to what most people think of as the battlefield, the town and the immediate area played a significant part in the Antietam story. Robert E. Lee set up his headquarters here. And on the eastern edge of town, McClellan did the same. Lincoln and McClellan had their famous post-battle meeting in Sharpsburg. The national cemetery was established here in 1867.

Hearing the artillery and musketry, families huddled in basements, not knowing who or what would face them when they left their places of shelter. Many of the farms and buildings in town served as field hospitals.

F-1: Lincoln-McClellan Meeting
39° 26.929' N, 77° 46.256' W

Citing shortages of equipment and fear of overextending his forces, General George B. McClellan refused to pursue Lee's Army of Northern Virginia after the battle, much to the chagrin and frustration of President Lincoln. Four days after Antietam, McClellan wrote that he had lost a huge number of men, including several generals and regimental officers; that his troops were scattered and exhausted; that no transportation was available to furnish supplies; that the army and its supply base were separated by the Potomac River; and that he needed time to refit regiments and appoint new officers. He ignored the fact that he had more than thirty thousand

fresh troops at his disposal. His reasoning did not impress Lincoln.

About two weeks after the battle, Lincoln arrived at Antietam to confer with McClellan and to try to motivate him to pursue Lee. While there, Lincoln visited wounded troops and toured the battlefield.

On October 1, the two conferred at McClellan's headquarters at the Pry House. Two days later, they met here at the Stephen Grove Farm to review the troops in the fields shown in the photo on page 116, after which they posed for Alexander Gardner's famous photograph, shown on page 117. They also posed for a photo at the headquarters tent of the Fifth Corps commander, General Fitz-John Porter, in the front yard of the Grove House shown on page 116. Again, Lincoln

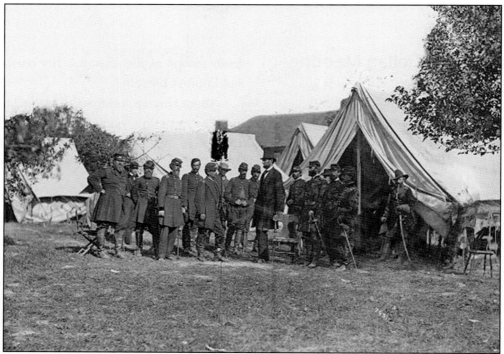

Lincoln meeting with McClellan and several officers at the Grove Farm
Library of Congress, Prints & Photographs Division, Reproduction Number LC-DIG-cwpb-04352

asked McClellan to initiate a pursuit of Lee, but McClellan argued that his men needed time to recover from the horrendous fighting and that his horses were broken down from fatigue. An exasperated Lincoln, perhaps recalling his earlier reference to the Army of the Potomac as "McClellan's Bodyguard," is said to have replied, "Pardon me for asking, but what have the horses of your army done since the Battle of Antietam that fatigue anything?"

In November, just one day after the congressional elections, Lincoln relieved McClellan of his command, effectively ending his military career. In 1864, McClellan ran against Lincoln for the presidency. Lincoln won in a landslide.

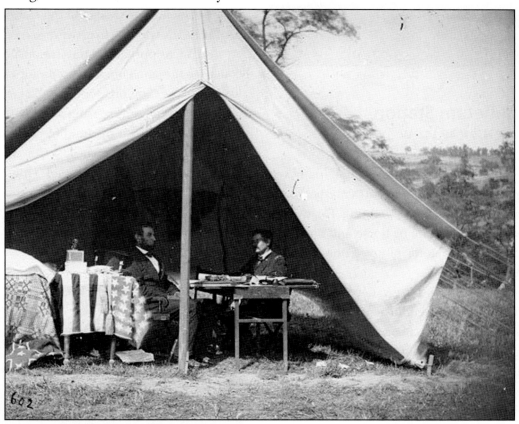

Lincoln and McClellan in McClellan's tent
Library of Congress, Prints & Photographs Division, Reproduction Number LC-DIG-cwpb-04351

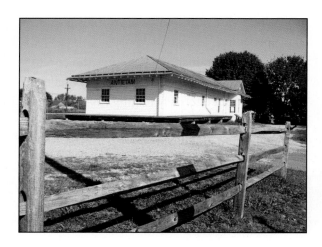

F-2: Antietam Station
39° 27.083' N, 77° 46.142' W

In the years following the battle, many veterans returned to Antietam, particularly around the anniversary date of the fighting. For twenty-one years, visitors came by horse and buggy, often to claim the remains of loved ones killed in the battle.

In 1883, the Sharpsburg Valley Railroad came to town. Now, visitors could arrive at the station, then walk the mile into Sharpsburg. Some of the Norway maple trees that still stand along the route were planted at that time to provide shade for the veterans and their families as they made the trek into Sharpsburg.

Antietam Station received its name after two railroad engineers somehow confused the name Sharpsburg with Shepherdstown, resulting in their two trains colliding.

The station in the photo is not the original, which was destroyed by fire in 1910. The original sat slightly west of this location. The rebuilt station closed in the 1950s. The structure has since been refurbished and rotated, as can be seen by the bay window in the front. The station originally sat facing the tracks, so the station master could use the window to observe arriving trains.

As trains approached the station, passengers could see the small monument beside the tracks. Known as the Cannon Monument, it consisted of eight field guns leaning against each other at the muzzle, topped by a pyramid of cannonballs as seen in the photo on page 119. The monument has long since been dismantled. Only the base remains as shown below.

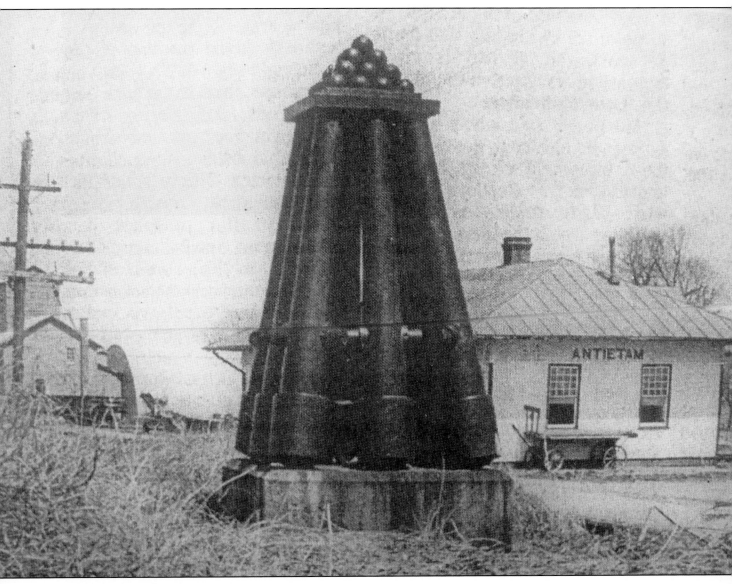

The Cannon Monument at Antietam Station
From National Park Service wayside marker

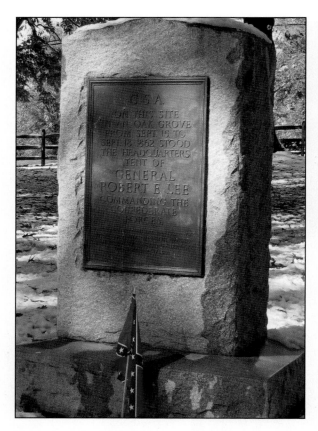

The monument, placed by the West Virginia Division of the United Daughters of the Confederacy, was unveiled on September 17, 1936. The parklike grounds were deeded to the federal government on July 4, 1942.

F-4: Slave Block
39° 27.530′ N, 77° 44.768′ W

Sitting on the southwest corner of the intersection of Routes 34 and 65, this small stone is often unnoticed by passersby. A stark reminder of a blot on our nation's history, it served as a slave auction block from 1800 to 1865. It sits at its original location and has been a local landmark for more than two hundred years.

The Battle of Antietam, while only a marginal victory for the North, provided President Abraham Lincoln the opportunity to issue his Eman-

F-3: Lee's Headquarters
39° 27.530′ N, 77° 44.770′ W

General Robert E. Lee, commander of the Army of Northern Virginia, established his headquarters in this small grove of oak trees for the four days immediately before, during, and after the fighting. From his tent, Lee planned strategy and issued the orders for the Confederate army throughout the battle.

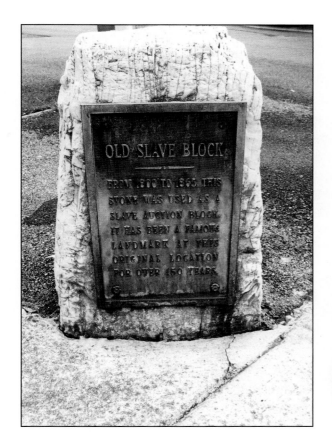

F-5: Sixth Virginia Infantry Monument
39° 28.075' N, 77° 44.705' W

When the Confederate line broke at the Sunken Road, its members pulled back to the relative safety of the Piper Farm. In the confusion, many Confederate batteries were abandoned as their gunners were either killed or simply chose to leave and find a safe haven.

Second Lieutenant W. W. Chamberlaine of the Sixth Virginia had gone for reinforcements when he was informed that General Richard Anderson, to whom he had planned to make his request, was wounded. Chamberlaine then joined other officers and men behind a stone wall to try

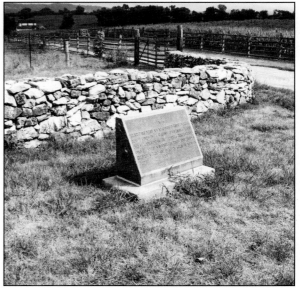

cipation Proclamation. As a border state that had not left the Union, Maryland was not included in the proclamation. However, the proclamation set the groundwork for the Thirteenth Amendment to the United States Constitution, which resulted in the end of slavery. The amendment ensured that never again would people be forced to stand on this or similar blocks to be auctioned off to the highest bidders.

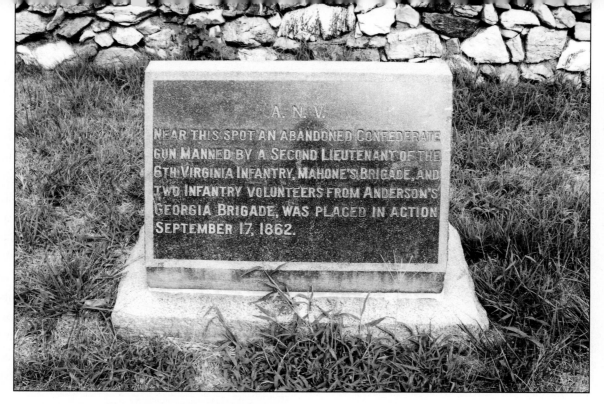

to stem the Union assault. Noticing an abandoned cannon, Chamberlaine recruited four infantrymen to help him pull it onto the Hagerstown Pike near the Piper Farm lane. For more than an hour, they fired volley after volley while more troops gathered around the gun. When the fighting subsided, Chamberlaine relinquished control of the gun to some nearby Georgia troops and left to rejoin his regiment.

Placed by Washington Camp No. 171 of the United Confederate Veterans, this monument honors Second Lieutenant Chamberlaine, after the war a lieutenant commander of the Sons of Confederate Veterans post in Washington, D.C. It marks the approximate location where Chamberlaine and his men manned the abandoned gun.

The marker was dedicated sometime prior to 1918. It was the first Confederate monument placed on the field, and the only one put there by Confederate veterans.

F-6: Piper Farm
39° 27.983′ N, 77° 44.615′ W

This farm, owned by Henry and Elizabeth Piper, was home to the Piper family, several

slaves, and a free black. Henry was known by the residents of Sharpsburg as "Old Stovepipe," for the tall hat he wore.

The center of the Confederate line stood in the area around the house. Generals James Longstreet and D. H. Hill established their headquarters there. After serving the Confederate officers dinner the night before the battle, the Pipers chose to leave the area, not knowing what to expect from the anticipated battle.

For several hours during the intense fighting, Hill's outnumbered troops stubbornly held off General Israel Richardson's Union advance across the Piper Farm, until they were eventually pushed back beyond the Piper cornfield. Later in the afternoon, Anderson's brigade stopped another advance.

During the fighting, many wounded Confederates found their way into the farmhouse, where they received rudimentary treatment. After the battle, three dead Confederate soldiers were found in the house, including one who succumbed while lying under a piano in the parlor, according to records held by the 130th Pennsylvania Infantry. The Pennsylvanians reported that every stitch of muslin, linen, and calico in the house appeared to have been used to treat the wounds of the Confederates.

The family had mixed emotions upon returning home. Dead soldiers lay throughout the property. Henry Piper reported only minimal destruction from the actual fighting but claimed more than two thousand dollars in damages during the days after the battle, when the farm was occupied by Federal forces. Piper blamed the Third and Fourth Pennsylvania cavalries and the Eighth New York Cavalry for the losses.

The barn, used as a hospital, is much larger today than it was at the time of the fighting. An addition was constructed in 1898.

F-7: Robert E. Lee Monument
39° 27.864' N, 77° 43.693' W

This monument depicting General Robert E. Lee has stirred controversy over its location and inscription. Placed here in June 2003 by a private citizen who owned the land, it was dedicated on June 24, 2005. A lawsuit asking for its removal

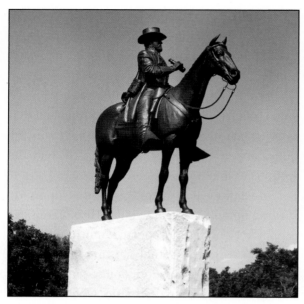

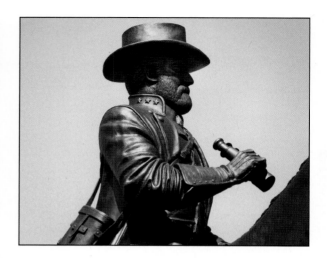

was subsequently filed. The controversy was finally resolved when the National Park Service purchased the land in 2008.

Both armies traveled across the nearby Middle Bridge and along the road that passes in front of Lee's statue. Lee himself was with the Army of Northern Virginia but rode in an ambulance, having injured his hands in a fall. In that respect, the present location of the monument is appropriate. The fact that it is in the midst of Federal lines, however, gave rise to the controversy. It is unlikely that the statue will be relocated now that the National Park Service has acquired ownership.

The controversy over the inscription arose from the statement that Lee was against slavery.

Many have argued that he, in fact, was not. They point out that Lee could have freed his wife's family's slaves when his father-in-law died but chose to hold them another five years, the maximum length of time his father-in-law's will stipulated they could be kept. This debate will likely never be settled to everyone's satisfaction. For now, at least, the inscription remains.

The monument is the work of Arkansas sculptor Ronald Moore.

F-8: Third Indiana Cavalry Monument
39° 27.850' N, 77° 43.682' W

When formed in August 1861, the Third Indiana Cavalry was intended to serve in the First

Indiana Cavalry. The six companies (A through F), also known as the Forty-fifth Indiana Infantry, were designated the East (or Right) Wing. Companies G through K, formed in October 1861, were designated the West (or Left) Wing. Three weeks later, the East Wing received its official designation as the Third Indiana Cavalry and was assigned to the Army of the Potomac. The West Wing eventually added two more companies and was assigned to the Army of the Ohio. The two wings never served together. The West Wing was eventually transferred to the Eighth Indiana Cavalry.

At approximately noon on September 17, 1862, the Third Indiana Cavalry crossed Antietam

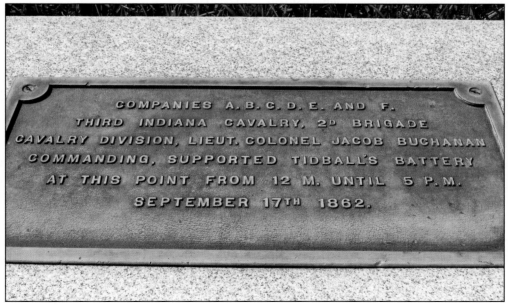

COMPANIES A. B. C. D. E. AND F.
THIRD INDIANA CAVALRY, 2D BRIGADE
CAVALRY DIVISION, LIEUT. COLONEL JACOB BUCHANAN
COMMANDING, SUPPORTED TIDBALL'S BATTERY
AT THIS POINT FROM 12 M. UNTIL 5 P.M.
SEPTEMBER 17TH 1862.

Creek by way of the Middle Bridge under heavy artillery fire. Fighting its way forward, it pushed skirmishers back, enabling four Federal artillery batteries to take position on the elevations north of the road. Under their commanding officer, Major George H. Chapman, the six cavalry companies from the Third Indiana remained here in support of Captain John Tidball's battery until late afternoon.

In the days immediately following the fighting, the Third joined other cavalry units on three separate reconnaissance advances across the river into Virginia to determine the strength and location of the Confederate cavalry. It also engaged in a pursuit of J. E. B. Stuart's cavalry, skirmishing with it near Monocacy, where it was able to recapture a herd of steers the Confederates had captured and were moving to Virginia.

The Third Indiana Cavalry's monument was dedicated on Indiana Day, September 17, 1910, and rededicated on September 9, 1962. As with all the Indiana markers, it was designed by architect John R. Lowe and constructed and erected by the J. N. Forbes Granite Company of Chambersburg, Pennsylvania.

F-9: Monument to Colonel J. H. Childs, Fourth Pennsylvania Cavalry

39° 27.835' N, 77° 43.697' W

Colonel Childs was born on July 4, 1834. He was in temporary command of Averill's brigade on the morning of the battle, since General Averill had taken ill. When Childs took over the regiment, Lieutenant Colonel James K. Kerr assumed command of the Fourth Pennsylvania Cavalry.

The Fourth Pennsylvania Cavalry was held in reserve at the Middle Bridge with other cavalry units. Several Confederate batteries positioned in what is now the national cemetery occasionally fired at the Union line near the bridge. Most of the shots went harmlessly overhead, and casualties were low. The Confederate gunners eventu-

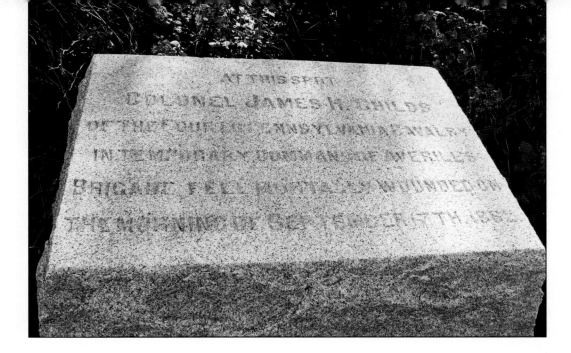

AT THIS SPOT
COLONEL JAMES H. CHILDS
OF THE FOURTH PENNSYLVANIA CAVALRY
IN TEMPORARY COMMAND OF AVERILL'S
BRIGADE FELL MORTALLY WOUNDED ON
THE MORNING OF SEPTEMBER 17TH 1862

ally got their range, however, landing shots in the midst of the Fourth Pennsylvania Cavalry.

Colonel Childs had just completed an inspection of his skirmish line and was talking with his staff when a solid shot struck him on his right hip, throwing him from his horse. The same shot killed two men and four horses. The shot passed through Childs's body, mortally wounding him. Childs famously sent a messenger to the surgeon requesting that if he was not attending to anyone whose life could be saved, to come to him, as he was in great pain.

He lived for nearly forty-five minutes—long enough to ask his assistant adjutant general, Captain Harry King, to pass along a farewell message to his wife and children.

The monument marks the location where Colonel Childs fell. It was dedicated in the early 1900s.

F-10: Newcomer Farm
39° 27.871' N, 77° 43.628' W

The Newcomer Farm was already a hundred years old when the armies clashed along Antietam Creek. A gristmill originally stood on the site. Over the years, a sawmill and a cooper shop were added, and the complex became quite prosperous. At the time of the battle, the property was owned by Joshua Newcomer. Today, only the house and barn remain.

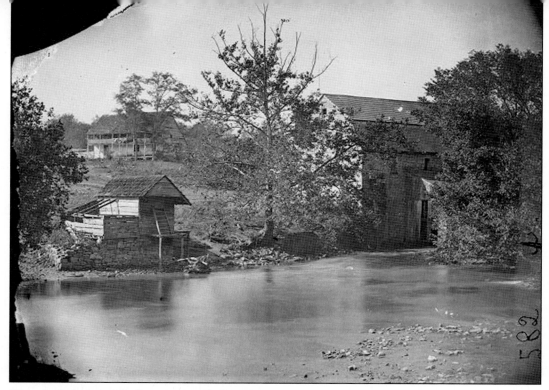

Historical photograph of Newcomer Farm and gristmill
Library of Congress, Prints & Photographs Division, Reproduction Number LC-DIG-cwpb-01119 DLC

The Confederate army crossed Antietam Creek and passed the Newcomer Farm on its way to Sharpsburg. Later that same day, Union forces crossed the nearby bridge. Skirmishing followed when the advance guard of the Union army encountered the rear of Lee's forces. Union troops occupied much of the Newcomer Farm for the next several days. Following the battle, the house, barn, and several outbuildings were used to care for the wounded.

Joshua Newcomer never recovered the damage to his property and eventually sold the farm and mill. The mill continued to operate under the new owner until the early 1900s.

The National Park Service purchased the property in 2007 and opened the house in September 2010 as a welcome and exhibit center for the Heart of the Civil War Heritage Area. It is generally open from April to November.

Present-day photographs of Newcomer Farm. The house is now a welcome center for the Heart of the Civil War Heritage Area.

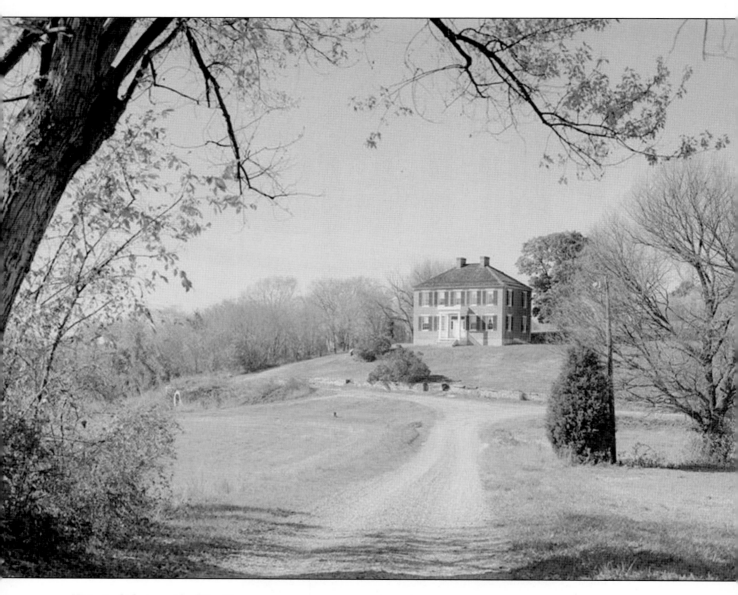

Historical photograph of Pry House
Library of Congress, Prints & Photographs Division, HABS Reproduction Number HABS MD, 22-SHARP.V, 8-2

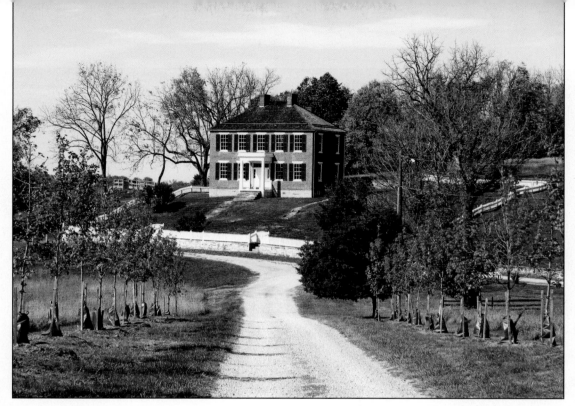

F-11: Pry Farm
39° 28.559′ N, 77° 42.852′ W

Now a seasonal home for the National Museum of Civil War Medicine, the Pry House served as the headquarters of General George B. McClellan during the battle. The house had a trapdoor that led to the roof for maintenance of the gutters and chimneys. McClellan and his Union staff utilized this to gain access to the roof, which then served as an observation post. From that vantage point, and from his post in the front yard, McClellan could see the entire northern and central parts of the battlefield.

The house was also used to treat wounded Union officers, while the barn, shown on page 132, served as a field hospital for enlisted men. General Joseph Hooker spent three days at the house recovering from his wounds. General Israel Richardson died there in November 1862, about two months following his wounding at Antietam. During his trip to meet with McClellan two weeks after the battle, Abraham Lincoln visited the house and spent some time with General Richardson.

The farm was owned by Philip and Elizabeth Pry, who remained during the early stages of the battle. As more wounded were brought to the

farm, McClellan ordered Elizabeth, her five children, and two free African-Americans who lived with the Prys to be taken to nearby Keedysville. But Philip stayed on the farm the entire battle. Soldiers camped out in the fields surrounding the house, and hundreds of campfires dotted the landscape.

Financially devastated by the battle, the Prys ultimately submitted a bill to the Federal government for twenty-five hundred dollars to cover damages to the house and property. They received only a portion of what they had lost and never recovered emotionally or financially from the ordeal of having Union forces occupy their farm. In 1873, they finally sold the farm and moved to Tennessee.

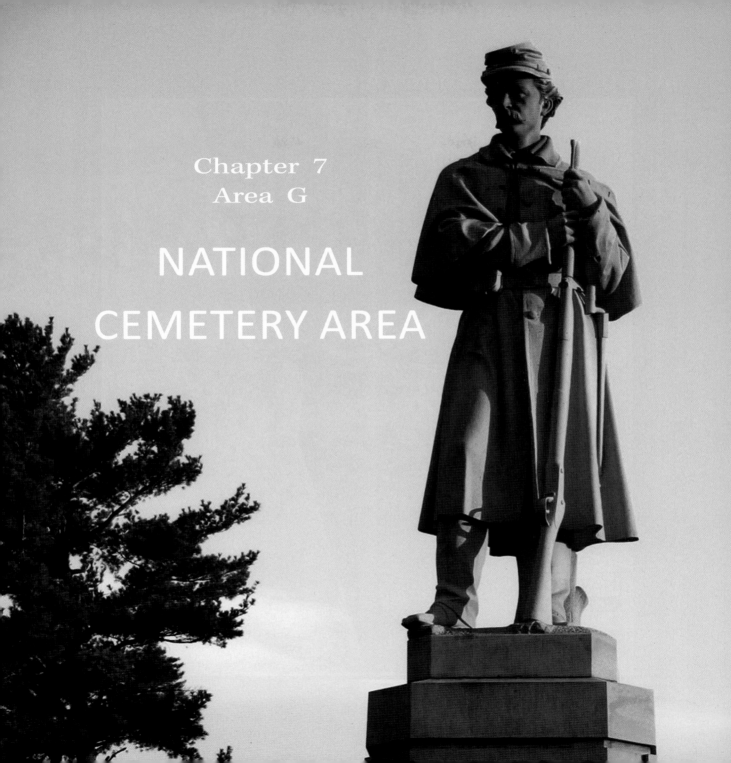

Chapter 7
Area G

NATIONAL

CEMETERY AREA

Area G National Cemetery Area

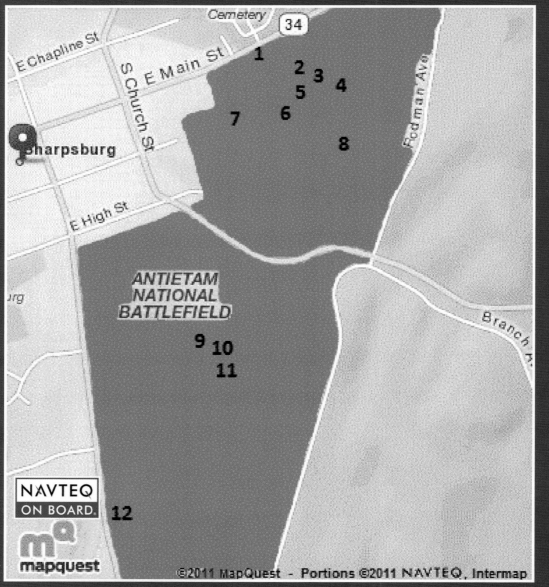

*T*wo years after the battle, State Senator Lewis P. Firey of Maryland introduced a plan to establish a burial place for those who died in the Maryland Campaign of 1862. Within a year, the state followed Firey's suggestion and purchased eleven and a quarter acres to be used as a cemetery.

Two Sharpsburg men, Aaron Good and Joseph Gill, took on the task of identifying bodies, using information buried with the soldiers, such as letters, diaries, and photos. The raising of money to cover reinterments then began. Contributions came in from eighteen Northern states. With sufficient money on hand, work began on the cemetery, using mostly former soldiers. By September 1867, the cemetery was ready.

September 17, 1867, the fifth anniversary of the battle, was chosen for the dedication date. President Andrew Johnson arrived from Washington to take part in the ceremony. A large number of veterans were in attendance.

Permanent headstones were not placed at the graves until 1873, when Congress approved funding. Until then, graves were marked with temporary wooden headboards.

On June 10, 1933, under Executive Order No. 6166, the cemetery was turned over from the War Department to the National Park Service, under whose jurisdiction it remains today.

During the battle, this area was occupied by Confederate artillery. For a long time, it was believed that Robert E. Lee had stood on a large boulder in the area now occupied by the cemetery. From that boulder, Lee was said to have observed much of the fighting. When the cemetery site was selected, it was deemed unacceptable to have such a landmark where Union soldiers were to be buried. After heated discussions, the rock was dug out, broken into small pieces, and scattered. Lieutenant Henry Kyd Douglas, staff officer with Stonewall Jackson, later revealed with amusement that Lee had never known of the rock. Indeed, the presence of several trees would have prevented Lee from seeing much from the rock even if he had stood on it.

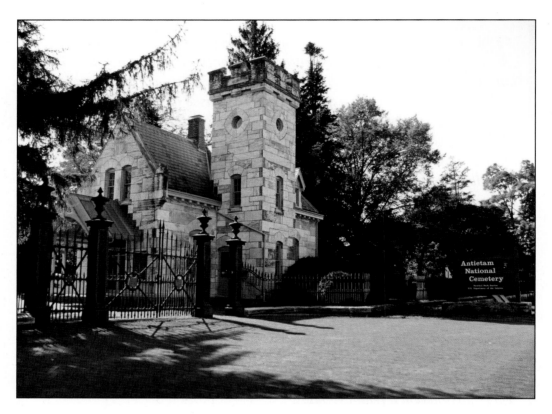

G-1: National Cemetery Entrance
39° 27.609′ N, 77° 44.515′ W

Known as the Lodge Building, this impressive limestone structure has served as living quarters for cemetery superintendents, as the original visitor center, and as administrative offices. Architect Paul Pelz, designer of the Library of Congress, also designed the Lodge Building.

Civil War veterans were the early superintendents. But by 1909, it was apparent that surviving veterans had reached an age at which they could no longer perform the function. The last Civil War veteran to serve as superintendent was Joshua V. Davis, a former member of the Sixty-sixth Pennsylvania Volunteers. Davis ended his time at Antietam National Cemetery on February 2, 1909.

G-2: Monument to Unknown Irish Brigade Soldiers

39° 27.594′ N, 77° 44.479′ W

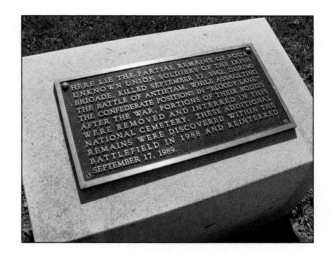

Most of those killed at Antietam were recovered from their battlefield resting places around the time the cemetery opened. However, additional graves have occasionally been found over the years. In 1988, remains were located at the Sunken Road. Forensic examinations determined that the remains were portions of four bodies of men from the Irish Brigade. More specifically, they were members of the Sixty-third New York, based on buttons and other items found with the bodies.

Although further efforts to identify three of the bodies with any degree of certainty have been unsuccessful, much has been learned about one of the men. A shoulder bone showed signs of ar-

thritis, and the condition of his teeth indicated he was in his mid-forties. He was struck in the chest by three Confederate bullets, leading archaeologists to believe he had been in the front rank, possibly as a color bearer or member of the color guard. Eight color bearers from the Irish Brigade fell the day of the battle. All this information led to a tentative identification of the man as Private James Gallagher, an immigrant from Kilkenny, Ireland. His three companions remain unnamed as of this writing.

One year after being found by relic hunters on land not part of the national park system at the time, the remains of the four were brought to the national cemetery, where they were reinterred on the anniversary of the battle, September 17, 1989. Comrades in the ranks, they now rest together in a common grave.

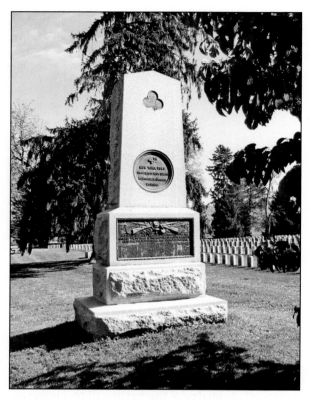

G-3: Fourth New York Infantry Monument

39° 27.592' N, 77° 44.483' W

The Fourth New York was also known as the First Scott Lifeguard Regiment, in honor of General Winfield Scott. Its commanding officer at Antietam was Lieutenant Colonel John D. McGregor.

Although most of the monuments on the battlefield were placed close to the locations at which the specific regiments fought, this one was not. The Fourth New York fought at the Sunken Road, where it was positioned at the left front of Weber's brigade in the first wave of the assault. This placed it on the right side of the Roulette Lane. There, it lost 150 men in the first volley fired by the well-hidden Confederates.

The Fourth New York was one of the first units organized when the war began. Most of the men were recruited in New York City. The exception was Company E, which was recruited in Brooklyn, an independent municipality until it was annexed by New York City in 1898.

The monument was dedicated in 1887. The front has a small clover leaf at the top, symbolizing the Second Corps. A bronze medallion identifies the regiment, and an interpretive plaque lists those from the regiment killed at Antietam.

The regiment chose to list its casualty totals for the entire Maryland Campaign, rather than just for the fighting at Antietam. It suffered 44 killed, 142 wounded, and one missing out of a total of 540 men.

G-4: National Cemetery
39° 27.603' N, 77° 44.494' W

Following the battle, burials were conducted hastily, or not at all. Many graves contained dozens of bodies, and markings were minimal. By the spring of 1864, more than eighteen months after

the battle, shallow graves were being exposed by weather and erosion, their gruesome contents visible for all to see. Legislation was introduced, but despite the urgency, it took another year before land was purchased to establish a final resting place for those who died at Antietam.

The original plan called for soldiers from both sides to be buried in the new cemetery. But feelings still ran high, and many opposed the burial of Confederate soldiers. The problem appeared solved when Southern states were unable to raise funds to join in the effort, relegating the burials of Confederates to other nearby cemeteries. No Confederate soldiers were buried in the national cemetery as a result. Instead, they were interred in Washington Confederate Cemetery in Hagerstown, Maryland; Mount Olivet Cemetery in Frederick, Maryland; and Elmwood Cemetery in Shepherdstown, West Virginia. Approximately twenty-eight hundred Confederate troops were laid to rest in those three cemeteries. Sadly, more than 60 percent were buried as unknown soldiers.

The remains of soldiers from wars as recent as the Korean Conflict are interred at the national cemetery, although most are men from Antietam, Monocacy, South Mountain, and other battles fought in Maryland. Near the right rear of the cemetery are a number of graves placed apart from the rest. They contain the remains of African-American troops from World War I, bur-

ied at a time when segregation still was part of our nation's fabric. Ironically, the battle that led to the Emancipation Proclamation took place on the very ground in which they were placed at rest.

The cemetery was closed to additional burials in 1953 but was reopened for that of Fireman

Patrick H. Roy, who was killed in the attack on the USS *Cole* in October 2000. Fireman Roy had lived in nearby Keedysville. His grave is located near the monument to the First United States Sharpshooters on the right side of the cemetery.

G-5: Twentieth New York Infantry Monument
39° 27.571′ N, 77° 44.477′ W

This is the second of two monuments to the Twentieth New York. The German inscription on its side is duplicated in English on the opposite side: "Erected in memory of our fallen comrades by the survivors of the regiment." The

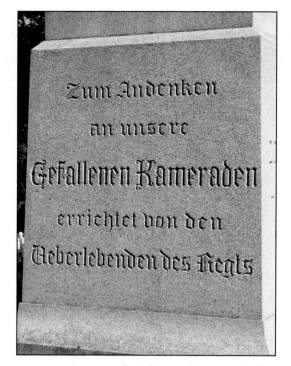

monument is topped with a sculpture of a drum, a cap, a corps badge, a wreath, a belt and buckle, a cartridge box, a bayonet, a scabbard, and a canteen. It was dedicated on September 17, 1887, the twenty-fifth anniversary of the Battle of Antietam. Many surviving members of the regiment were present. One of the speakers was Mrs. Ottile Gerth, who was designated the daughter of the regiment. Mrs. Gerth had served the regiment as a nurse and camp attendant.

Also known as the United Turner Rifles, the Twentieth New York was originally commanded by Colonel Max Weber. At Antietam, however, it

was led by a Swedish-born colonel, Ernest Mattias Peter von Vegesack, since Weber was by then a general in command of the Third Brigade, Third Division.

The regiment's casualties at the Battle of Antietam included thirty-eight killed, ninety-six wounded, and eleven missing. Most losses occurred in the West Woods.

This Twentieth New York marker was the first regimental monument erected at Antietam.

G-6: Private Soldier Monument ("Old Simon")
39° 27.550′ N, 77° 44.467′ W

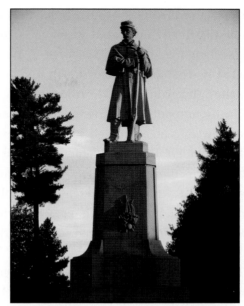

Officially the Private Soldier Monument, this statue is more commonly referred to as "Old Simon." Designed by James Batterson of Hartford, Connecticut, and his employee, George Keller, it is the cemetery's centerpiece and the first monument placed at Antietam. Batterson went on to found the Travelers Insurance Company. James W. Pollette sculpted the figure.

Old Simon originally stood at the Centennial Exposition in Philadelphia in 1876 but was disassembled and taken to Sharpsburg in 1880. En route, the upper portion of the statue fell into the Potomac River in Washington, delaying the arrival.

On September 17 of that year—the eighteenth

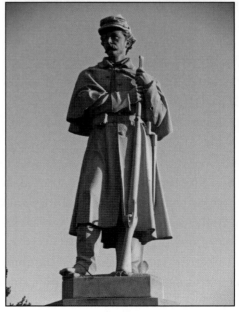

anniversary of the Battle of Antietam—the monument was finally dedicated when Miss Helen Wright, daughter of General George B. Wright, unveiled it. The soldier faces north and represents the fallen from all the Northern states.

The monument is constructed of 27 separate pieces. It weighs an estimated 250 tons and is almost 45 feet high. The soldier alone weighs about 30 tons and is more than 21 feet tall; it is made of two separate pieces. Carved on the base of the monument are a laurel wreath, crossed swords, draped colors, a drum, a canteen, and a cartridge box.

The ultimate sacrifice made by those interred here is reflected in Old Simon's inscription: "Not for themselves, but for their country."

G-7: Monument to Vermont Company F, First United States Sharpshooters
39° 27.534′ N, 77° 44.513′ W

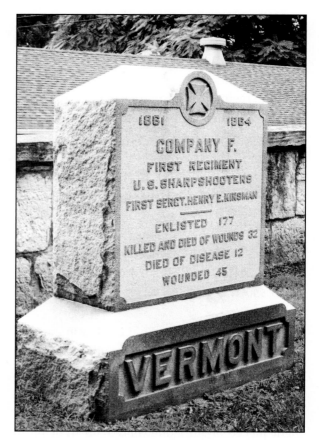

This regiment of sharpshooters was led by First Sergeant Henry E. Kinsman. Its casualties in the three years it existed totaled thirty-two killed or mortally wounded, seventeen more who died of disease, and forty-five wounded.

In 1934, the superintendent of the cemetery, John C. O'Connell, attempted to gather information about the monument but was told by the adjutant general of Vermont, Herbert T. Johnson, that the state had no record of its erection and dedication. Johnson was able to determine that money indeed was appropriated for those purposes. And since the monument was in place, that money had obviously been spent. But everything about the monument had to be presumed. It is believed to have been dedicated in 1900 or 1901.

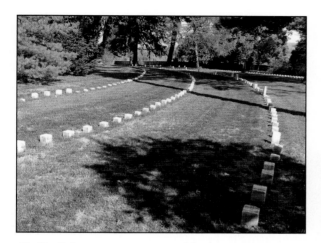

G-8: Monument to Unknown Soldiers, National Cemetery

39° 27.528′ N, 77° 44.450′ W

Every effort was made to identify those lost on the field of battle, using uniform markings, photos found on the bodies, diaries, and any other means possible. The problem of identification after the Battle of Antietam was complicated by two major factors, however. First, what are known today as dog tags were not in use during the Civil War. Although a crude form was available, few soldiers used them. Second, the bodies had been hastily buried where they were found, with no embalming or other preparation. After nearly three years, this left most of them in an advanced state of decomposition. As a result, many of the remains were never identified.

The unknown dead in Antietam National Cemetery rest near the rear of the grounds. They are marked primarily with small, six-inch-square stones, although some have more standard upright headstones. The small stones were used until 1902, when it was decided to convert to the larger markers.

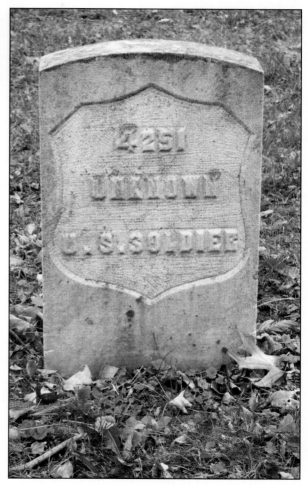

Looking at the small stones, visitors may see two numbers. In the photo, those numbers are 2300 and 5. The larger figure, in this case 2300, indicates the plot number. The smaller figure indicates the number of unknown dead buried together in that particular plot, in this case five.

Of the nearly 4,800 soldiers buried here, 1,836 are unknown.

G-9: Ninth New York Infantry (Hawkins' Zouaves) Monument
39° 27.166′ N, 77° 44.626′ W

Commanded by Lieutenant Colonel Edgar Kimball during the battle, this regiment forded Antietam Creek in midafternoon on September 17. Part of Fairchild's brigade, it immediately met heavy resistance and slowly fought its way to the position marked by the monument, where the men remained until they were withdrawn when A. P. Hill's advancing Confederates threatened their left flank and rear.

The fighting was so fierce that the men of the Ninth New York pressed as close to the ground as was physically possible. Many speculated as to whether or not they could hold up a finger without getting it shot off.

Only eight companies of the regiment fought at Antietam. Companies C and K had been placed on detached duty at Plymouth, North Carolina, from July through November 1862.

The regiment suffered 54 killed, 158 wounded, and 28 missing. The total casualty count of 240 represented more than 64 percent of the men present that day. Most of the casualties occurred in the immediate area surrounding where the monument stands.

The monument was erected on May 31, 1897, by the state of New York. Wearing a red, white, and blue dress, Miss Lillian Elsie Horner, daughter of Major James B. Horner, unveiled it. The regiment's motto, "*Toujours Pret*" ("Always Ready"), appears on the west face. The monument features a forty-foot obelisk and has a total height of fifty-two feet.

Captain Adolphe Libaire of Company E was

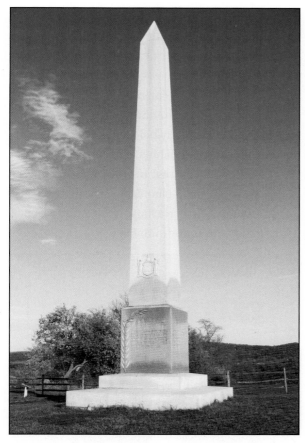

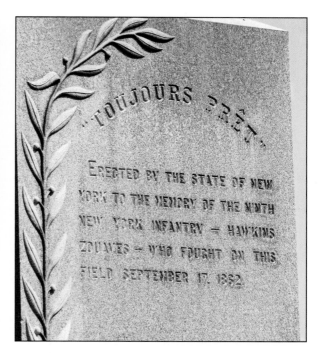

awarded the Medal of Honor for picking up the regimental colors after the color bearer and the entire color guard of eight men were killed or wounded. He carried it to the extreme front, urging the men forward, all in the face of intense Confederate fire.

A second member of the regiment, fifteen-year-old drummer boy J. C. Julius Langbein, also received the Medal of Honor, for his actions at Camden, North Carolina, five months earlier. There, he voluntarily went under heavy fire to assist a wounded officer, obtained medical assistance, and helped carry him to safety.

G-10: Brigadier General Isaac P. Rodman Monument
39° 27.160' N, 77° 44.623' W

Rodman was one of three Union generals—and six generals total— killed at Antietam. Fittingly for a Quaker, his middle name was Peace. Born in Rhode Island, he had been a director of

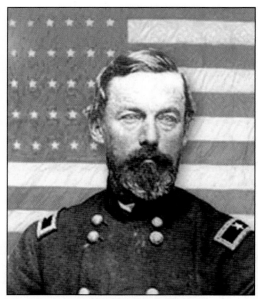

Photo courtesy of National Park Service

Confederate counterattack under General A. P. Hill coming. As he rushed to warn his leading regiments, he was struck by a bullet in the chest. Mortally wounded, he was carried to a field hospital at the Rohrbach Farm, where he died a few days later. Notified of her husband's wound, Sally reached his side shortly before his death and was present when he took his last breath. General Rodman was laid to rest in the family cemetery in Peace Dale, Rhode Island.

Colonel Edward Harland took command of the division when Rodman fell.

the Wakefield Bank and had taught a Bible class in his church. He was married to Sally Lyman Arnold, daughter of Governor Lemuel Arnold of Rhode Island. Rodman had also served as a representative in the Rhode Island General Assembly and then in the state senate.

When war broke out, he helped organize a company of volunteers, receiving his commission as captain in the Second Rhode Island Infantry. He had just returned to the army a few weeks before Antietam, after recuperating for several months from typhoid fever.

During the last Union attack, conducted between the Lower Bridge and Sharpsburg, Rodman was leading his troops when he saw a

G-11: Eighth Connecticut Infantry Monument

39° 27.142' N, 77° 44.622' W

Around two o'clock, Brigadier General Isaac P. Rodman's division of the Ninth Corps, including the Eighth Connecticut, moved to a position about a mile below the Lower (Burnside) Bridge. Two companies of the Eighth Connecticut were sent ahead as skirmishers and found a ford. The rest of the Eighth supported a battery covering the ford while the division crossed. The regiment represented the Union line's extreme left.

Later in the afternoon, the regiment was ordered forward and took control of a small hill. However, due to a mix-up in orders, the men emerged from the Otto cornfield alone and unsupported, and their exposed position left them unable to fend off a counterattack. The commander of the regiment, Colonel Hiram Appelman, ordered the color guard to protect the colors at all costs. Within minutes, five of the guard had fallen. Private Charles H. Walker picked up the flag and waved it in defiance as the Confederates advanced.

The fighting grew so intense that twenty men fell every minute, according to regimental records. Among the wounded was Colonel Appelman. Even the regiment's chaplain, John Morris, took up a weapon from a dead soldier and joined the fight. Major John E. Ward, who had taken over for Colonel Appelman, gave the order to fall back. Casualties totaled 194 killed, wounded, and missing—about half the regiment's strength.

General Rodman was mortally wounded in the fighting, at which time Colonel Edward Harland took command of the division. Several men of the Eighth Connecticut carried Rodman to the rear. While Harland re-formed the division into a defensive position, Confederate pickets organized on the crest of a nearby hill. The wounded lay between the lines. Many were in the rear of the Confederate line. Throughout the night, the men of the Eighth Connecticut worked to retrieve their wounded, bringing them to a nearby barn.

The next day, the Eighth carried out the sad task of gathering its dead.

The Eighth's monument was erected by the state of Connecticut and dedicated on October 8, 1894. It shows the tools of the infantryman: a knapsack, a cartridge box, a bayonet, a belt, and a cap box. The symbol of the Ninth Corps, a cannon tube and anchor, adorns the top face. The monument was constructed by Stephen Malsen of Hartford.

G-12: Monument to First Maryland Artillery, Dement's Battery (CSA)
39° 26.926′ N, 77° 44.787′ W

To the casual observer, the inscription on this monument may be confusing, considering that Dement's Battery did not actually participate in the battle. Although the inscription says the battery occupied a position in the rear of the marker, it is known that it was actually in Harpers Ferry the day before the battle. No record exists of its participation in the fighting at Antietam. Official maps of the Antietam Battlefield Board do not show Dement's Battery on the field at any time, and other reliable sources likewise fail to mention its presence.

The battery, under Captain William F. Dement, did take an active part in the capture of Harpers Ferry, however, fighting at Loudon Heights. It is likely that it came to Antietam but arrived too late to participate. A newspaper account of the monument's dedication supports this with the statement, "Dement's Battery, it is said, did not officially engage in the battle, although its guns were ready."

The monument was erected by the state of Maryland. It was dedicated on May 30, 1900, and rededicated on September 20, 1961.

Chapter 8
Area H

BURNSIDE BRIDGE AREA

Area H Burnside Bridge Area

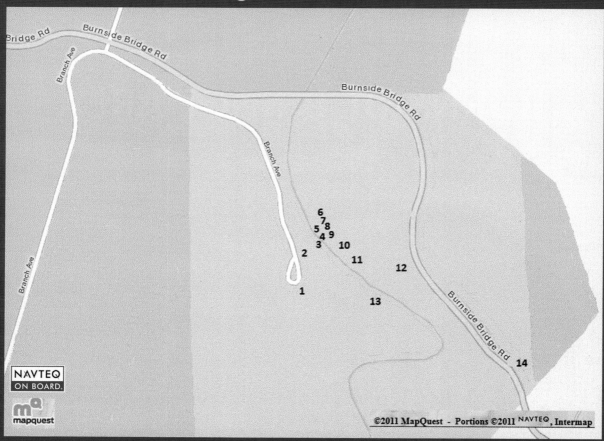

*G*eneral Robert E. Lee had a formidable Confederate force in this area in the morning. But when fighting intensified in the West Woods, he ordered most of his troops there to stem the Union advance. This left only a small force at the bridge, an important route for Confederate reinforcements from Harpers Ferry. Although vastly outnumbered, the Southerners held the high ground, neutralizing the advantage the Federals had in numbers.

The Second Georgia and Twentieth Georgia infantries, under Colonel Henry C. Benning, were positioned on the high ground above the bridge. Downstream were the Fiftieth Georgia Infantry, Jenkins's Brigade, and the Texas Brigade. Altogether, the Confederates had between five hundred and six hundred men, under the overall command of General Robert Toombs.

While the fighting at the Sunken Road was still in progress, the Union's Ninth Corps commander, General Ambrose Burnside, was ordered to attack Lee's right flank. Burnside sent General Isaac Rodman and thirty-two hundred soldiers downstream with orders to cross Antietam Creek and attack the Confederate troops positioned on the high bluffs on the west side of the stream. At the same time, Burnside planned a frontal assault across the bridge.

Led by the Eleventh Connecticut Infantry, the first attack deteriorated into confusion. The second assault did the same.

Meanwhile, Rodman encountered skirmishers from the Fiftieth Georgia at the closest ford and was unable to cross the stream as planned. He and his troops were forced downstream to the next closest shallow point, Snavely's Ford. The extra marching cost Rodman two hours, and still he encountered Confederate troops. The Ninth New York (Hawkins' Zouaves) was the first Union regiment to successfully cross the creek. Others quickly followed and pushed the Southern troops back, but valuable time had been lost. The crossing was achieved around the same time that the Union was finally able to take the bridge.

For more than three hours, the outmanned Confederates defended the

bridge against Federal assaults. *The Confederate breastworks had depressions created when the stone was quarried to build the bridge, providing ideal cover.*

At about one o'clock that afternoon, as the Confederate defenders were running low on ammunition, the Fifty-first Pennsylvania and the Fifty-first New York successfully crossed the bridge in the Union's third attempt. The Pennsylvanians lost 19 men killed and another 68 wounded in the attack, while the New Yorkers lost 21 killed and 99 wounded. When Rodman's troops also crossed the creek and flanked them, the Confederates were forced to retreat. The Second and Twentieth Georgia infantries had 120 men killed, wounded, or captured.

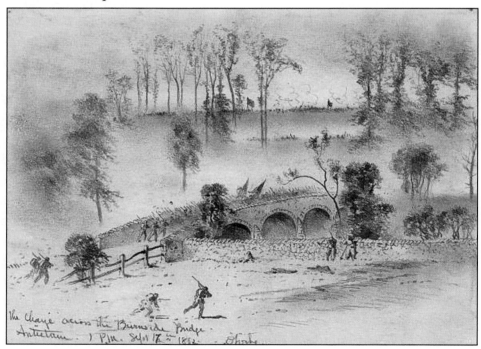

Contemporary drawing of the charge across the bridge
Library of Congress, Prints & Photographs Division, Reproduction Number LC-DIG-ppmsca-20513 (digital file from original item)

Although the Union now held the bridge, the delaying action by Toombs and his men provided enough time for General A. P. Hill's Confederate troops to arrive on the field from Harpers Ferry.

The commander responsible for the Confederate right flank was General David R. Jones. A West Point graduate known as "Neighbor" for his pleasant disposition, he faced his brother-in-law, Colonel Henry Kingsbury, in the fight. Neighbor Jones's troops wounded Kingsbury four times in the first assault on the bridge. Kingsbury died the next day from his wounds before ever seeing his son, who was born three months later. The thirty-seven-year-old Jones would die four months after the battle from heart disease.

In the fighting for the bridge, the Union army lost approximately 500 men killed, wounded, or missing. Confederate losses totaled about 120, or one of every four soldiers engaged.

Ever since the battle, the Lower Bridge has been known as the Burnside Bridge. Burnside himself would serve three terms as governor of Rhode Island and two terms as a Untited States senator. He also served as commander in chief of the Grand Army of the Republic and as president of the National Rifle Association.

H-1: William McKinley Monument

39° 26.952' N, 77° 43.978' W

During the fighting, McKinley, commissary sergeant of the Twenty-third Ohio, carried coffee and roasted meat to his men using a mule-drawn cart, despite the risk to his own safety. This action while under fire earned the nineteen-year-old a promotion to second lieutenant from his commanding officer.

McKinley would go on to become a member of Congress for fourteen years, a two-term governor of Ohio, and the twenty-fifth president of the United States. The colonel of the regiment, Rutherford B. Hayes, was also elected president. The Twenty-third Ohio has the distinction of being the only regiment in either army to have two future presidents in its ranks.

The relief on the monument commemorates McKinley's actions. A plaque on its side shows him as a soldier in the Twenty-third and as president.

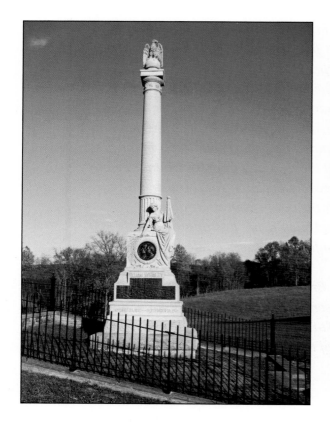

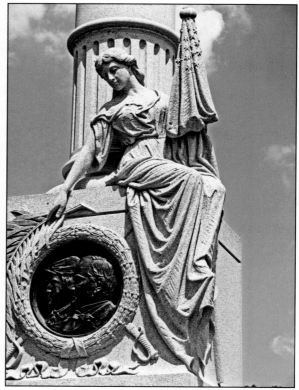

According to the *Report of the Ohio Antietam Battlefield Commission*, the female figure seated on the monument's base represents "the spirit of the people in their devotion to the martyred dead."

The monument was built for the Hughes Granite and Marble Company of Clyde, Ohio, by Scottish sculptor J. B. King. It was dedicated on October 13, 1903, about two years after McKinley was shot by anarchist Leon Czolgosz while attending the Pan-American Exposition in Buffalo, New York. McKinley lived for eight days before succumbing to his wounds.

H-2: Confederate Rifle Pits
39° 26.996' N, 77° 43.933' W

When it came time for a bridge to be constructed across Antietam Creek in 1836, the

builders didn't have to go far for their materials. A huge limestone outcropping was located on the hillside above the stream, reducing the time and effort needed to move materials into position.

The quarrying of the limestone left gaping depressions in the hillside. The Confederates defending the bridge quickly utilized these natural rifle pits to their advantage. The troops were able to remain largely out of sight within the voids left by the removed limestone.

While they are now difficult to see, particularly when the grass is high, traces of the rifle pits remain on the slopes approaching the bridge. They are best seen from the viewing area above the bridge.

H-3: Burnside Bridge
39° 27.025' N, 77° 43.928' W

Built at a cost of twenty-three hundred dollars in 1836, this small stone bridge across Antietam Creek served as a connector on the road between Sharpsburg and nearby Rohrersville. Prior to the battle, it was known by two names. Some called it the Rohrbach Bridge, after a nearby farm, while others simply referred to it as the Lower Bridge, because it was farther downstream than two other local bridges across the creek. It was actively used until 1966, when it was closed to vehicle traffic and restored to its 1862 appearance.

Peaceful today, it was the scene of intense fighting in September 1862. The bridge was important to Robert E. Lee because Union control would threaten the rear of the Confederate army. He wanted to hold the bridge at all costs.

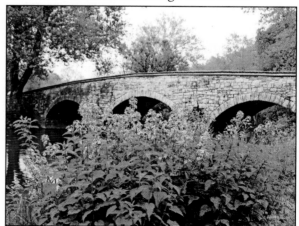

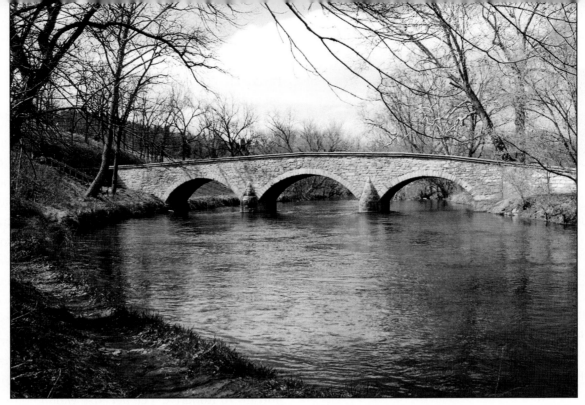

Even though General Ambrose Burnside had far more men at his disposal than did the Confederates, they were no match for the entrenched troops concealed on the opposite hillside. The first Union attack on the bridge started at ten in the morning, led by the Eleventh Connecticut Infantry, which was decimated by Confederate snipers. The Federal troops were quickly repulsed and pinned down. General James Nagle's brigade—consisting of the Second Maryland, the Sixth and Ninth New Hampshire, and the Forty-ninth Pennsylvania—attempted a second assault about an hour later but found the same result.

The final attack on the bridge was made by General Edward Ferrero's veteran brigade. At about one o'clock that afternoon, Federal artillery fire was concentrated on the hillside opposite the bridge. This enabled the Fifty-first Pennsylvania and the Fifty-first New York to finally get across. With the bridge now open, they were quickly followed by the remaining Union troops, forcing the Confederates into a retreat. The Ninth Corps spent the next two hours preparing for the final assault.

The question is often asked why Burnside chose to force his way across the bridge when he simply could have forded the stream a few hundred yards below it. The relatively shallow

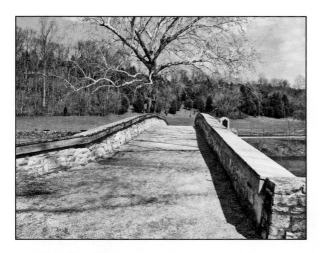

the contingent reached was that Burnside's decision to assault the bridge was reasonable.

H-4: Witness Tree
39° 27.039' N, 77° 43.898' W

Witness trees are trees that were present on the battlefield at the time of the action and thus witnessed the fighting. This sycamore stands adjacent to the northeast corner of the Burnside Bridge. Its location has led some to refer to it as

crossing would appear to be easy. But it was not the crossing that presented the problem. Rather, troops would have had to climb the steep, muddy banks while under fire. Burnside may have recognized this. And he certainly had no idea he faced only a few hundred troops.

In 1994, a contingent from West Point tested the plan to ford the stream. It started out in an orderly line and began to wade the creek. The line quickly deteriorated as the cadets attempted to exit the stream by way of the muddy banks. The more feet that slid on the muddy surface, the worse the traction became, until those in the rear had to be assisted out of the creek. All told, the crossing and exiting of the stream took more than four minutes—and that was under ideal conditions, with nobody shooting at the cadets, no need to return fire, and no wounded comrades needing assistance. The conclusion

the Burnside Sycamore. Only a few years old in 1862, it was shot by famed Civil War photographer Alexander Gardner just two days after the battle. It witnessed the deaths of hundreds of Union soldiers as they attempted to cross the bridge. Considering the intensity of the battle, it is likely that the tree contains a quantity of bullets and shrapnel.

H-5: Wall at Burnside Bridge
39° 27.043' N, 77° 43.896' W

This wall offered temporary cover for the men of the Fifty-first Pennsylvania after their rush down the hill opposite the bridge's approach. Following a brief respite at the wall, the

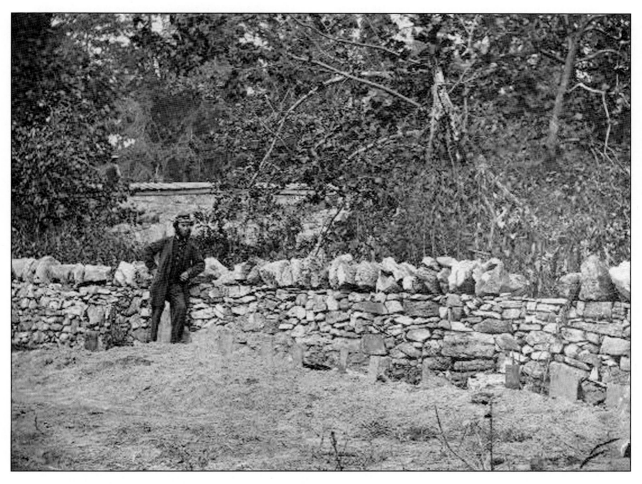

Graves of Union soldiers appear in front of the man standing at the wall.
Library of Congress, Prints & Photographs Division, Reproduction Number LC-USZ62-116321 (black-and-white film copy neg.)

Pennsylvanians joined the Fifty-first New York in a successful assault on the bridge.

Many of those killed in the fight for the Burnside Bridge were temporarily buried on the battlefield after the action subsided. Some were buried at this wall. They were reinterred later, many in the national cemetery. The black-and-white photo on page 159 shows graves immediately in front of the man standing at the wall, although they are difficult to see. The headboards for the graves were made from planks from the bridge. The wall on which the man is leaning is that extending from the bridge and running parallel to the pathway.

H-6: Twenty-first Massachusetts Infantry Monument
39° 27.049' N, 77° 43.896' W

The Twenty-first Massachusetts, commanded by Colonel William S. Clark, was one of the many regiments backed up at the approach to the bridge as Burnside attempted his assault. The regiment was generally positioned along the roadway from the bridge approach, extending to the right as visitors look at the monument. The men's role was to concentrate their fire so heavily that the Confederates on the opposite bank would not be able to effectively prevent the Fifty-

first Pennsylvania and the Fifty-first New York from crossing.

The regiment lost ten killed and another thirty-five wounded. The names of the ten dead are listed on the side of the monument's base. When

the monument was dedicated on September 17, 1898, it was mounted on a corner of the bridge. At the three other corners were the monuments of the Second Maryland, the Thirty-fifth Massachusetts, and the Fifty-first Pennsylvania. The monument of the Twenty-first Massachusetts sat on the southwest corner. The monuments remained on the corners until the bridge was restored in the 1960s, when they were moved to their present locations. The monument was rededicated on September 9, 1962.

The monument is a model of a minie ball, the most common bullet used in the Civil War.

H-7: Thirty-fifth Massachusetts Infantry Monument
39° 27.047′ N, 77° 43.895′ W

The Thirty-fifth Massachusetts stood next to the Twenty-first Massachusetts and aided in keeping the Confederates occupied while the Fifty-first Pennsylvania and the Fifty-first New York stormed the bridge. Once the bridge was taken, the Thirty-fifth crossed it and climbed the bluff on the opposite side, where later in the day it participated in the assault toward the Otto Farm, where it suffered most of its casualties. The regiment paid a stiff price at Antietam, as 214 of its men were killed or wounded.

The monument is topped by three gran-ite cannonballs and contains a listing of those killed. The Latin phrase at the bottom translates as, "It is glorious to die for one's country." The north face of the monument shows the symbol of the Ninth Corps, an intertwined cannon and anchor inside a shield. The monument was erected in 1898 by Lieutenant Colonel Albert A. Pope as a memorial to his dead comrades. It was rededicated on September 9, 1962.

Two men from the regiment were awarded the Medal of Honor for their actions at Antietam. Sergeant Marcus M. Haskell of Company C

received his for exposing himself to heavy fire while already wounded so he could rescue a wounded comrade and convey him to safety. Private Frank M. Whitman of Company G stayed on the field after most of the rest of the army had left, saving the lives of several of his companions. Whitman would receive a second Medal of Honor for being foremost in the line during an assault at Spotsylvania, where he lost a leg.

Like those of the Second Maryland, the Twenty-first Massachusetts, and the Fifty-first Pennsylvania, the monument to the Thirty-fifth Massachusetts was mounted on a corner of the bridge—specifically, the northwest corner. When the bridge was refurbished in the 1960s, all four markers were moved to their present locations.

H-8: Second Maryland Infantry (US) Monument
39° 27.043' N, 77° 43.891' W

Under the command of Lieutenant Colonel J. Eugene Duryea, the Second Maryland sustained most of its casualties in the span of only ten minutes of fighting at midmorning. Supported by the Sixth and Ninth New Hampshire, the Second Maryland charged to within a hundred yards of the bridge before being halted by heavy fire from the Georgians on the opposite bank of the creek. The men were forced to take shelter along the

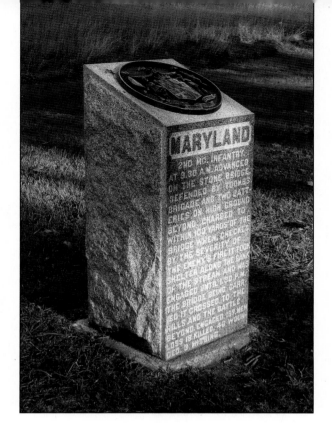

stream. From there, they fought until the bridge was taken. They participated in the final attack once the bridge was under Union control.

The regiment's losses totaled eighteen killed, forty-eight wounded, and three missing.

Its monument was dedicated on May 30, 1900. It originally was located on the northeast corner of the bridge but was relocated to its present site in 1964 when the bridge was refurbished. Monuments to the Thirty-fifth Massachusetts, the Fifty-first Pennsylvania, and the Twenty-first Massachusetts occupied the remaining three corners.

H-9: Fifty-first Pennsylvania Infantry Monument

39° 27.039' N, 77° 43.889' W

The Fifty-first was one of the regiments recently disciplined by its brigade commander, Colonel Edward Ferrero, who took away its whiskey ration. When Ferrero asked the Fifty-first Pennsylvania and the Fifty-first New York if they would take the bridge, the men of the Fifty-first

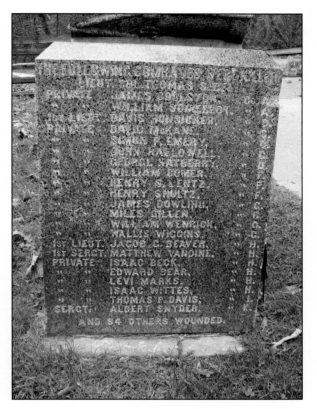

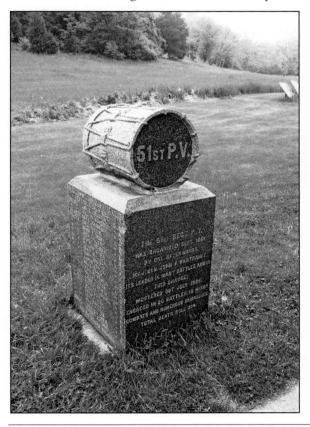

Pennsylvania said they would if he returned their whiskey ration. Ferrero agreed, and the two regiments rushed down the hill and onto the bridge. True to his word, Ferrero returned the whiskey allotment a few days after the battle.

The regiment was organized by Colonel John F. Hartranft, who received the Medal of Honor for his actions at First Manassas and would gain fame as a special provost marshal for the Lincoln conspirators. He also organized the Fourth Pennsylvania Infantry.

The granite monument is topped by a field drum. The names of the regiment's twenty-two men who were killed are listed on the side. The monument also refers to the eighty-four wounded. The opposite side contains the names of five men and a mysterious inscription—"Omitted"—the meaning of which is open to discussion.

The target of vandals on at least one occasion, the monument was placed as a means of honoring the men of the regiment killed while storming the bridge. A larger monument sits on Branch Avenue.

The monument was originally located on the southeast corner of the bridge but was relocated to its present site in 1964 when the bridge was refurbished. Monuments to the Thirty-fifth Massachusetts, the Second Maryland, and the Twenty-first Massachusetts adorned the remaining three corners.

H-10: Fifty-first New York Infantry Monument
39° 27.033' N, 77° 43.878' W

Under orders to carry the bridge at all hazards, the Fifty-first New York joined forces with the Fifty-first Pennsylvania and rushed from the high ground behind the site of its monument to the bridge, which the men took with fixed bayonets. In the charge, the Fifty-first New York was

on the left of the Pennsylvanians. In the process of taking the bridge, it lost one officer and eighteen men killed, plus another four officers and sixty-four men wounded.

The regiment, also known as the Shepard Rifles, was commanded by Colonel Robert B. Potter. Organized in October 1861, it was formed by consolidating a number of other regiments that had not yet filled their rosters. The Shepard Rifles was the largest of these regiments, so that name was given to the Fifty-first New York. Other regiments that were part of the Fifty-first were the

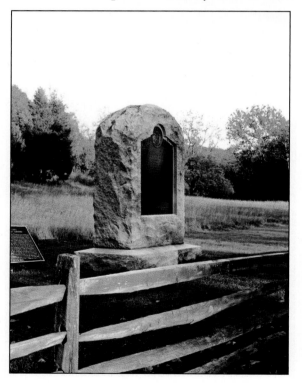

New York Rifles, the Scott Rifles, the Union Rifles, the Empire Zouaves, and the Mechanic Rifles.

Private Orlando E. Caruana of Company K was awarded the Medal of Honor for his conduct at New Bern, North Carolina, in March 1862 and for his actions at South Mountain a few days prior to Antietam. At New Bern, he carried the wounded color sergeant off the field, saving the regiment's colors from capture. At South Mountain, he was one of four soldiers who volunteered to seek out the Confederates' position. He was the only one who survived, as the men ran headlong into the Confederate army before they realized it.

The monument is a large, rough-cut slab of granite with a bronze plaque on the front. It was erected in 1908 by the state of New York.

H-11: Union Advance on Burnside Bridge
39° 27.035' N, 77° 43.896' W

Because of the terrain, many Union troops at some point had to traverse this road, known locally as the Rohrbach Lane, to get to the bridge. After the attack by the Eleventh Connecticut failed, the Second Maryland and the Sixth New Hampshire followed the road in a column of fours. This placed the men parallel to the Confederate troops on the opposite side of the stream and, since they had little or no cover, exposed their flank to destructive fire. The Second Maryland and the Sixth New Hampshire charged with bayonets and got to within 250 feet of the bridge before the Confederate fire became too intense.

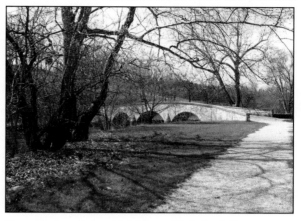

Present-day photo of bridge and Rohrbach Lane

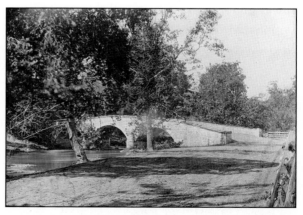

Period photo of the approach to the bridge, known then as the Rohrbach Lane
Library of Congress, Prints & Photographs Division, Reproduction Number LC-DIG-cwpb-01134

At that point, the Union troops were forced back to cover. In the process, the Second Maryland lost 44 percent of its men, the highest percentage loss of any regiment involved in the bridge assault.

H-12: Eleventh Connecticut Infantry Monument
39° 27.017′ N, 77° 43.766′ W

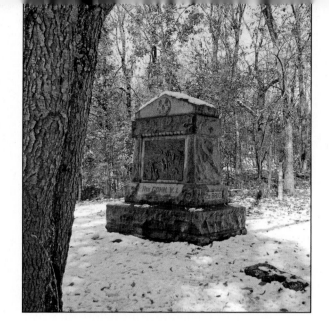

Under Colonel Henry W. Kingsbury, the Eleventh Connecticut had the honor of opening the fighting on this part of the field. The regiment came down the hill as scouts and skirmishers to draw attention from Rodman's probe downstream. The men quickly came under heavy artillery and infantry fire from the opposite bank, dominated at that point by what has become

known as the Georgia Overlook. The fighting grew so severe that the regiment was forced back, losing 139 killed and wounded in the process.

Colonel Kingsbury was wounded four times in the attack. Those wounds proved mortal. He died on September 18, 1862, at the Rohrbach farmhouse, which no longer stands. His wife was a daughter of Zachary Taylor, the former president. Major John Ward took command of the regiment when Kingsbury fell.

Captain John Griswold of the Eleventh is reported to have made a last request to his comrades just before he died. He said, "I die as I have ever wished to die—for my country. Tell my mother that I died at the head of my company."

The regiment's monument contains a list of those killed in the assault. A relief on the front depicts the regiment's attempt to gain the bridge.

Georgia Overlook

The monument also shows a cannon tube and anchor, the Ninth Corps emblem. Constructed by Stephen Malsen of Hartford, it was dedicated on October 8, 1894.

H-13: Georgia Overlook
39° 26.974' N, 77° 43.861' W

As Burnside's Union attackers moved along the road on the opposite side of Antietam Creek, Georgia troops had a direct line of fire along the columns of men. The Georgians had the higher stream bank, allowing them to fire downward into the Federal lines.

The Twentieth Georgia occupied the elevation directly opposite the end of the bridge. The Second Georgia, the Fiftieth Georgia, and a company of South Carolinians extended along the creek to Snavely's Ford, slightly more than a mile downstream.

From this overlook, and for the entire distance to the bridge, Union troops were exposed to deadly fire. Despite being greatly outnumbered, the Confederates held control for several hours, buying enough time for A. P. Hill's troops to arrive from Harpers Ferry and provide a counterattack.

When it became apparent that the bridge was about to be taken by Union troops, the order came for the defenders to withdraw. It appears that the order never reached the men at this overlook, most of whom were killed where they stood. It is possible that they were accidentally

shot by their own troops in the confusion of the retreat.

H-14: Monument to First Battery, Ohio Light Artillery
39° 26.821' N, 77° 43.55' W

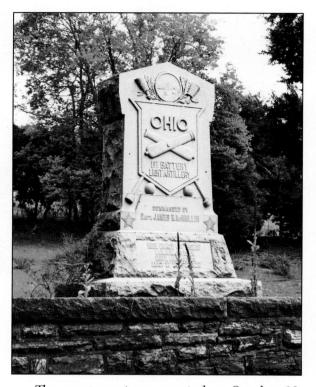

Standing just outside the national park boundary on a stretch of road with few places to park, this may be the least-visited monument associated with the battle.

Commanded by Captain James R. McMullin, the battery occupied a position about 250 yards from where the monument stands. Sitting on the far left flank of the Union army, it took position in the late morning and kept up a steady fire throughout the day until running out of ammunition around three in the afternoon. The First was alternately known as the Jackass Battery because it originally used not horses but mules, which were much more difficult to control. Reports from the time stated that it was common to see a mule running away from the battery, pulling a piece of artillery or a chest of ammunition.

The monument was constructed by the Hughes Granite and Marble Company of Clyde, Ohio, as were all the Ohio markers. It features a shield with two crossed sponge rammers, devices used to swab out the cannon bores. Two cannonballs rest beneath the shield.

The monument was erected on October 13, 1903, by the state of Ohio. The original plan was to dedicate all the Ohio monuments on September 17, 1903. However, as the date of the dedication drew near, it was uncertain that all the monuments would be completed and delivered on time. Realizing that New Jersey had already made arrangements to dedicate all that state's monuments on September 17, Ohio selected October 13.

One of the battery's men, Alonzo Rooks, and one horse were killed in the action.

RODMAN AND
BRANCH AVENUES:
THE FINAL ATTACK

Area I Rodman and Branch Avenues

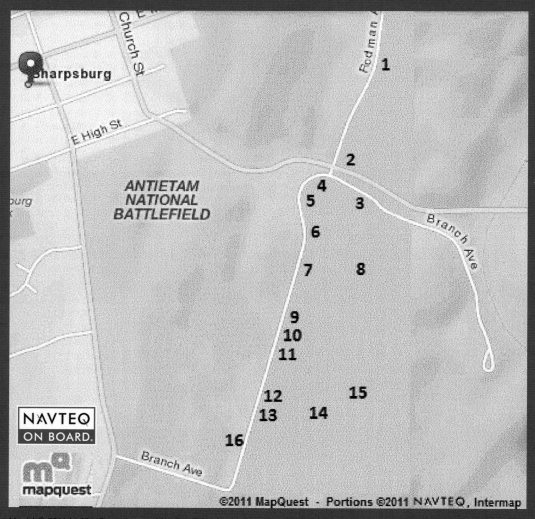

*T*he fight for the Lower Bridge was settled, Burnside having gained control. Now, close to nine thousand Federal troops who had crossed Antietam Creek formed a mile-wide battle line. As the Union men began their final attack in an effort to push Lee's army out of Maryland, twenty-five hundred Confederate soldiers and forty cannons formed their own line from the town of Sharpsburg southward toward Miller's Sawmill Road.

At three o'clock in the afternoon, Burnside's men pushed through a hail of artillery and infantry fire. The Southerners fought to hold them off, but gradually the Union forces pushed them back toward Sharpsburg.

An hour after the assault began, Confederate reinforcements under General A. P. Hill arrived from Harpers Ferry, joining the fray after a seventeen-mile march. Hill's troops immediately slammed into the Union left flank in John Otto's cornfield, and the flow of battle reversed. The Sixteenth Connecticut, having been organized only three weeks earlier, crumbled, suffering 185 casualties in a matter of minutes.

Burnside's troops gradually fell back to a position on the west bank of Antietam Creek. There, Burnside urgently requested more men and guns, only to be told by McClellan that he could spare only one battery. The cautious McClellan said, "I can do nothing more. I have no infantry"—this despite the fact that nearly a third of McClellan's army remained in reserve, never having fired a shot. Burnside's men spent the rest of the day guarding the bridge they had sacrificed so greatly to acquire just a few hours earlier.

The battle was over. The field fell silent, neither side wishing to prolong the misery. Nearly one of every four men who had fought that day was a casualty. More than twenty-three thousand brave young men lay across the battlefield, over thirty-six hundred of them dead. The bloodiest day in American military history was mercifully over.

Note: Many of the monuments in this portion of the battlefield, although seemingly remote, can be visited by taking the Final Attack Trail through the Otto Farm fields.

I-1: Fiftieth Pennsylvania Infantry Monument

39° 27.510' N, 77° 44.198' W

This regiment was also known as the Goodrich Guards and as "Old Reliable." Its monument is a statue of Brigadier General Benjamin Christ, the regiment's original colonel. It shows him using his field glasses to observe troop movements. Christ had moved up to brigade command in July 1861. The regiment was commanded by Major Edward Overton Jr. at Antietam until he was wounded advancing up the slope from the Burnside Bridge. Captain William H. Diehl took command after Overton's wounding. The image of an anchor and cannon in a shield, symbol of the Ninth Army Corps, also appears on the monument.

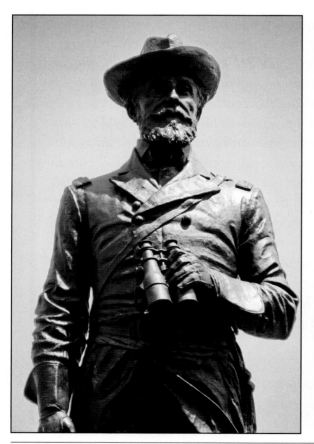

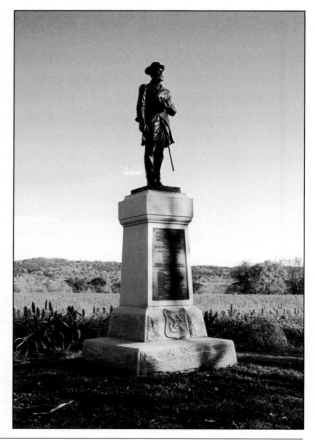

The Fiftieth Pennsylvania lost eight killed and forty-six wounded in the fighting. Another three were missing.

The day after the battle, the men of Company A were sent out as skirmishers. Even though the fighting was over, they crossed paths with the Palmetto Sharpshooters of South Carolina. A brief firefight ensued, every man in the company reportedly firing at least a hundred shots in forcing the South Carolinians back.

The Fiftieth Pennsylvania claimed a distinction few army regiments could boast. A year earlier, the ship transporting it to South Carolina, the *Winfield Scott*, began to take on water. As the officers and crew prepared to abandon ship, the men of the Fiftieth Pennsylvania took charge of the pumps and began bailing by hand. Their efforts prevented the ship from sinking.

The monument was sculpted by W. Clark Noble under the watchful eye of H. J. Christ, General Christ's son, and General Samuel K. Schwenk, a friend of General Christ. It was dedicated on September 17, 1904, the unveiling performed by Mrs. Benjamin Franklin George, a daughter of the regiment.

I-2: Sherrick Farm
39° 27.366′ N, 77° 44.273′ W

The Sherrick Farm was the site of the first contact between Burnside's troops and the Confederate army in the Union's final attack as it attempted to drive the Army of Northern Virginia back through Sharpsburg. The extreme right of the Union line, under General Orlando Wilcox, met the Confederate left in one of Joseph Sherrick's fields, just a few yards from the house. Heavy fire rained down on the Northern troops from sharpshooters posted in the house, outbuildings, and orchard.

The house itself was struck by only one artillery shell and a few bullets, suffering minimal damage. The farm in general, however, sustained significant damage, its crops destroyed, its fences torn down, and its food supplies gone. Bodies littered the fields. As with many of the other farms, much of the damage came from occupying troops rather than from actual fighting. Sherrick submitted claims for about $1,351 in damages by Federal troops.

In fact, the Sherrick family no longer lived on the farm in September 1862, although its actual whereabouts are not known with any degree of certainty. The farm was occupied by Leonard Emmert, who leased the property from the Sherricks. The fact that Samuel Mumma's family lived in the Sherricks' house while its own house was being rebuilt after the battle suggests that Emmert may have simply farmed the land while living elsewhere.

The foundation is all that remains of the barn, which was destroyed by fire in 1982.

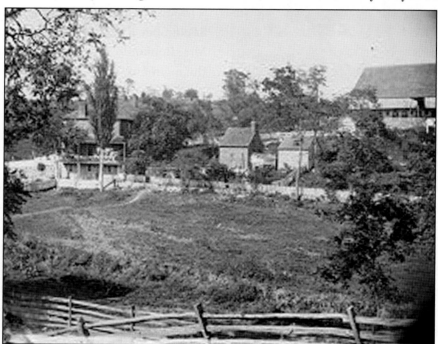

The Sherrick Farm shortly after the battle
Library of Congress, Prints & Photographs Division,
Reproduction Number LC-DIG-cwpb-00263 DLC (digital file from original neg.)

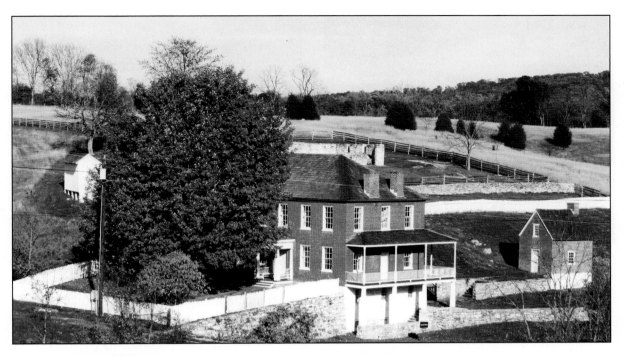

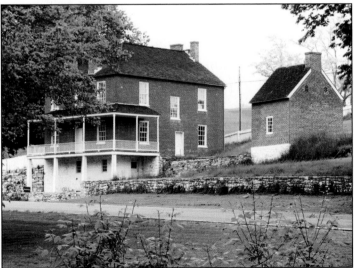

Views of Sherrick Farm today

I-3: Otto Farm
39° 27.260' N, 77° 44.222' W

John Otto built this home in 1833, before he married. A few years after completing it, he wed his first wife, Dorcus. The two began their life together by adding several outbuildings to the property. Dorcus died in the farmhouse just a few years later, after which John worked the farm alone until he married Katherine, who lived on a neighboring farm. Bricks made on the Otto Farm were used in the construction of the Dunker Church.

Seeing troops moving across the farm and hearing of the impending battle, the Ottos left their home the day before the fighting. Losses for both sides were high in the farm's fields. The cornfield, its crop head-high at the time of the battle, was especially bloody. The First South Carolina Rifles and the Twelfth South Carolina Infantry nearly decimated the Sixteenth Connecticut and the Fourth Rhode Island in the ravine that made up most of the cornfield.

The farm served as a field hospital for the Union's Ninth Corps after the battle.

John Otto's son subsequently took over the farm, which he operated successfully for several years.

I-4: Forty-fifth Pennsylvania Infantry Monument
39° 27.289' N, 77° 44.322' W

The Forty-fifth Pennsylvania took part in the final attack on the Confederate line, its Companies A and K serving as skirmishers. The men had

been held in reserve near the Burnside Bridge the morning of the battle but moved forward after the bridge was taken. They were forced to withdraw with the rest of the corps when A. P. Hill's troops attacked their left flank.

The regiment was led by Lieutenant Colonel John I. Curtin, half-brother of Andrew Curtin, governor of Pennsylvania. The men were able to reach a point 264 yards northwest of where their monument stands before being driven back by Hill's counterattack. The Forty-fifth had one man killed in the fighting, another thirty-six wounded, and one missing.

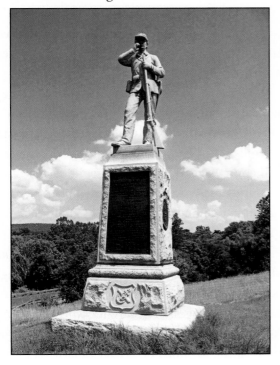

The monument depicts a soldier tearing a paper cartridge tube with his teeth in preparation for the next step in the loading procedure, in which he would pour the powder down the barrel. Fittingly, the title of the monument is *Tear Cartridge.*

The portrait on the left side is of Colonel Thomas Welsh, the commander of the Forty-fifth Pennsylvania from the time of its organization the year before. At Antietam, Welsh was in command of Wilcox's Second Brigade. He would be promoted to brigadier general in November 1862 but would contract malaria during the Vicksburg

Campaign and die in August 1863.

The monument was sculpted by E. L. A. Pausch and dedicated on September 17, 1904, with the removal of the flag by Minnie Eckert.

I-5: 100th Pennsylvania Infantry Monument
39° 27.283' N, 77° 44.320' W

The men of the 100th Pennsylvania acted as skirmishers at Antietam and were spared the heavy losses suffered by many other regiments.

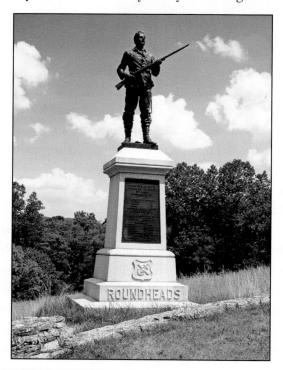

Seven men were wounded, and one was declared missing. Lieutenant Colonel David A. Leckey commanded the regiment.

The artist for the monument—which was dedicated on Pennsylvania Day, September 17, 1904—was W. Clark Noble. It was refurbished and rededicated in 1996. Titled *Challenge*, it shows a soldier on picket duty. His cap lies at his feet, and he stands ready to challenge anyone approaching. The regimental nickname, "Roundheads," appears on the base of the monument.

"Roundheads" dates as far back as the 1640s, when supporters of Parliament during the English Civil War were given the derisive name in reference to the short haircuts worn by some Puritans, as opposed to the long-haired wigs of many of the supporters of King Charles I. Many

of those supporters of Parliament eventually made their way to the United States and settled in southwestern Pennsylvania, where the 100th Pennsylvania was recruited. As descendants of the original Roundheads, the regiment's men embraced their nickname proudly.

The roadbed in front of the monument was not present at the time of the battle.

I-6: Thirty-sixth Ohio Infantry Monument
39° 27.236′ N, 77° 44.338′ W

The Thirty-sixth Ohio, under the command of Lieutenant Colonel Melvin Clarke, was part of the charge that secured the Burnside Bridge. Once across, the regiment formed along the base of the hill, its right flank extending almost to the Sharpsburg Road.

At approximately three o'clock that afternoon, the regiment was ordered to advance. The route took it through plowed fields of the Otto Farm and across fence lines, all while under constant attack from Confederate sharpshooters and artillery fire. In the advance, Clarke was killed when he was struck by a shot in the hip. The regiment had one additional man killed at Antietam and twenty-one wounded. Two more men were missing.

As darkness fell, the regiment withdrew, end-

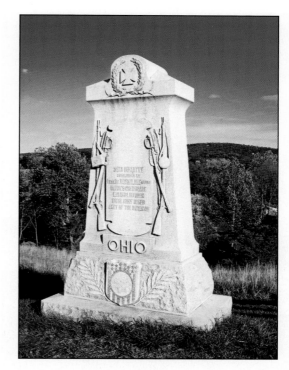

ing up at its former position on the brow of the hill overlooking the bridge.

The regiment's monument was erected on October 13, 1903.

I-7: Twenty-eighth Ohio Infantry Monument
39° 27.184′ N, 77° 44.357′ W

On the morning of the battle, the Twenty-eighth Ohio was sent on a reconnaissance mission above the Burnside Bridge several hours

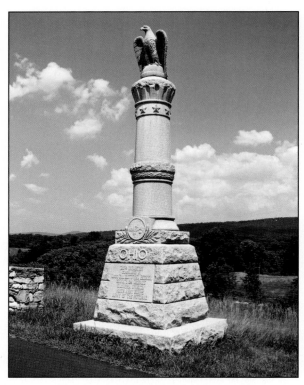

before the intense fight there. Five companies succeeded in crossing the creek before the Fifty-first Pennsylvania and the Fifty-first New York captured the bridge. Reaching the bridge, those companies joined in the advance that pushed the Confederates back toward town.

In the final attack, the Twenty-eighth Ohio was one of the few Federal regiments able to hold its position when Hill's Confederates launched their counterattack. The men fell back only when the general withdrawal of the Ninth Corps was ordered.

The regiment was commanded by Lieutenant Colonel Gottsfried Becker, a political refugee from Germany who came to America after an 1848 revolution in Europe. The Twenty-eighth Ohio was alternately known as the Second German Ohio Regiment. Its losses at Antietam were two men killed and nineteen wounded.

The monument to the Twenty-eighth Ohio consists of a tall shaft topped by an eagle. Stars surround the column near the top. The monument was dedicated on October 13, 1903.

I-8: Eleventh Ohio Infantry Monument

39° 27.117′ N, 77° 44.277′ W

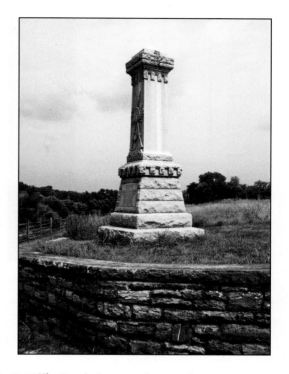

The Eleventh Ohio was commanded by Lieutenant Colonel Augustus H. Coleman, who had attended West Point but did not graduate. After Coleman was killed in the battle, Major Lyman Jackson took his place.

On the morning of the battle, the Eleventh Ohio was part of the first thrust to capture the Burnside Bridge, following closely behind the Eleventh Connecticut. In midafternoon, the regiment sent five companies to a point some 250 yards north of the bridge, where they forded the stream and advanced up the slope. The remainder of the regiment crossed the bridge and advanced. The regiment assisted in slowing General A. P. Hill's Confederate advance but was eventually forced back.

The monument is located at the approximate center of the advance. It sits on a retaining wall for the Otto Farm lane. Few people visit the monument because of its relatively remote location, although it is easily reached by following the Final Attack Trail. To draw visitors' attention, a smaller marker along Branch Avenue, pictured on page 182, points out the monument some 167 yards away. During the fighting, the Eleventh Ohio advanced up the forward slope of the ridge where the monument is now located.

In addition to Lieutenant Colonel Coleman, the regiment lost three men killed, one officer and eleven men wounded, and five men missing.

The monument was erected on October 13, 1903, by the state of Ohio. It contains a relief of crossed muskets and a laurel wreath on the front.

I-9: Fifty-first Pennsylvania Infantry Monument
39° 27.072' N, 77° 44.398' W

The Fifty-first Pennsylvania is best known for its charge across the Burnside Bridge that allowed the Federal army to capture it and drive the Confederates back toward Sharpsburg. After capturing the bridge, the regiment re-formed and waited in reserve, protecting the approaches to the bridge. It was positioned on a hill downstream from the bridge when Hill launched his counterattack. Soon out of ammunition, the men of the Fifty-first anxiously awaited replenishment. When the anticipated supply failed to arrive, they fixed their bayonets and held their position until forced back with the rest of the corps.

In the fighting, the regiment lost twenty-one killed and ninety-nine wounded. Among the dead was Lieutenant Colonel Thomas S. Bell. Major Edwin Schall took command when Bell was killed.

Many men in the regiment had previously served in the Fourth Pennsylvania, one of the first ninety-day regiments recruited from Pennsylvania.

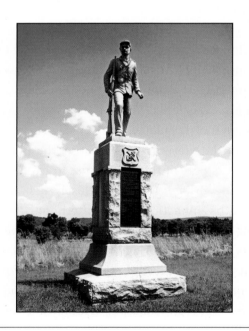

The Fifty-first Pennsylvania Infantry's statue is titled *Skirmisher*. It shows a skirmisher holding his musket at "shoulder arms" as he advances through the underbrush, not knowing where or when he may encounter the enemy. A relief on the side of the monument commemorates the storming of the Burnside Bridge by the regiment and the Fifty-first New York Infantry.

The regimental association also placed a small marker east of the Burnside Bridge. It lists the Fifty-first's casualties.

The artist for the monument was E. L. A. Pausch. The dedication took place on September 17, 1904.

The unveiling was conducted by May Rupert Bolton, daughter of General William J. Bolton and a daughter of the regiment.

I-10: Monument to Durell's Independent Battery D, Pennsylvania Artillery
39° 27.064′ N, 77° 44.402′ W

The Pennsylvania Independent Artillery, Battery D, was commanded by Captain George Durell and therefore assumed his name. At around

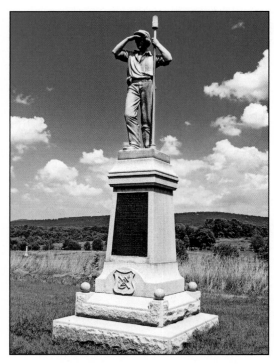

nine o'clock in the morning, the battery was ordered to a point about three-quarters of a mile from the Burnside Bridge. Three hours later, it moved to a new position that required the men to cross a steep, heavily wooded area. Their objective was a hill overlooking the bridge. The terrain was so difficult that several horses collapsed from exhaustion. Durell's men pushed and carried the guns up the slope with the assistance of several nearby troops. They arrived at the top of the hill just as the Fifty-first Pennsylvania and the Fifty-first New York made their charge across the bridge. With no time to rest from the effort of

getting the guns up the slope, Durell's men hastened down the hill to the bridge. Rushing across, they successfully brought the first artillery guns to the other side.

They then followed the infantry up the hill and provided cover for the advancing foot soldiers. For two hours, they engaged in a close-range artillery duel with the Washington Artillery of Louisiana and Wise's Virginia battery until their ammunition ran low and they were ordered to move back. Casualties for the battery were light. Only three men were wounded.

Titled *Watching Effect of Shot,* the monu-

ment features an artilleryman holding a sponge rammer and peering toward his target to determine if his firing has had the desired effect. Four cannonballs on the corners of the base symbolize the artillery. The symbol of the Ninth Corps, the anchor and cannon tube, is visible on the front beneath the plaque. The artist for the monument, dedicated on September 17, 1904, was E. L. A. Pausch.

I-11: Forty-eighth Pennsylvania Infantry Monument
39° 27.056′ N, 77° 44.405′ W

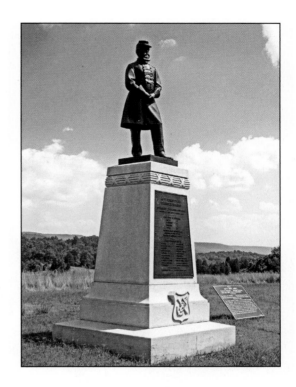

The Forty-eighth Pennsylvania was commanded by Lieutenant Colonel Joshua K. Sigfried at Antietam. After being repulsed in its first attempt, the regiment followed the Fifty-first Pennsylvania across the Burnside Bridge. Its men then served as skirmishers in the final attack toward Sharpsburg. The regiment suffered sixty casualties at Antietam—eight killed, fifty-one wounded, and one missing.

The Forty-eighth was one of two regiments (the other being the 124th Pennsylvania) that added money to their twenty-five-hundred-dollar monument allotments from the state. The Forty-eighth's monument honors Brigadier General James Nagle, the organizer and first colonel of the regiment. At Antietam, Nagle commanded the First Brigade, Second Division, Ninth Corps.

Over the course of its existence, the regiment was assigned to both the First Corps and the Fifth Corps. It included the symbol of each on the side of the monument by placing a Maltese cross (the Fifth Corps symbol) inside a circle (the First Corps symbol).

Nagle's son James posed as the model for the monument. James wore his father's uniform to ensure that the artist, Albert T. Bureau, was accurate in his depiction. General Nagle's grandson, Frank Nagle, a West Point cadet at the time of the

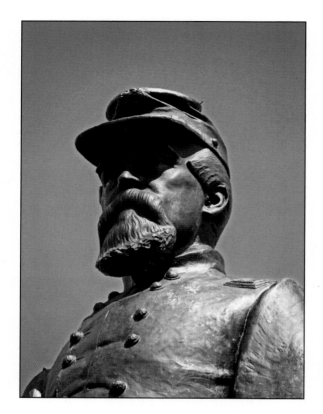

I-12: Twenty-third Ohio Infantry Monument
39° 27.02′ N, 77° 44.419′ W

The Twenty-third Ohio took little part in the fighting until late afternoon. Shortly after five o'clock, it became engaged with Confederates from Archer's Brigade. At the time of the battle, a stone wall ran about where Branch Avenue lies today. The regiment initially positioned itself behind that wall in a defensive position. As the fighting became more intense, the men turned their front ninety degrees—an action known as

dedication, participated in the unveiling of the monument on September 17, 1904. The monument received a replacement sword and was re-dedicated on May 29, 1910.

The Forty-eighth Pennsylvania Volunteer Infantry fought in many battles. None, however, garnered it more fame than the Battle of Petersburg, in which the Forty-eighth, utilizing the skills of many of the miners in the regiment, dug the tunnel beneath Confederate lines that was exploded to create the famous Crater.

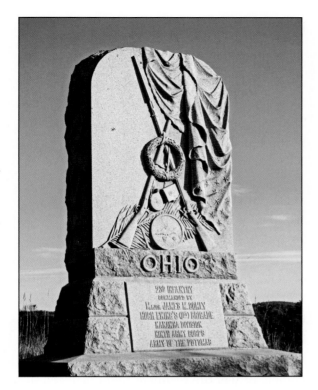

who would be assassinated in his second term as the twenty-fifth president. Hayes was not present at Antietam, having been badly wounded in the left arm just a few days earlier at South Mountain.

The fighting spirit of the soldiers on both sides was exemplified by a remark of the Twenty-third Ohio's color bearer after the Battle of South Mountain. When told no man could carry the colors and hope to live, he replied, "Then, I'll carry it and die!" Prophetically, he was one of those who fell at Antietam.

The monument has a relief on its front showing crossed muskets with a wreath superimposed. A flag is draped over the upper corner. The monument was dedicated on October 13, 1903.

I-13: Thirtieth Ohio Infantry Monument
39° 26.93' N, 77° 44.453' W

This monument marks the approximate location of the regiment in late afternoon on the day of the battle. The Thirtieth Ohio and the Twenty-third Ohio formed here to redress their lines after advancing from the Burnside Bridge. Shortly afterward, the Thirtieth came under attack on its left flank. Its flag was torn in fourteen places by shot and shell, and two color bearers were killed. Sergeant William Carter of Company C grasped

"refusing the line"—to meet Hill's Confederates as they approached from the south. After about thirty minutes of heavy fighting, the Twenty-third Ohio fell back to the Burnside Bridge.

The regiment, commanded by Major James M. Comly at Antietam, lost eight men killed, one officer and fifty-eight men wounded, and two men missing.

The regiment was famous for having two future presidents in its ranks—Lieutenant Colonel Rutherford B. Hayes, who would become the nineteenth president, and William McKinley,

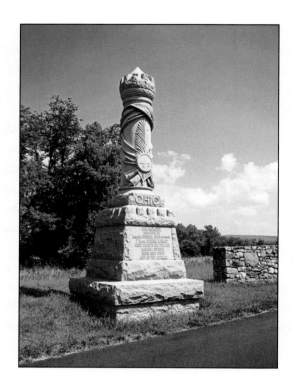

prisoner, among them Lieutenant Colonel Jones.

The monument has a large sculpted shield on the front and muskets, sabers, and other items used by the typical soldier on the sides. The base has a small shield surrounded by palm branches. The monument was erected on October 13, 1903, by the state of Ohio.

I-14: Sixteenth Connecticut Infantry Monument
39° 26.875' N, 77° 44.371' W

Like many other Union regiments at Antietam, the Sixteenth Connecticut had never been in battle. It left Harpers Ferry early the morning of the battle and marched seventeen miles in about eight hours. Commanded by Colonel Francis Beach, the regiment had organized just a month earlier, most of the men coming from wealthy families. Unaccustomed as they were to hard labor, many succumbed to heat exhaustion and sunstroke before they even reached Antietam. They would suffer more once they arrived, losing 43 killed and 161 wounded, for a total of 204 casualties, many resulting from friendly fire when observers mistakenly thought the men of the Sixteenth were Confederates moving in on Burnside's left flank. The inexperienced officers and enlisted men had been given scant training and knew little of regimental movements, caus-

the flagstaff so firmly in his death throes that it was pulled from his hands only with great difficulty. The regiment was soon forced to retrace its steps to the bridge.

Lieutenant Colonel Theodore Jones commanded the regiment until he was captured, at which time Major George H. Hildt assumed command.

The regiment's losses were three officers and ten men killed, including two color bearers. In addition, one officer and forty-eight men were wounded and two officers and fifteen men taken

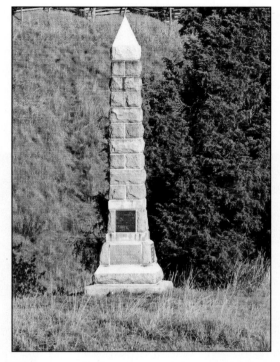

This monument marks the regiment's position near the end of the battle. The bronze relief on the front shows an officer on horseback reacting to a bursting artillery shell. This is believed to commemorate the mortal wounding of Brigadier General Isaac P. Rodman. Because of the monument's relatively remote location, few visitors view it up close. The bronze relief went missing for several years. In 1996, Dean Nelson, director of the Museum of Connecticut History, found a photograph that showed the relief. Working with the image, sculptor Bruce Papitto re-created the relief. This replacement effort was led by the Connecticut Historical Society.

The monument, constructed by the Smith Granite Company of Westerly, Rhode Island, was dedicated on October 8, 1894. It was rededicated on September 20, 1998, following the replacement of the missing relief.

I-15: Twelfth Ohio Infantry Monument
39° 26.861' N, 77° 44.238' W

Under the command of Colonel Carr B. White, the Twelfth Ohio moved into this position on the afternoon of September 17, 1862. The regiment had been on the extreme left of the Union line.

After crossing Antietam Creek at Snavely's

ing them to mill about in confusion.

The regiment suffered additional casualties when Hill's troops struck it in the Otto Farm cornfield. The Eighth Connecticut, on the Sixteenth Connecticut's right, was outside the cornfield and was able to move forward at a faster rate than the Sixteenth, which had to contend with the corn. A gap resulted, and Hill's troops quickly took advantage of it, striking the Sixteenth on its flank before the men realized what had happened. Casualties in the Otto cornfield were so high that some refer to it as "Antietam's Other Cornfield."

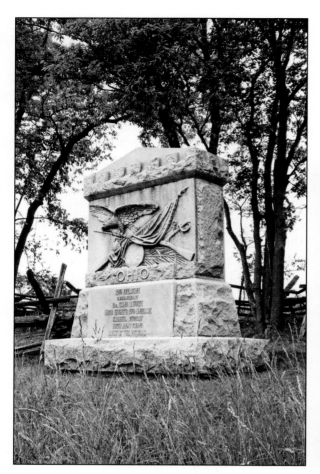

Ford, it moved parallel to the stream until nearly reaching the Burnside Bridge. It then advanced uphill, where it encountered the advance of A. P. Hill's division. Under heavy fire on their flank, the men were forced back to a position just east of where their marker stands. They were able to hold that position for the remainder of the day. The regiment's losses were seventeen men killed and twenty-five wounded.

The men of the Twelfth Ohio were probably unaware that they fought beside a hero. Corporal Leonidas H. Inscho of Company E was destined to receive the Medal of Honor for his actions just a few days earlier at the Battle of South Mountain. There, with no assistance, he had captured five Confederates, including an officer. He had done this without the use of a badly wounded hand.

Their regiment's monument sits at the location where it fought—which, unfortunately, is somewhat remote. It is most accessible by hiking the Final Attack Trail. To draw attention to the monument's presence, a small marker has been placed on Branch Avenue.

The monument to the Twelfth was erected by the state of Ohio on October 13, 1903. It contains an impressive relief of an eagle with outstretched wings as it sits on the instruments of war: a crossed flag and musket, cannonballs, and a sword.

I-16: Brigadier General Lawrence O'Bryan Branch Monument
39° 26.878' N, 77° 44.479' W

Like Brigadier General George Anderson, Branch was born in North Carolina. A Princeton graduate, Branch served in Congress from 1855 to 1861 and served in the United States Army during the Seminole War.

On the day of the battle, he marched with his Confederate men from Harpers Ferry, a distance

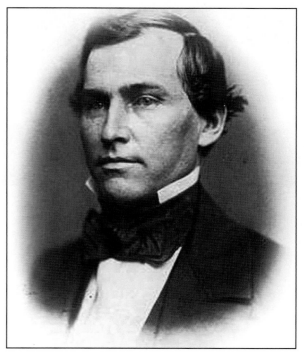

Library of Congress, Prints & Photographs Division, Reproduction Number LC-DIG-ppmsca-26684

of nearly seventeen miles. Exhausted from the march, Branch's brigade fought valiantly nonetheless, helping repel Burnside's attack late in the day. Branch was shot as his men pursued Union troops toward the Lower Bridge, making him one of six generals to be killed at Antietam. It is believed the shot that killed him was fired by a sharpshooter as Branch met with A. P. Hill, the division commander.

Command of the brigade fell to Colonel James H. Lane when Branch died.

Chapter 10

GENERAL

General 1: War Department Markers

More than three hundred tablets similar to this one have been placed strategically across the battlefield to aid visitors in understanding the battle. Created and installed in the 1890s by the War Department, they mark the locations of specific portions of the armies at various times throughout the fighting.

While they do take some time to read, the markers are invaluable in conveying details of the battle that are not readily available elsewhere. Visitors who do not read these tablets are doing themselves a great disservice and will miss much of the information important for a greater understanding of the battle.

General 2: Wayside Markers

These informational signs are also placed at significant locations throughout the battlefield.

Although they don't give much detailed information about the movements of the armies, they do provide maps that offer visitors a perspective on where the troops were positioned, as well as general information about what was taking place at specific times in the areas surrounding the markers.

Quotes from the men who participated, human interest stories, and general battle information make these popular markers an important source of information on the battle. They should be read in conjunction with the War Department markers, rather than instead of them. For those following particular regiments or individuals, both markers will prove valuable sources of information.

General 3: Artillery

More than 500 cannons of all types were pressed into service by the two sides at Antietam, the Union having 293 and the Confederates 246. More than 50,000 rounds of ammunition were fired—an average of nearly 70 rounds every minute of the day-long battle. Captain John Tompkins's Union battery, positioned behind where the visitor center now stands, was said to have fired more than 1,000 rounds in only three hours in its support of the fighting at the Sunken Road. Major General A. P. Hill said it was the worst artillery fire he had ever seen, while a fellow Confederate, Colonel S. D. Lee, referred to the battle as "artillery hell." Lee's artillery battalion sat where the visitor center is located today. From there, it wreaked havoc on Union troops in the Miller Cornfield.

Because the battlefield looks much as it did

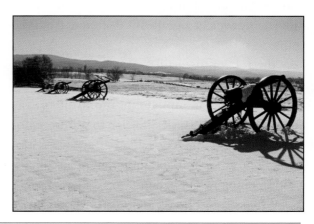

in 1862, it is easy to grasp the importance of artillery at Antietam. Since much of the ground was farmland, few wood lots impeded the artillerists. Troop movements could be seen from great distances, enabling both sides to effectively strike the enemy even at significant distances from the guns.

The role of the artillery was to provide support for the infantry. Both sides did that with great efficiency at Antietam. The artillery was organized into batteries, rather than into companies like the infantry. Each battery was comprised of a comparable number of men to an infantry company and had four to six cannons.

While smoothbore cannons were present at Antietam, the presence of rifled cannons allowed both sides to be effective at greater distances.

General 4: Hospitals

As would be expected for a battle as ferocious as Antietam, field and receiving hospitals sprang up at an astonishing pace in the surrounding area. Northern losses totaled 12,400 killed, wounded, or missing. Southern losses were 10,300. Many of the wounded from South Mountain were also hospitalized in the area. The entire stretch between Boonsboro and Sharpsburg was said to be "one vast hospital."

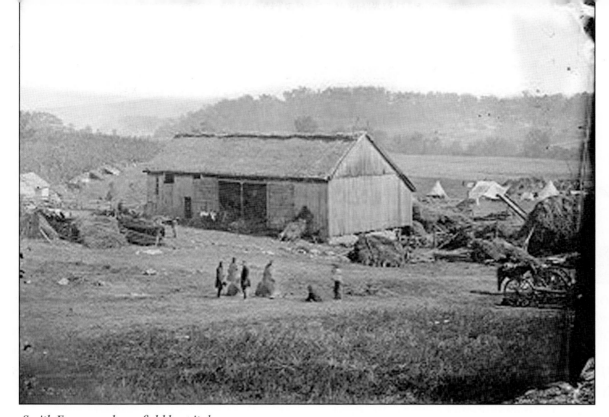

Smith Farm, used as a field hospital
Library of Congress, Prints & Photographs Division, Reproduction Number LC-DIG-cwpb-00256 DLC

The Union army established criteria to determine which buildings were to be used as hospitals. They had to be secure from enemy artillery fire. Ideally, barns were preferred to houses because of their greater size and better ventilation. The hospitals had to have access to large quantities of straw and hay for bedding. They also needed a good water supply. Although barns were preferred, their number was vastly insufficient for the many wounded. Altogether, nearly a hundred buildings of all types were pressed into service in the Sharpsburg area alone.

Homes and churches in surrounding towns as far away as Hagerstown took in the wounded. Pry's Mill near Keedysville became a field hospital, temporarily halting its primary function of grinding grain just as the fall harvest was at its peak. Homes in Shepherdstown served as Confederate hospitals for those who could not be transported. Those able to travel were moved farther away, out of the range of Federal artillery.

Six hundred tents were set up on the

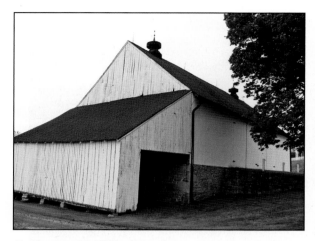

Pry barn at McClellan's headquarters. Enlisted Union soldiers were treated here. Officers were treated in the nearby house.

side doors and windows. Antietam after the battle was not a place for the faint of heart.

By the time the last soldier was treated, the area boasted the largest collection of hospitals ever seen up to that time.

The adjacent photo shows the barn at the Pry Farm, used as a hospital while the adjacent Pry House was still in service as McClellan's headquarters.

General 5: Fences

The many farms in the Sharpsburg area utilized fences to keep farm animals out of gardens

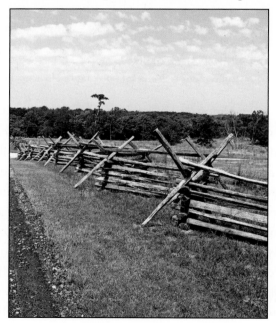

Hoffman Farm for long-term care for the severely wounded from the Union right who could not be moved to more remote hospitals. The Crystal Farm was used for similarly wounded troops on the Union left.

Surgeons on both sides operated on the wounded with no regard to the color of the uniforms. Even captured surgeons were quickly pressed into service. The wounds were too many and too serious for surgeons to be concerned if it was friend or foe on the table. Jonathan Letterman, medical director of the Army of the Potomac, estimated that twenty-five hundred Confederates were treated by Union surgeons, including wounded from South Mountain and Crampton's Pass. Amputated limbs piled up out-

and to delineate pastures. Wood lots were defined by fencing, and nearly every lane and road had fences on either side. Unfortunately for the farmers, soldiers depended on the fences for firewood and shelter. Most were destroyed during the fighting and the weeks that followed.

The National Park Service, using maps from the time of the battle, has placed fences in the approximate locations where they stood in 1862. Visitors will note the two types of fencing—five-rail vertical fences and snake, or worm, fences.

General 6: Reenactors

Reenactors can be found at most Civil War battlefields, and Antietam is no exception. These living-history enthusiasts possess a wealth of information and are more than eager to talk to visitors. Found most often at the Dunker Church and the Newcomer House, they conduct live demonstrations of marching drills, weaponry, medicine, and camp life.

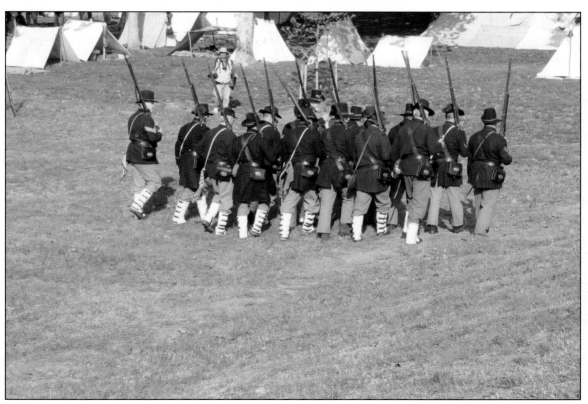

Appendix A: Lee's Lost Orders

Special Orders, No. 191
Hdqrs. Army of Northern Virginia
September 9, 1862

1. The citizens of Fredericktown being unwilling while overrun by members of this army, to open their stores, in order to give them confidence, and to secure to officers and men purchasing supplies for benefit of this command, all officers and men of this army are strictly prohibited from visiting Fredericktown except on business, in which cases they will bear evidence of this in writing from division commanders. The provost-marshal in Fredericktown will see that his guard rigidly enforces this order.

2. Major Taylor will proceed to Leesburg, Virginia, and arrange for transportation of the sick and those unable to walk to Winchester, securing the transportation of the country for this purpose. The route between this and Culpepper [sic] Court-House east of the mountains being unsafe, will no longer be traveled. Those on the way to this army already across the river will move up promptly; all others will proceed to Winchester collectively and under command of officers, at which point, being the general depot of this army, its movements will be known and instructions given by commanding officer regulating further movements.

3. The army will resume its march tomorrow, taking the Hagerstown road. General Jackson's command will form the advance, and, after passing Middletown, with such portion as he may select, take the route toward Sharpsburg, cross the Potomac at the most convenient point, and by Friday morning take possession of the Baltimore and Ohio Railroad, capture such of them as may be at Martinsburg, and intercept such as may attempt to escape from Harpers Ferry.

4. General Longstreet's command will pursue the same road as far as Boonsborough, where it will halt, with reserve, supply, and baggage trains of the army.

5. General McLaws, with his own division and that of General R. H. Anderson, will follow General Longstreet. On reaching Middletown will take

the route to Harpers Ferry, and by Friday morning possess himself of the Maryland Heights and endeavor to capture the enemy at Harpers Ferry and vicinity.

6. General Walker, with his division, after accomplishing the object in which he is now engaged, will cross the Potomac at Cheek's Ford, ascend its right bank to Lovettsville, take possession of Loudoun Heights, if practicable, by Friday morning, Key's Ford on his left, and the road between the end of the mountain and the Potomac on his right. He will, as far as practicable, cooperate with General McLaws and Jackson, and intercept retreat of the enemy.

7. General D. H. Hill's division will form the rear guard of the army, pursuing the road taken by the main body. The reserve artillery, ordnance, and supply trains, &c., will precede General Hill.

8. General Stuart will detach a squadron of cavalry to accompany the commands of Generals Longstreet, Jackson, and McLaws, and, with the main body of the cavalry, will cover the route of the army, bringing up all stragglers that may have been left behind.

9. The commands of Generals Jackson, McLaws, and Walker, after accomplishing the objects for which they have been detached, will join the main body of the army at Boonsborough or Hagerstown.

10. Each regiment on the march will habitually carry its axes in the regimental ordnance-wagons, for use of the men at their encampments, to procure wood &c.

By command of General R. E. Lee
R. H. Chilton,
Assistant Adjutant General

Source: *Official Records*, 19: 603.

Appendix B: Confederate Order of Battle

Army of Northern Virginia
(General Robert E. Lee)

**Longstreet's Command
(Major General James Longstreet)**

**McLaws' Division
(Major General Lafayette McLaws)**

Kershaw's Brigade
(Brigadier General J. B. Kershaw)

 Second South Carolina Infantry
 Third South Carolina Infantry
 Seventh South Carolina Infantry
 Eighth South Carolina Infantry

Cobb's Brigade
(Brigadier General Howell Cobb)

 Sixteenth Georgia Infantry
 Twenty-fourth Georgia Infantry
 Cobb's (Georgia) Legion
 Fifteenth North Carolina Infantry

Semmes' Brigade
(Brigadier General Paul J. Semmes)

 Tenth Georgia Infantry
 Fifty-third Georgia Infantry
 Fifteenth Virginia Infantry
 Thirty-second Virginia Infantry

Barksdale's Brigade
(Brigadier General William Barksdale)

 Thirteenth Mississippi Infantry
 Seventeenth Mississippi Infantry
 Eighteenth Mississippi Infantry
 Twenty-first Mississippi Infantry

Artillery
(Major S. P. Hamilton)

 Manly's (North Carolina) Battery
 Pulaski (Georgia) Artillery
 Richmond (Fayette) Artillery
 Richmond Howitzers, First Company
 Troup (Georgia) Artillery

**Anderson's Division
(Major General Richard H. Anderson)**

Wilcox's Brigade
(Colonel Alfred Cumming)

 Eighth Alabama Infantry
 Ninth Alabama Infantry
 Tenth Alabama Infantry
 Eleventh Alabama Infantry

Mahone's Brigade
(Colonel William A. Parham)

 Sixth Virginia Infantry
 Twelfth Virginia Infantry
 Sixteenth Virginia Infantry
 Forty-first Virginia Infantry
 Sixty-first Virginia Infantry

Featherston's Brigade
(Brigadier General Winfield S. Featherston)

Twelfth Mississippi Infantry
Sixteenth Mississippi Infantry
Nineteenth Mississippi Infantry
Second Mississippi Battalion

Armistead's Brigade
(Brigadier General Lewis A. Armistead)

Ninth Virginia Infantry
Fourteenth Virginia Infantry
Thirty-eighth Virginia Infantry
Fifty-third Virginia Infantry
Fifty-seventh Virginia Infantry

Pryor's Brigade
(Brigadier General Roger A. Pryor)

Fourteenth Alabama Infantry
Second Florida Infantry
Fifth Florida Infantry
Eighth Florida Infantry
Third Virginia Infantry

Wright's Brigade
(Brigadier General A. R. Wright)

Forty-fourth Alabama Infantry
Third Georgia Infantry
Twenty-second Georgia Infantry
Forty-eighth Georgia Infantry

Artillery
(Major John S. Saunders)

Donaldsonville (Louisiana) Artillery
Huger's (Virginia) Battery
Moorman's (Virginia) Battery
Thompson's (Grimes') (Virginia) Battery

Jones' Division
(Brigadier General David R. Jones)

Toombs' Brigade
(Brigadier General Robert Toombs)

Second Georgia Infantry
Fifteenth Georgia Infantry
Seventeenth Georgia Infantry
Twentieth Georgia Infantry

Drayton's Brigade
(Brigadier General Thomas F. Drayton)

Fiftieth Georgia Infantry
Fifty-first Georgia Infantry
Fifteenth South Carolina Infantry
Third South Carolina Battalion
Phillips' (Georgia) Legion

Pickett's Brigade
(Brigadier General Richard B. Garnett)

Eighth Virginia Infantry
Eighteenth Virginia Infantry
Nineteenth Virginia Infantry
Twenty-eighth Virginia Infantry
Fifty-sixth Virginia Infantry

Kemper's Brigade
(Brigadier General J. L. Kemper)

First Virginia Infantry
Seventh Virginia Infantry
Eleventh Virginia Infantry
Seventeenth Virginia Infantry
Twenty-fourth Virginia Infantry

Jenkins' Brigade
(Colonel Joseph Walker)

First South Carolina Volunteers
Second South Carolina Rifles
Fifth South Carolina Infantry
Sixth South Carolina Infantry
Fourth South Carolina Battalion
Palmetto (South Carolina) Sharpshooters

Anderson's Brigade
(Colonel George T. Anderson)

First Georgia Infantry (Regulars)
Seventh Georgia Infantry
Eighth Georgia Infantry
Ninth Georgia Infantry
Eleventh Georgia Infantry

Artillery

Fauquier (Virginia) Artillery*
Loudoun Virginia) Artillery*
Turner (Virginia) Artillery*
Wise (Virginia) Artillery

**Walker's Division
(Brigadier General John G. Walker)**

Walker's Brigade
(Colonel Van H. Manning)

Third Arkansas Infantry
Twenty-seventh North Carolina Infantry
Forty-sixth North Carolina Infantry
Forty-eighth North Carolina Infantry
Thirtieth Virginia Infantry
French's (Virginia) Battery

Ransom's Brigade
(Brigadier General Robert Ransom Jr.)

Twenty-fourth North Carolina Infantry
Twenty-fifth North Carolina Infantry
Thirty-fifth North Carolina Infantry
Forty-ninth North Carolina Infantry
Branch's Field Artillery (Virginia)

**Hood's Division
(Brigadier General John B. Hood)**

Hood's Brigade
(Colonel W. T. Wofford)

Eighteenth Georgia Infantry
Hampton (South Carolina) Legion
First Texas Infantry
Fourth Texas Infantry
Fifth Texas Infantry

Whiting's Brigade
(Colonel E. M. Law)

Fourth Alabama Infantry
Second Mississippi Infantry
Eleventh Mississippi Infantry
Sixth North Carolina Infantry

Artillery
(Major B. W. Frobel)

 German (South Carolina) Artillery
 Palmetto (South Carolina) Artillery
 Rowan (North Carolina) Artillery

Evans' Brigade
(Brigadier General Nathan G. Evans)

 Seventeenth South Carolina Infantry
 Eighteenth South Carolina Infantry
 Twenty-second South Carolina Infantry
 Twenty-third South Carolina Infantry
 Holcombe (South Carolina) Legion
 Macbeth (South Carolina) Artillery

Washington (Louisiana) Artillery
(Colonel J.B. Walton)

 First Company
 Second Company
 Third Company
 Fourth Company

Lee's Battalion
(Colonel S. D. Lee)

 Ashland (Virginia) Artillery
 Bedford (Virginia) Artillery
 Brooks' (South Carolina) Artillery
 Eubanks' (Virginia) Artillery
 Madison (Louisiana) Artillery
 Parker's (Virginia) Battery

Jackson's Command
(Major General Thomas J. Jackson)

Ewell's Division
(Brigadier General A. R. Lawton)

Lawton's Brigade
(Colonel M. Douglass)

 Thirteenth Georgia Infantry
 Twenty-sixth Georgia Infantry
 Thirty-first Georgia Infantry
 Thirty-eighth Georgia Infantry
 Sixtieth Georgia Infantry
 Sixty-first Georgia Infantry

Early's Brigade
(Brigadier General Jubal A. Early)

 Thirteenth Virginia Infantry
 Twenty-fifth Virginia Infantry
 Thirty-first Virginia Infantry
 Forty-fourth Virginia Infantry
 Forty-ninth Virginia Infantry
 Fifty-second Virginia Infantry
 Fifty-eighth Virginia Infantry

Trimble's Brigade
(Colonel James A. Walker)

 Fifteenth Alabama Infantry
 Twelfth Georgia Infantry
 Twenty-first Georgia Infantry
 Twenty-first North Carolina Infantry
 First North Carolina Battalion (attached to
 Twenty-first North Carolina Infantry)

Hays' Brigade
(Brigadier General Harry T. Hays)

 Fifth Louisiana Infantry
 Sixth Louisiana Infantry
 Seventh Louisiana Infantry
 Eighth Louisiana Infantry
 Fourteenth Louisiana Infantry

Artillery
(Major A. R. Courtney)

 Charlottesville (Virginia) Artillery*
 Chesapeake (Maryland) Artillery*
 Courtney (Virginia) Artillery*
 Johnson's (Virginia) Battery
 Louisiana Guard Artillery
 First Maryland Battery*
 Staunton (Virginia) Artillery*

**Hill's Light Division
(Major General Ambrose P. Hill)**

Branch's Brigade
(Brigadier General L. O'B. Branch)

 Seventh North Carolina Infantry
 Eighteenth North Carolina Infantry
 Twenty-eighth North Carolina Infantry
 Thirty-third North Carolina Infantry
 Thirty-seventh North Carolina Infantry

Gregg's Brigade
(Brigadier General Maxcy Gregg)

 First South Carolina Infantry (Provisional
 Army)

 First South Carolina Rifles
 Twelfth South Carolina Infantry
 Thirteenth South Carolina Infantry
 Fourteenth South Carolina Infantry

Field's Brigade
(Colonel J. M. Brockenbrough)

 Fortieth Virginia Infantry
 Forty-seventh Virginia Infantry
 Fifty-fifth Virginia Infantry
 Twenty-second Virginia Battalion

Archer's Brigade
(Brigadier General J. J. Archer)

 Fifth Alabama Battalion
 Nineteenth Georgia Infantry
 First Tennessee Infantry (Provisional
 Army)
 Seventh Tennessee Infantry
 Fourteenth Tennessee Infantry

Pender's Brigade
(Brigadier General William D. Pender)

 Sixteenth North Carolina Infantry
 Twenty-second North Carolina Infantry
 Thirty-fourth North Carolina Infantry
 Thirty-eighth North Carolina Infantry

Thomas' Brigade
(Colonel Edward L. Thomas)

 Fourteenth Georgia Infantry
 Thirty-fifth Georgia Infantry
 Forty-fifth Georgia Infantry
 Forty-ninth Georgia Infantry

Artillery
(Lieutenant Colonel R. L. Walker)

 Branch (North Carolina) Artillery*
 Crenshaw's (Virginia) Battery
 Fredericksburg (Virginia) Artillery
 Letcher (Virginia) Artillery*
 Middlesex (Virginia) Artillery*
 Pee Dee (South Carolina) Artillery
 Purcell (Virginia) Artillery

**Jackson's Division
(Brigadier General John R. Jones)**

Winder's Brigade
(Colonel A. J. Grigsby)

 Second Virginia Infantry
 Fourth Virginia Infantry
 Fifth Virginia Infantry
 Twenty-seventh Virginia Infantry
 Thirty-third Virginia Infantry

Taliaferro's Brigade
(Colonel E. T. H. Warren)

 Forty-seventh Alabama Infantry
 Forty-eighth Alabama Infantry
 Tenth Virginia Infantry
 Twenty-third Virginia Infantry
 Thirty-seventh Virginia Infantry

Jones' Brigade
(Colonel B. T. Johnson)

 Twenty-first Virginia Infantry
 Forty-second Virginia Infantry

 Forty-eighth Virginia Infantry
 First Virginia Battalion

Starke's Brigade
(Brigadier General William E. Starke)

 First Louisiana Infantry
 Second Louisiana Infantry
 Ninth Louisiana Infantry
 Tenth Louisiana Infantry
 Fifteenth Louisiana Infantry
 Coppens' (Louisiana) Battalion

Artillery
(Major L. M. Shumaker)

 Alleghany (Virginia) Artillery
 Brockenbrough's (Maryland) Battery
 Danville (Virginia) Artillery
 Hampden (Virginia) Artillery
 Lee (Virginia) Battery
 Rockbridge (Virginia) Artillery

**Hill's Division
(Major General Daniel H. Hill)**

Ripley's Brigade
(Brigadier General Roswell S. Ripley)

 Fourth Georgia Infantry
 Forty-fourth Georgia Infantry
 First North Carolina Infantry
 Third North Carolina Infantry

Rodes' Brigade
(Brigadier General R. E. Rodes)

Third Alabama Infantry
Fifth Alabama Infantry
Sixth Alabama Infantry
Twelfth Alabama Infantry
Twenty-sixth Alabama Infantry

Garland's Brigade
(Brigadier General Samuel Garland Jr.)

Fifth North Carolina Infantry
Twelfth North Carolina Infantry
Thirteenth North Carolina Infantry
Twentieth North Carolina Infantry
Twenty-third North Carolina Infantry

Anderson's Brigade
(Brigadier General George B. Anderson)

Second North Carolina Infantry
Fourth North Carolina Infantry
Fourteenth North Carolina Infantry
Thirtieth North Carolina Infantry

Colquitt's Brigade
(Colonel A. H. Colquitt)

Thirteenth Alabama Infantry
Sixth Georgia Infantry
Twenty-third Georgia Infantry
Twenty-seventh Georgia Infantry
Twenty-eighth Georgia Infantry

Artillery
(Major Scipio Pierson)

Hardaway (Alabama) Battery
Jeff. Davis (Alabama) Artillery
Jones' (Virginia) Battery
King William (Virginia) Artillery

Reserve Artillery
(Brigadier General William N. Pendleton)

Brown's Battalion
(Colonel J. Thompson Brown)

Powhatan Artillery
Richmond Howitzers,
 Second and Third Companies
Salem Artillery
Williamsburg Artillery

Cutts' Battalion
(Lieutenant Colonel A. S. Cutts)

Blackshears' (Georgia) Battery
Irwin (Georgia) Artillery
Lloyd's (North Carolina) Battery
Patterson's (Georgia) Battery
Ross' (Georgia) Battery

Jones' Battalion
(Major H. P. Jones)

Morris (Virginia) Artillery
Orange (Virginia) Artillery
Turner's (Virginia) Battery
Wimbish's (Virginia) Battery

Nelson's Battalion
(Major William Nelson)

 Amherst (Virginia) Artillery
 Fluvanna (Virginia) Artillery
 Huckstep's (Virginia) Battery
 Johnson's (Virginia) Battery
 Milledge (Georgia) Artillery

Miscellaneous Artillery

 Cutshaw's (Virginia) Battery
 Dixie (Virginia) Artillery
 Magruder (Virginia) Artillery
 Rice's (Virginia) Battery
 Thomas (Virginia) Artillery*

Cavalry
(Major General James E. B. Stuart)

Hampton's Brigade
(Brigadier General Wade Hampton)

 First North Carolina Cavalry
 Second South Carolina Cavalry
 Tenth Virginia Cavalry
 Cobb's (Georgia) Legion
 Jeff. Davis Legion

Lee's Brigade
(Brigadier General Fitzhugh Lee)

 First Virginia Cavalry
 Third Virginia Cavalry
 Fourth Virginia Cavalry
 Fifth Virginia Cavalry
 Ninth Virginia Cavalry

Robertson's Brigade
(Colonel Thomas T. Munford)

 Second Virginia Cavalry
 Sixth Virginia Cavalry
 Seventh Virginia Cavalry
 Twelfth Virginia Cavalry
 Seventeenth Virginia Battalion

Horse Artillery
(Captain John Pelham)

 Chew's (Virginia) Battery
 Hart's (South Carolina) Battery
 Pelham's (Virginia) Battery

* On detached duty

Source: Official Records, Series 1, Volume XIX, Part 1, pages 803–10

Appendix C: Union Order of Battle

Army of the Potomac
(Major General George B. McClellan)
Escort: (Captain James B. McIntyre)
Independent Company Oneida (New York)
Cavalry Fourth United States Cavalry,
Companies A and E

Volunteer Engineer Brigade
(Brigadier General Daniel P. Woodbury)

Fifteenth New York Infantry
Fiftieth New York Infantry

Regular Engineer Battalion
(Captain James C. Duane)

Provost Guard
(Major William H. Wood)

Second United States Cavalry, Companies
E, F, H, and K
Eighth United States Infantry, Companies
A, D, F, and G
Nineteenth United States Infantry,
Companies G and H

Headquarters Guard
(Major Granville O. Haller)

Sturgis (Illinois) Rifles
Ninety-third New York Volunteers

Quartermaster Guard
(Captain Marcus A. Reno)

First United States Cavalry, Companies B,
C, H, and I

First Corps
(Major General Joseph Hooker)
Escort: Second New York Cavalry (four
companies), Captain John E. Naylor

First Division
(Brigadier General Abner Doubleday)

First Brigade
(Colonel Walter J. Phelps Jr.)

Twenty-second New York Infantry
Twenty-fourth New York Infantry
Thirtieth New York Infantry
Eighty-fourth New York Infantry (Four-
teenth Brooklyn)
Second United States Sharpshooters

Second Brigade
(Lieutenant Colonel J. William Hoffman)

Seventh Indiana Infantry
Fifty-sixth Pennsylvania Infantry
Seventy-sixth New York Infantry
Ninety-fifth New York Infantry

Third Brigade
(Brigadier General Marsena R. Patrick)

Twenty-first New York Infantry
Twenty-third New York Infantry
Thirty-fifth New York Infantry

Eightieth New York Infantry (Twentieth Militia)

Fourth Brigade
(Brigadier General John Gibbon)

Nineteenth Indiana Infantry
Second Wisconsin Infantry
Sixth Wisconsin Infantry
Seventh Wisconsin Infantry

Artillery
(Captain J. Albert Monroe)

New Hampshire Light, First Battery
First New York Light, Battery L
First Rhode Island Light, Battery D
Fourth United States Artillery, Battery B

**Second Division
(Brigadier General James B. Ricketts)**

First Brigade
(Brigadier General Abram Duryea)

Ninety-seventh New York Infantry
104th New York Infantry
105th New York Infantry
107th New York Infantry

Second Brigade
(Colonel William A. Christian)

Twenty-sixth New York Infantry
Ninety-fourth New York Infantry
Eighty-eighth Pennsylvania Infantry
Ninetieth Pennsylvania Infantry

Third Brigade
(Brigadier General George L. Hartsuff)

Sixteenth Maine Infantry*
Twelfth Massachusetts Infantry
Thirteenth Massachusetts Infantry
Eighty-third New York Infantry (Ninth Militia)
Eleventh Pennsylvania Infantry

Artillery

First Pennsylvania Light, Battery F
Pennsylvania Light, Battery C

**Third Division
(Brigadier General George G. Meade)**

First Brigade
(Brigadier General Truman Seymour)

First Pennsylvania Reserves
Second Pennsylvania Reserves
Fifth Pennsylvania Reserves
Sixth Pennsylvania Reserves
Thirteenth Pennsylvania Reserves

Second Brigade
(Colonel Albert L. Magilton)

Third Pennsylvania Reserves
Fourth Pennsylvania Reserves
Seventh Pennsylvania Reserves
Eighth Pennsylvania Reserves

Third Brigade
(Colonel Thomas F. Gallagher)

Ninth Pennsylvania Reserves
Tenth Pennsylvania Reserves
Eleventh Pennsylvania Reserves
Twelfth Pennsylvania Reserves

Artillery

First Pennsylvania Light, Batteries A, B, and G
Fifth United States Artillery, Battery C

Second Corps
(Major General Edwin V. Sumner)
Escort: Sixth New York Cavalry, Companies D and K

First Division
(Major General Israel B. Richardson)

First Brigade
(Brigadier General John C. Caldwell)

Fifth New Hampshire Infantry
Seventh New York Infantry
Sixty-first New York Infantry
Sixty-fourth New York Infantry
Eighty-first Pennsylvania Infantry

Second Brigade
(Brigadier General Thomas F. Meagher)

Twenty-ninth Massachusetts Infantry
Sixty-third New York Infantry
Sixty-ninth New York Infantry
Eighty-eighth New York Infantry

Third Brigade
(Colonel John R. Brooke)

Second Delaware Infantry
Fifty-second New York Infantry
Fifty-seventh New York Infantry
Sixty-sixth New York Infantry
Fifty-third Pennsylvania Infantry

Artillery

First New York Light, Battery B
Fourth United States Artillery, Batteries A and C

Second Division
(Major General John Sedgwick)

First Brigade
(Brigadier General Willis A. Gorman)

Fifteenth Massachusetts Infantry
First Minnesota Infantry
Thirty-fourth New York Infantry (Second Militia)
Eighty-second New York Infantry
Massachusetts Sharpshooters, First Company
Minnesota Sharpshooters, Second Company

Second Brigade
(Brigadier General Oliver O. Howard)

Sixty-ninth Pennsylvania Infantry
Seventy-first Pennsylvania Infantry

Seventy-second Pennsylvania Infantry
106th Pennsylvania Infantry

Third Brigade
(Brigadier General Napoleon J. T. Dana)

Nineteenth Massachusetts Infantry
Twentieth Massachusetts Infantry
Seventh Michigan Infantry
Forty-second New York Infantry
Fifty-ninth New York Infantry

Artillery

First Rhode Island Light, Battery A
First United States Artillery, Battery I

Third Division
(Brigadier General William H. French)

First Brigade
(Brigadier General Nathan Kimball)

Fourteenth Indiana Infantry
Eighth Ohio Infantry
132nd Pennsylvania Infantry
Seventh West Virginia Infantry

Second Brigade
(Colonel Dwight Morris)

Fourteenth Connecticut Infantry
108th New York Infantry
130th Pennsylvania Infantry

Third Brigade
(Brigadier General Max Weber)

First Delaware Infantry
Fifth Maryland Infantry
Fourth New York Infantry

Unassigned Artillery

First New York Light, Battery G
First Rhode Island Light, Batteries B and G

Couch's Division
(Major General Darius N. Couch)

First Brigade
(Brigadier General Charles Devens Jr.)

Seventh Massachusetts Infantry
Tenth Massachusetts Infantry
Thirty-sixth Massachusetts Infantry
Second Rhode Island Infantry

Second Brigade
(Brigadier General Albion P. Howe)

Sixty-second New York Infantry
Ninety-third Pennsylvania Infantry
Ninety-eighth Pennsylvania Infantry
102nd Pennsylvania Infantry
139th Pennsylvania Infantry

Third Brigade
(Brigadier General John Cochrane)

Sixty-fifth New York Infantry
Sixty-seventh New York Infantry
122nd New York Infantry

Twenty-third Pennsylvania Infantry
Thirty-first Pennsylvania Infantry
Sixty-first Pennsylvania Infantry
Eighty-second Pennsylvania Infantry

Artillery

New York Light, Third Battery
First Pennsylvania Light, Batteries
 C and D
Second United States Artillery, Battery G

Fifth Corps
(Major General Fitz-John Porter)

First Division
(Major General George W. Morell)

First Brigade
(Colonel James Barnes)

Second Maine Infantry
Eighteenth Massachusetts Infantry
Twenty-second Massachusetts Infantry
First Michigan Infantry
Thirteenth New York Infantry
Twenty-fifth New York Infantry
118th Pennsylvania Infantry
Massachusetts Sharpshooters, Second
 Company

Second Brigade
(Brigadier General Charles Griffin)

Second District of Columbia Infantry
Ninth Massachusetts Infantry
Thirty-second Massachusetts Infantry

Fourth Michigan Infantry
Fourteenth New York Infantry
Sixty-second Pennsylvania Infantry

Third Brigade
(Colonel T. B. W. Stockton)

Twentieth Maine Infantry
Sixteenth Michigan Infantry
Twelfth New York Infantry
Seventeenth New York Infantry
Forty-fourth New York Infantry
Eighty-third Pennsylvania Infantry
Michigan Sharpshooters, Brady's
 Company

Artillery—Sharpshooters

Massachusetts Light, Battery C
First Rhode Island Light, Battery C
Fifth United States Artillery, Battery D

Unassigned

First United States Sharpshooters

Second Division
(Brigadier General George Sykes)

First Brigade
(Lieutenant Colonel Robert C. Buchanan)

Third United States Infantry
Fourth United States Infantry
Twelfth United States Infantry
 (two battalions)
Fourteenth United States Infantry
 (two battalions)

Second Brigade
(Major Charles S. Lovell)

First United States Infantry
Second United States Infantry
Sixth United States Infantry
Tenth United States Infantry
Eleventh United States Infantry
Seventeenth United States Infantry

Third Brigade
(Colonel Gouverneur K. Warren)

Fifth New York Infantry
Tenth New York Infantry

Artillery

First United States Artillery, Batteries
 E and G
Fifth United States Artillery, Batteries
 I and K

**Third Division
(Brigadier General Andrew A.
 Humphreys)**

First Brigade
(Brigadier General Erastus B. Tyler)

Ninety-first Pennsylvania Infantry
126th Pennsylvania Infantry
129th Pennsylvania Infantry
134th Pennsylvania Infantry

Second Brigade
(Colonel Peter H. Allabach)

123rd Pennsylvania Infantry
131st Pennsylvania Infantry
133rd Pennsylvania Infantry
155th Pennsylvania Infantry

Artillery

First New York Light, Battery C
First Ohio Light, Battery L

Artillery Reserve
(Lieutenant Colonel William Hays)

First Battalion, New York Light,
 Batteries A, B, C, and D
New York Light, Fifth Battery
First United States Artillery, Battery K
Fourth United States Artillery, Battery G

**Sixth Corps
(Major General William B. Franklin)**
Escort: Sixth Pennsylvania Cavalry,
Companies B and G

**First Division
(Major General Henry W. Slocum)**

First Brigade
(Colonel Alfred T. A. Torbert)

First New Jersey Infantry
Second New Jersey Infantry
Third New Jersey Infantry
Fourth New Jersey Infantry

Second Brigade
(Colonel Joseph J. Bartlett)

Fifth Maine Infantry
Sixteenth New York Infantry
Twenty-seventh Pennsylvania Infantry
Ninety-sixth Pennsylvania Infantry
121st New York Infantry

Third Brigade
(Brigadier General John Newton)

Eighteenth New York Infantry
Thirty-first New York Infantry
Thirty-second New York Infantry
Ninety-fifth New York Infantry

Artillery
(Captain Emory Upton)

Maryland Light, Battery A
Massachusetts Light, Battery A
New Jersey Light, Battery A
Second United States Artillery, Battery D

**Second Division
(Major General William F. Smith)**

First Brigade
(Brigadier General Winfield S. Hancock)

Sixth Maine Infantry
Forty-third New York Infantry
Forty-ninth Pennsylvania Infantry
137th Pennsylvania Infantry
Fifth Wisconsin Infantry

Second Brigade
(Brigadier General W. T. H. Brooks)

Second Vermont Infantry
Third Vermont Infantry
Fourth Vermont Infantry
Fifth Vermont Infantry
Sixth Vermont Infantry

Third Brigade
(Colonel William H. Irwin)

Seventh Maine Infantry
Twentieth New York Infantry
Thirty-third New York Infantry
Forty-ninth New York Infantry
Seventy-seventh New York Infantry

Artillery
(Captain Romeyn B. Ayres)

Maryland Light, Battery B
New York Light, First Battery
Fifth United States Artillery, Battery F

**Ninth Corps
(Brigadier General Jacob D. Cox)**
Escort: First Maine Cavalry, Company G

**First Division
(Brigadier General Orlando B. Willcox)**

First Brigade
(Colonel Benjamin C. Christ)

Twenty-eighth Massachusetts Infantry
Seventeenth Michigan Infantry
Seventy-ninth New York Infantry
Fiftieth Pennsylvania Infantry

Second Brigade
(Colonel Thomas Welsh)

Eighth Michigan Infantry
Forty-sixth New York Infantry
Forty-fifth Pennsylvania Infantry
100th Pennsylvania Infantry

Artillery

Massachusetts Light, Eighth Battery
Second United States Artillery, Battery E

Second Division
(Brigadier General Samuel D. Sturgis)

First Brigade
(Brigadier General James Nagle)

Second Maryland Infantry
Sixth New Hampshire Infantry
Ninth New Hampshire Infantry
Forty-eighth Pennsylvania Infantry

Second Brigade
(Brigadier General Edward Ferrero)

Twenty-first Massachusetts Infantry
Thirty-fifth Massachusetts Infantry
Fifty-first New York Infantry
Fifty-first Pennsylvania Infantry

Artillery

Pennsylvania Light, Battery D
Fourth United States Artillery, Battery E

Third Division
(Brigadier General Isaac P. Rodman)

First Brigade
(Colonel Harrison S. Fairchild)

Ninth New York Infantry
Eighty-ninth New York Infantry
103rd New York Infantry

Second Brigade
(Colonel Edward Harland)

Eighth Connecticut Infantry
Eleventh Connecticut Infantry
Sixteenth Connecticut Infantry
Fourth Rhode Island Infantry

Artillery

Fifth United States Artillery, Battery A

Kanawha Division
(Colonel Eliakim P. Scammon)

First Brigade
(Colonel Hugh Ewing)

Twelfth Ohio Infantry
Twenty-third Ohio Infantry
Thirtieth Ohio Infantry

Ohio Light Artillery, First Battery
Gilmore's Company, West Virginia Cavalry
Harrison's Company, West Virginia
 Cavalry

Second Brigade
(Colonel George Crook)

Eleventh Ohio Infantry
Twenty-eighth Ohio Infantry
Thirty-sixth Ohio Infantry
Schambeck's Company, Chicago Dragoons
Kentucky Light Artillery, Simmond's
 Battery

Unassigned

Sixth New York Cavalry (eight companies)
Ohio Cavalry, Third Independent
 Company
Third United States Artillery, Batteries
 L and M

Twelfth Corps
(Major General Joseph K. F. Mansfield)
Escort: First Michigan Cavalry, Company L

First Division
(Brigadier General Alpheus S. Williams)

First Brigade
(Brigadier General Samuel W. Crawford)

Fifth Connecticut Infantry*
Tenth Maine Infantry
Twenty-eighth New York Infantry
Forty-sixth Pennsylvania Infantry

124th Pennsylvania Infantry
125th Pennsylvania Infantry
128th Pennsylvania Infantry

Third Brigade
(Brigadier General George H. Gordon)

Twenty-seventh Indiana Infantry
Second Massachusetts Infantry
Thirteenth New Jersey Infantry
107th New York Infantry
Third Wisconsin Infantry
Zouaves d'Afrique (Pennsylvania)

Second Division
(Brigadier General George S. Greene)

First Brigade
(Lieutenant Colonel Hector Tyndale)

Fifth Ohio Infantry
Seventh Ohio Infantry
Twenty-ninth Ohio Infantry
Sixty-sixth Ohio Infantry
Twenty-eighth Pennsylvania Infantry

Second Brigade
(Colonel Henry J. Stainrook)

Third Maryland Infantry
102nd New York Infantry
109th Pennsylvania Infantry*
111th Pennsylvania Infantry

Third Brigade
(Colonel William B. Goodrich)

Third Delaware Infantry
Purnell Legion (Maryland)
Sixtieth New York Infantry
Seventy-eighth New York Infantry

Artillery
(Captain Clermont L. Best)

Maine Light, Fourth Battery
Maine Light, Sixth Battery
First New York Light, Battery M
New York Light, Tenth Battery
Pennsylvania Light, Batteries E and F
Fourth United States Artillery, Battery F

**Cavalry Division
(Brigadier General Alfred Pleasonton)**

First Brigade
(Major Charles J. Whiting)

Fifth United States Cavalry
Sixth United States Cavalry

Second Brigade
(Colonel John F. Farnsworth)

Eighth Illinois Cavalry
Third Indiana Cavalry
First Massachusetts Cavalry
Eighth Pennsylvania Cavalry

Third Brigade
(Colonel Richard H. Rush)

Fourth Pennsylvania Cavalry
Sixth Pennsylvania Cavalry

Fourth Brigade
(Colonel Andrew T. McReynolds)

First New York Cavalry
Twelfth Pennsylvania Cavalry

Fifth Brigade
(Colonel Benjamin F. Davis)

Eighth New York Cavalry
Third Pennsylvania Cavalry

Horse Artillery

Second United States Artillery
Batteries A, B C, G, L and M

Unassigned

First Maine Cavalry*
Fifteenth Pennsylvania Cavalry
Detachment

* On detached duty

Source: Official Records, Series 1, Volume XIX,
Part 1, pages 169–80

Appendix D: Medal of Honor Awards for Valor at Antietam

Second Lieutenant Hillary Beyer, Company H, Ninetieth Pennsylvania Infantry
Citation: "After his command had been forced to fall back, remained alone on the line of battle, caring for his wounded comrades and carrying one of them to a place of safety."

Second Lieutenant John J. Carter, Company B, Thirty-third New York Infantry
Citation: "While in command of a detached company, seeing his regiment thrown into confusion by a charge of the enemy, without orders made a countercharge upon the attacking column and checked the assault. Penetrated within the enemy's lines at night and obtained valuable information."

Corporal Benjamin H. Child, Battery A, First Rhode Island Light Artillery
Citation: "Was wounded and taken to the rear insensible, but when partially recovered insisted on returning to the battery and resumed command of his piece, so remaining until the close of the battle."

Private Charles Cleveland, Company C, Twenty-sixth New York Infantry
Citation: "Voluntarily took and carried the colors into action after the color bearer had been shot."

Bugler John Cook, Battery B, Fourth United States Artillery
Citation: "Volunteered at the age of fifteen years to act as a cannoneer, and as such volunteer served a gun under a terrific fire of the enemy."

Assistant Surgeon Richard J. Curran, Thirty-third New York Infantry
Citation: "Voluntarily exposed himself to great danger by going to the fighting line, there succoring the wounded and helpless and conducting them to the field hospital."

Major and Assistant Adjutant General Oliver D. Greene, United States Army Sixth Corps
Citation: "Formed the columns under heavy fire and put them into position."

Second Lieutenant Theodore W. Greig, Company C, Sixty-first New York Infantry
Citation: "A Confederate regiment, the Fourth Alabama Infantry (C.S.A.), having planted its battle flag slightly in advance of the regiment, this officer rushed forward and seized it, and, although shot through the neck, retained the flag and brought it within the Union lines."

Corporal Ignatz Gresser, Company D, 128th Pennsylvania Infantry
Citation: "While exposed to the fire of the enemy, carried from the field a wounded comrade."

Sergeant Marcus M. Haskell, Company C, Thirty-fifth Massachusetts Infantry
Citation: "Although wounded and exposed to a heavy fire from the enemy, at the risk of his own life he rescued a badly wounded comrade and succeeded in conveying him to a place of safety."

Private William P. Hogarty, Company D, Twenty-third New York Infantry
Citation: "Distinguished gallantry in actions while attached to Battery B, Fourth U.S. Artillery." Hogarty would receive a second Medal of Honor three months later when he lost his left arm at Fredericksburg.

Major Thomas W. Hyde, Seventh Maine Infantry
Citation: "Led his regiment in an assault on a strong body of the enemy's infantry and kept up the fight until the greater part of his men had been killed or wounded, bringing the remainder safely out of the fight."

Private John Johnson, Company D, Second Wisconsin Infantry
Citation: "Conspicuous gallantry in battle in which he was severely wounded. While serving as cannoneer he manned the positions of fallen gunners."

Private Samuel Johnson, Company G, Ninth Pennsylvania Reserves
Citation: "Individual bravery and daring in capturing from the enemy two colors of the First Texas Rangers (C.S.A.), receiving in the act a severe wound."

Captain Adolphe Libaire, Company E, Ninth New York Infantry
Citation: "In the advance on the enemy and after his color bearer and the entire color guard of eight men had been shot down, this officer seized the regimental flag and with conspicuous gallantry carried it to the extreme front, urging the line forward."

Private John P. Murphy, Company K, Fifth Ohio Infantry
Citation: "Capture of flag of Thirteenth Alabama Infantry (C.S.A.)."

Corporal Jacob G. Orth, Company D, Twenty-eighth Pennsylvania Infantry
Citation: "Capture of flag of Seventh South Carolina Infantry (C.S.A.), in hand-to-hand encounter, although he was wounded in the shoulder."

Private William H. Paul, Company E, Ninetieth Pennsylvania Infantry
Citation: "Under a most withering and concentrated fire, voluntarily picked up the colors of

his regiment, when the bearer and two of the color guard had been killed, and bore them aloft throughout the entire battle."

Second Lieutenant Charles B. Tanner, Company H, First Delaware Infantry
Citation: "Carried off the regimental colors, which had fallen within twenty yards of the enemy's lines, the color guard of nine men having all been killed or wounded; was himself three times wounded."

Private Frank M. Whitman, Company G, Thirty-fifth Massachusetts Infantry
Citation: "Was among the last to leave the field at Antietam and was instrumental in saving the lives of several of his comrades at the imminent risk of his own. At Spotsylvania was foremost in line in the assault, where he lost a leg, receiving his second Medal of Honor."

Private Samuel C. Wright, Company E, Twenty-ninth Massachusetts Infantry
Citation: "Was one of a detachment of sixteen men who heroically defended a wagon train against the attack of 125 cavalry, repulsed the attack and saved the train."

Source: Congressional Medal of Honor Society Records

Index